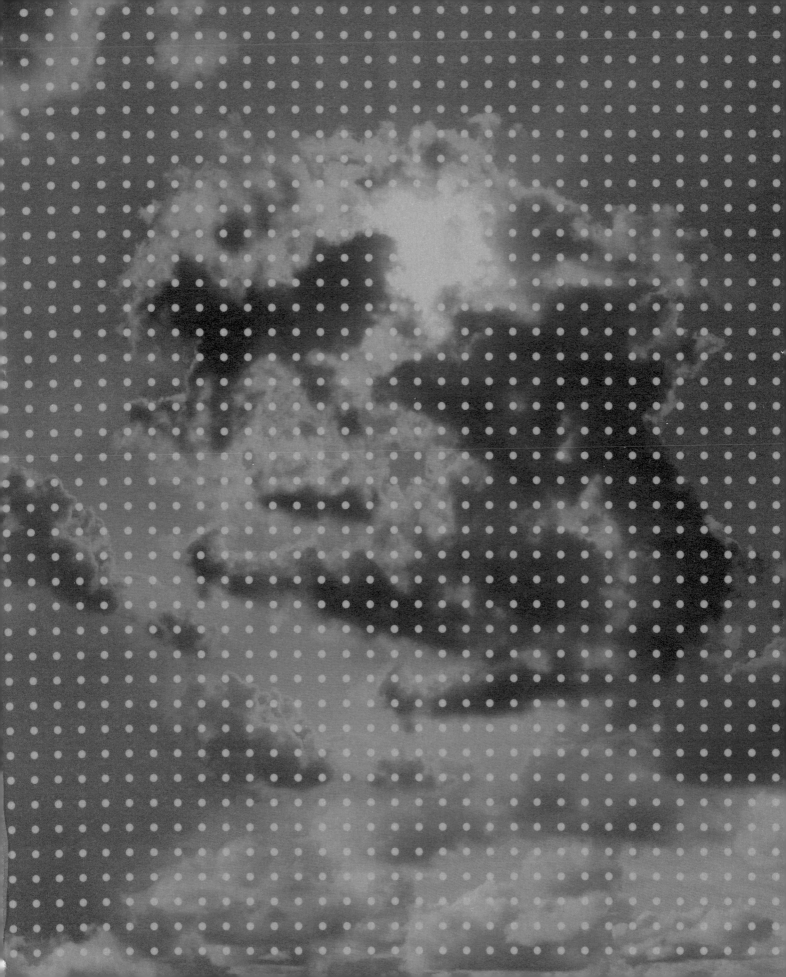

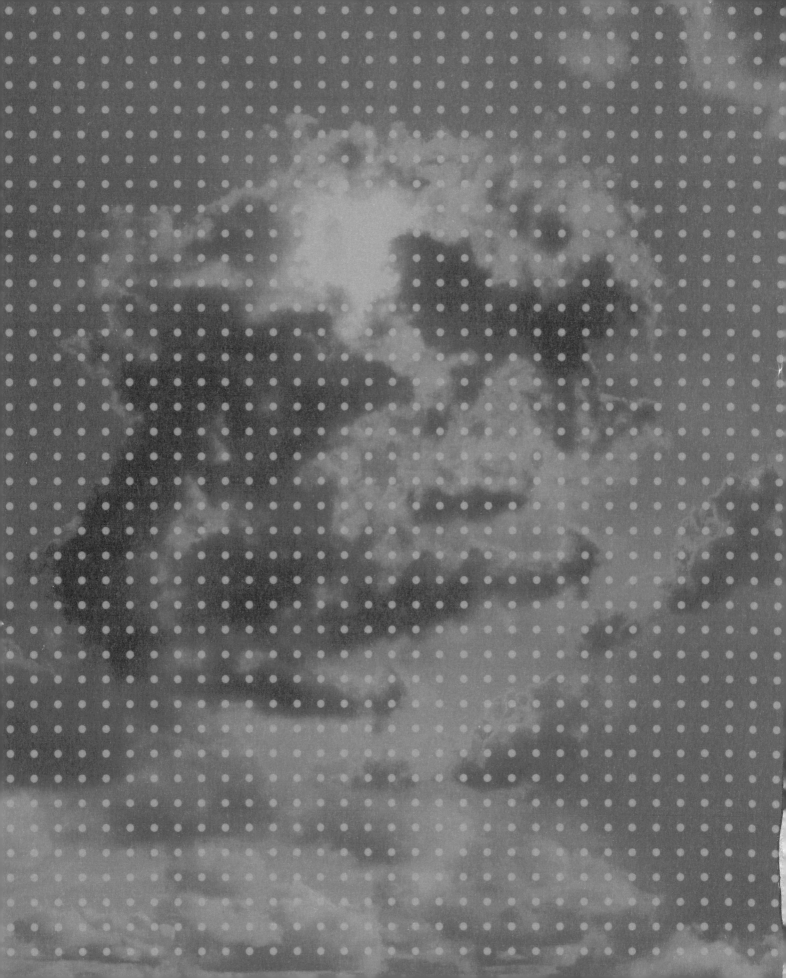

# Seattle's
## Olympic
## Sculpture
## Park

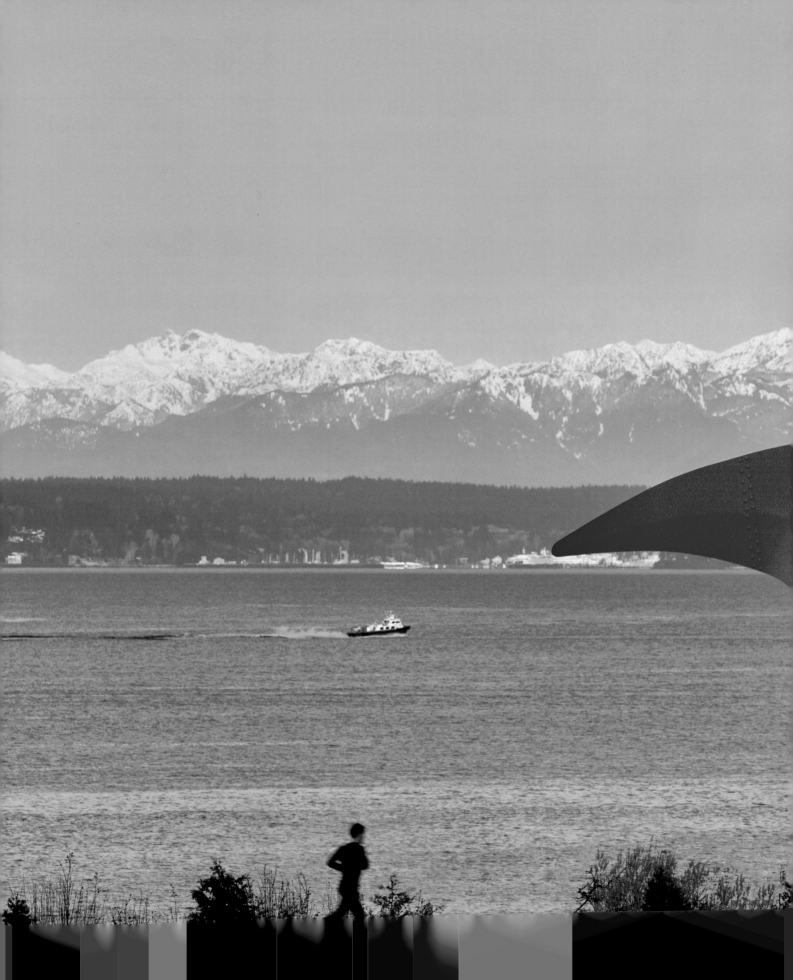

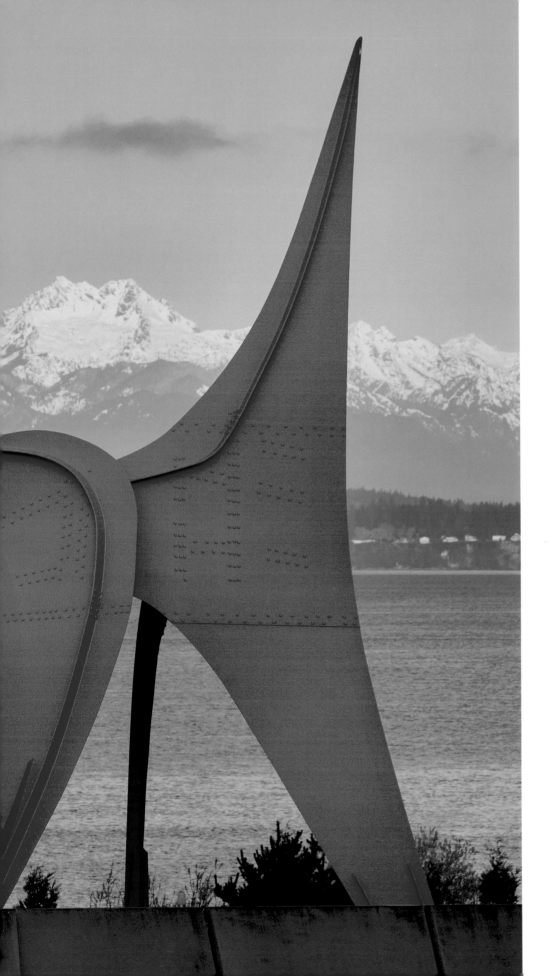

# Seattle's Olympic Sculpture Park

## A Place for Art, Environment, and an Open Mind

Edited by Mimi Gardner Gates
and Renée Devine

WITH CONTRIBUTIONS BY
Barry Bergdoll
Lisa Graziose Corrin
Mark Dion
Teresita Fernández
Leonard Garfield
Jerry Gorovoy for Louise Bourgeois
Michael A. Manfredi
Lynda V. Mapes
Roy McMakin
Peter Reed
Pedro Reyes
Maggie Walker
Marion Weiss

Seattle Art Museum

In association with
University of Washington Press,
Seattle and London

# Contents

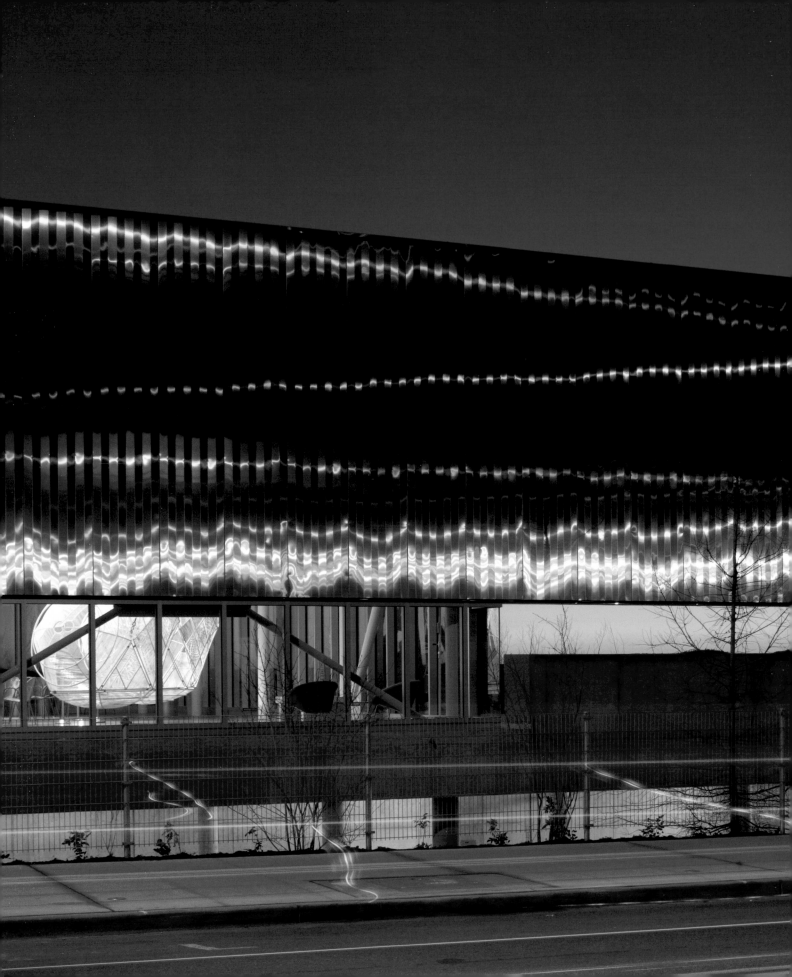

## Dedication

With affection, admiration, and respect, we dedicate this book to founding donors Jon and Mary Shirley, who championed the idea of a sculpture park as a cultural asset of the city of Seattle—a park free of charge, open to all, safe and unfenced, owned and operated by the Seattle Art Museum. The Shirleys' vision, generosity, and commitment inspired the waterfront Olympic Sculpture Park.

# Director's Foreword

*The Seattle Art Museum would like to acknowledge that we are on the traditional homelands of the Duwamish, and the customary territories of the Suquamish and Muckleshoot Peoples. As a cultural and educational institution, we honor our ongoing connection to these communities past, present, and future. We also acknowledge the many urban Native Peoples from many Nations who call Seattle their home.*

Imbued with a strong sense of place, the Seattle Art Museum (SAM)'s Olympic Sculpture Park captures the energy and striking beauty of Seattle. During the past year, as the COVID-19 pandemic ravaged our nation and the world, this exquisitely designed park, free and open to all, offered solace, tranquility, and inspiration to an entire region. People gravitated to this airy, waterfront green space to partake of its restorative value. Located on the northern edge of the hilly downtown, landscaped with plants native to the Northwest, and incorporating an underwater fish habitat, the site offers spectacular views over Puget Sound to the majestic, snowy Olympic peaks. City, water, Chinook salmon, sky, mountains . . . it could only be the Pacific Northwest.

I returned to Seattle as SAM's new director twelve years after attending the opening festivities for the park. What had most impressed me then was the quality of the art—a combination of classic sculptures by Alexander Calder and Louise Nevelson and site-specific commissions by then-emerging talents like Teresita Fernández and Roy McMakin. The range of work and intelligence of the placement were just perfect.

That nascent version of the sculpture park has evolved into a full-fledged oasis of nature and art, which Seattleites have made their own. The rhythm of life in the park starts early with dog walking and running; then office workers take midday breaks as the Tiny Trees preschoolers run gleefully through the mud; and as the sun sets over Puget Sound, bikers and walkers head homeward, outpacing the descending darkness. There is perhaps no better compliment than that most people think the Olympic Sculpture Park is a city park . . . it belongs to all.

A true gift to the city, the park was proposed in the mid-nineties by civic leaders Jon and Mary Shirley and Virginia and Bagley Wright, joined by Ann Wyckoff. Their munificence and dedication to the project cannot be overstated. SAM's then-director, Mimi Gardner Gates, shared their vision of an accessible, free urban refuge with museum-caliber artwork and realized the project with characteristic passion and energy. SAM's board of trustees, led by board chair Herman Sarkowsky and president Belle Maxwell, quickly rallied around the project, providing crucial leaders. As the project unfolded, subsequent board leaders, including Susan Brotman, Dick Cooley, Brooks Ragen, and Jon Shirley, added their support. Additional individuals contributed works of art and funding for the museum to purchase or commission installations for the park. Lisa Corrin, SAM's curator of modern and contemporary art at the time, spearheaded the visionary artistic program. SAM's staff boldly embraced the challenge.

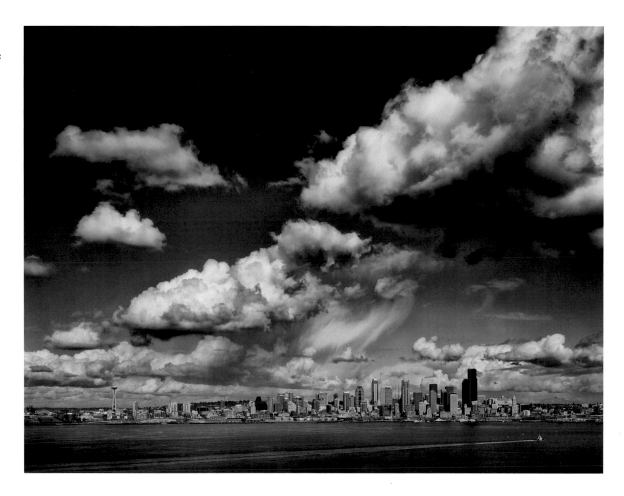

The award-winning design by Weiss/ Manfredi Architecture/Landscape/Urbanism imagined an innovative concept of an urban sculpture park. Architects Marion Weiss and Michael A. Manfredi seamlessly blended landscape, city infrastructure, and art in an experience that is intimate and yet expresses the grandeur of this remarkable site. SAM's project manager, Chris Rogers, worked with Barrientos LLC and Sellen Construction to realize their vision.

This publication is a testament to the fearless dedication of many individuals who made a contaminated brownfield into a beloved outdoor museum and green space. Special gratitude goes to Mimi Gardner Gates for initiating this book to document the evolution of the project. Thank you to all of the authors who have provided insightful perspectives. Lucia|Marquand has produced a beautiful publication, as they always do.

When COVID-19 forced the closure of indoor cultural facilities, including the downtown Seattle Art Museum and the Seattle Asian Art Museum, the civic importance of the Olympic Sculpture Park became even more apparent. Here, in an outdoor urban setting, Seattleites (masked and physically distanced) were able to experience great art, mountains, and water, refreshing heart, mind, and soul. In the future, once the redesign of the downtown waterfront park by James Corner Field Operations is realized, the adjacent Olympic Sculpture Park will be a part of an expansive waterfront that dynamically connects the city of Seattle and Puget Sound, providing inviting experiences of art and nature.

Amada Cruz
Illsley Ball Nordstrom Director and
Chief Executive Officer, Seattle Art Museum

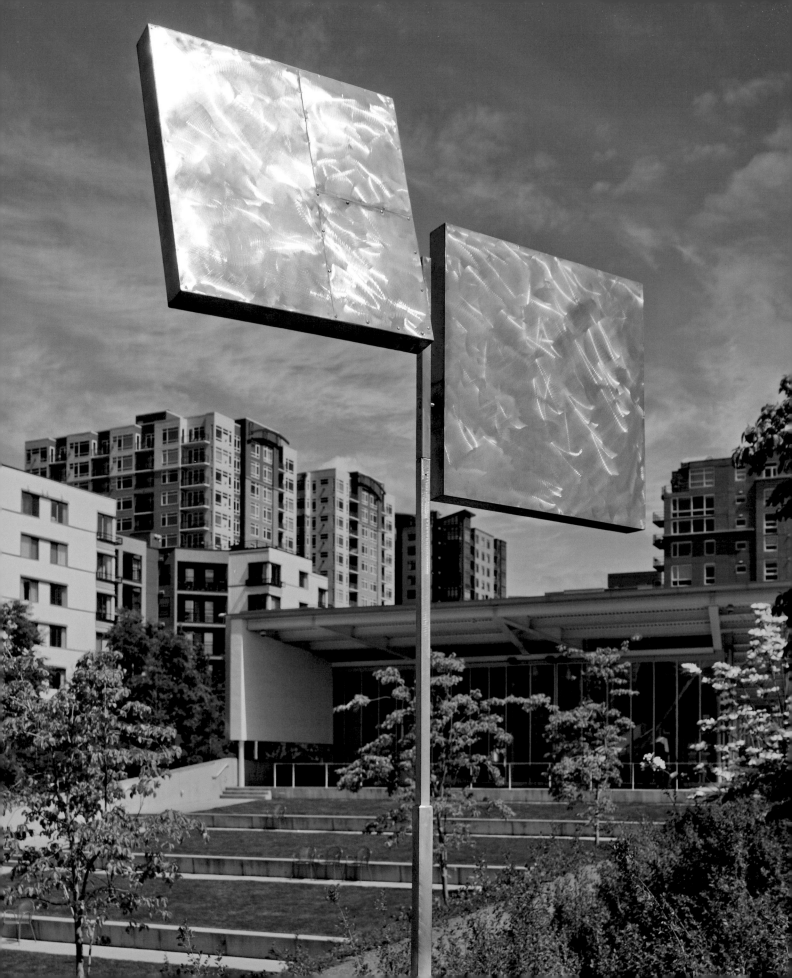

# Acknowledgments

Rarely do the stars align as perfectly as they did for the realization of Seattle's Olympic Sculpture Park, presenting the opportunity for a civic-minded nonprofit, an art museum, to make a stunningly beautiful and enduring gift to its community. Owned and operated by the Seattle Art Museum (SAM) and accessible to all, free of charge, the sculpture park is the creation of a multitude of risk-taking visionaries, innovative architects and artists, engineers and construction experts, and dedicated museum trustees and staff, as well as funders, public and private, large and small, from throughout the community and the region. To all we owe deep gratitude.

From the park's originating group of Mary and Jon Shirley, Virginia and Bagley Wright, Ann Wyckoff, and Martha Wyckoff, to the museum's supportive Board of Trustees and talented staff, the Seattle Art Museum—where I was then serving as director—was the seminal force behind this bold idea. Their strong leadership and unrelenting determination brought the project to fruition. Building the sculpture park and the simultaneous downtown museum expansion necessitated fundraising on an unprecedented scale through the Transformation of SAM Campaign, masterminded by President Susan Brotman, Senior Deputy Director Maryann Jordan, Major Gifts Officer Jennifer Aydelott, and Director of Marketing and Public Relations Cara Egan. Campaign contributions from over ten thousand donors, from Founders to Sponsors to the many individuals whose names are inscribed on the Olympic Outlook railing, reflect how rapidly momentum built outside the museum. Creating this artful green space was an inclusive, community-wide effort. We are grateful to every contributor.

Partnerships were also instrumental. The Trust for Public Land (TPL) was an invaluable partner, particularly in identifying and negotiating SAM's acquisition from Unocal of the last parcel of undeveloped waterfront in downtown Seattle. Thanks to the concerted efforts of Davis Wright Tremaine lawyer Lynn Manolopoulos and TPL employee and future sculpture park project manager Chris Rogers, Unocal demonstrated goodwill not only by giving SAM the first option to purchase the land but also by reducing the sale price and accepting responsibility in the distribution of future liability. Gratitude is also due to the Washington State Department of Ecology, notably Robert Warren, manager, and Nnamdi Madakor, project manager, who did a remarkable job expediting permitting and more, thus moving the sculpture park project forward at a critical time. The late Lori Herman (Hart Crowser) deserves gratitude for developing the cleanup action plan.

The City of Seattle was a steadfast partner, led by visionary mayor Paul Schell, assisted by Lisa Fitzhugh, and later mayor Greg Nickels. Many

other public officials, including members of City Council, King County Executive Ron Sims and the King County Council, the Port Commissioners, and Ken Bounds, the city's superintendent of parks and recreation, lent their wholehearted support.

Washington State's congressional delegation, including Senators Patty Murray and Maria Cantwell and Congressmen Norm Dicks and Jim McDermott, also worked tirelessly to secure federal funding. Total public funding at all levels (federal, state, county, and city) for the project exceeds $21 million, an impressive sum that attests to how vital public/private partnerships were in the sculpture park's success.

Another significant factor was the choice of lead designers for the park: award-winning architects Marion Weiss and Michael A. Manfredi, selected through an international competition funded by the National Endowment for the Arts and the Target Foundation. Weiss/Manfredi's dynamic Z-shaped design seamlessly unites architecture, landscape architecture, and urban infrastructure. Together with their project manager Chris Ballentine, Marion and Michael worked in tandem with SAM project manager Chris Rogers and his assistant, Laura Ballock; consultants Maria Barrientos and John Schwartz; and Scott Redman of Sellen Construction, assembling a formidable team of consultants to engineer and construct the Olympic Sculpture Park.

Gratitude and recognition are also due to the generous donors of the works of art that grace the park and to the talented artists who created them. The magnanimity of Seattle collectors quelled the doubts of art critics who questioned the wisdom of creating a sculpture park when the museum did not yet boast a strong collection of outdoor sculpture. For example, the Shirleys and the Wrights graciously invited Lisa Corrin, who curated the park's artistic program, to select major sculptures from their collections, then donated those works of art to SAM. In addition, a bequest from Ernest Stuart Smailes funded the commission of Louise Bourgeois's *Father and Son* fountain; the Brotmans, Wrights, and Ann Wyckoff joined forces to purchase Richard Serra's magnificent *Wake*; the family of the late Tony Smith donated his monumental sculpture *Stinger*; and the Allen Family Collection lent Claes Oldenburg's *Typewriter Eraser Scale X*, proving that if you create inspired space, great art will follow. Moreover, commissioned infrastructure projects by Louise Bourgeois, Mark Dion, Teresita Fernández, Roy McMakin, and Pedro Reyes embedded site-specific artworks in the fabric of the park. We are grateful to these artists, and to Bourgeois's assistant Jerry Gorovoy, not only for their work but for their interviews in this publication. Recognition and thanks are also due to Michael McCafferty, SAM's former exhibition designer, who expertly sited each work of art.

In reconstructing the decade-long development of the sculpture park, we spoke to many people and made surprising discoveries. Jennifer Aydelott, Maria Barrientos, Susan Brotman, Lisa Corrin, Robert Cundall, Maud Daudon, Renée Devine, Cara Egan, Peter Hummel, Chiyo Ishikawa, Maryann Jordan, Michael Manfredi, Lynn Manolopoulos, Bobby McCullough, Doug Norberg, Doug Raff, Chris Rogers, Brooks and Susie Ragen, Faye Sarkowsky, Jon Shirley, Jason Toft, Marion Weiss, Charles Wright, Virginia Wright, Martha Wyckoff, and Ann Wyckoff, as well as others with whom we had casual conversations, deserve our heartfelt thanks.

This book not only documents the creation of the Olympic Sculpture Park but also explores its multiple dimensions—civic, artistic, and environmental—and its catalytic role in the ongoing revitalization of Seattle's waterfront. I sincerely thank our contributors—art historians, writers, and artists—for sharing their insights and expertise. This publication is also indebted to the photographers who have captured the park over the years and generously allowed us to reproduce their images, particularly Robert Wade,

Benjamin Benschneider, Bruce Moore, and the late Paul Macapia.

Publication of this volume was made possible by the generous financial support of Susan Brotman, the Bill & Melinda Gates Foundation, Lyn and Jerry Grinstein, Janet Ketcham, Linda Nordstrom, Faye Sarkowsky, Virginia Wright, Ann Wyckoff, and Martha Wyckoff and Jerry Tone. I am especially grateful to them and to Amada Cruz, current director of the Seattle Art Museum, and her predecessor, Kim Rorschach, for their enthusiasm about the Olympic Sculpture Park and publication of this book.

At SAM, Zora Hutlova Foy, former deputy director for art administration, took charge of the budget, adroitly shepherding the manuscript from inception to publication, while Tina Lee, senior manager for exhibitions and publications, assisted with images and rights. Barbara Brotherton, curator of Native American art, and Bobby McCullough, facilities and landscape manager, helped compile the map of plants on pages 136–37, which incorporates essential input from native Lushootseed speakers Vi taqʷšəblu Hilbert, Zalmai ʔəswəli Zahir, and Tracy Rector, who consulted on the park's plant labels prior to opening day in 2007.

As coeditor, Renée Devine, a member of the original Olympic Sculpture Park team, coordinated this publication, carrying out meticulous research, selecting images, and advising authors—notably Lisa Corrin, Lynda Mapes, and me. She provided impressive knowledge of the sculpture park project and invaluable moral support at every stage of the book's development.

We are deeply indebted to copy editor Kristin Swan, who graciously worked her magic on the text. Proofreader Barbara Bowen helped perfect this volume as it neared completion, and indexer Dave Luljak made its content more accessible for researchers. The book was produced by Lucia | Marquand of Seattle, designed by Ryan Polich, typeset by Tina Henderson, and coordinated by Melissa Duffes and Kestrel Rundle.

Ed Marquand not only advised us from the outset, but gave us the benefit of his expertise by reading an early version of the manuscript. Jon and Kim Shirley inspired us to undertake this book project, to put down on paper the story of the Olympic Sculpture Park for future generations, for all who walk the waterfront.

For love, understanding, and support, I thank the Gardner family; my son, Casey Neill, and his wife, Tracey Cozine; and the Gates family, especially my late husband, William Henry Gates.

Mimi Gardner Gates

# Olympic Sculpture Park Map
## *Works of Art*

 **1** Ellsworth Kelly, *Curve XXIV*, 1981

 **2** Glenn Rudolph, *Travelers*, from *Neighborhood Scenes 1986–2006*
On view 2007–8

 **3** Pedro Reyes, *Evolving City Wall Mural* and *Capulas XVI* and *XVII*, all 2006
On view 2007–8

 **4** Anthony Caro, *Riviera*, 1971–74
On view 2007–10

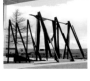 **5** George Rickey, *Two Plane Vertical Horizontal Variation III*, 1973

 **6** Richard Serra, *Wake*, 2002–3

 **7** Louise Nevelson, *Sky Landscape I*, 1976–83

 **8** Beverly Pepper, *Perre's Ventaglio III*, 1967

 **9** Beverly Pepper, *Persephone Unbound*, 1999

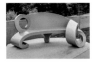 **10** Ginny Ruffner, *Mary's Invitation— A Place to Regard Beauty*, 2014

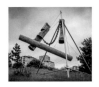 **11** Mark di Suvero, *Bunyon's Chess*, 1965

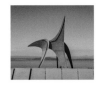 **12** Alexander Calder, *The Eagle*, 1971

 **13** Roy McMakin, *Untitled*, 2004–7

 **14** Claes Oldenburg and Coosje van Bruggen, *Typewriter Eraser, Scale X*, 1998–99
Lent by the Allen Family Collection
On view 2007–17

 **15** Tony Smith, *Stinger*, 1967–68/ 1999

 **16** Tony Smith, *Wandering Rocks*, 1967–74

 **17** Teresita Fernández, *Seattle Cloud Cover*, 2004–6

 **18** Louise Bourgeois, *Eye Benches I, II,* and *III*, 1996–97

 **19** Louise Bourgeois, *Father and Son*, 2005

 **20** Jaume Plensa, *Echo*, 2011

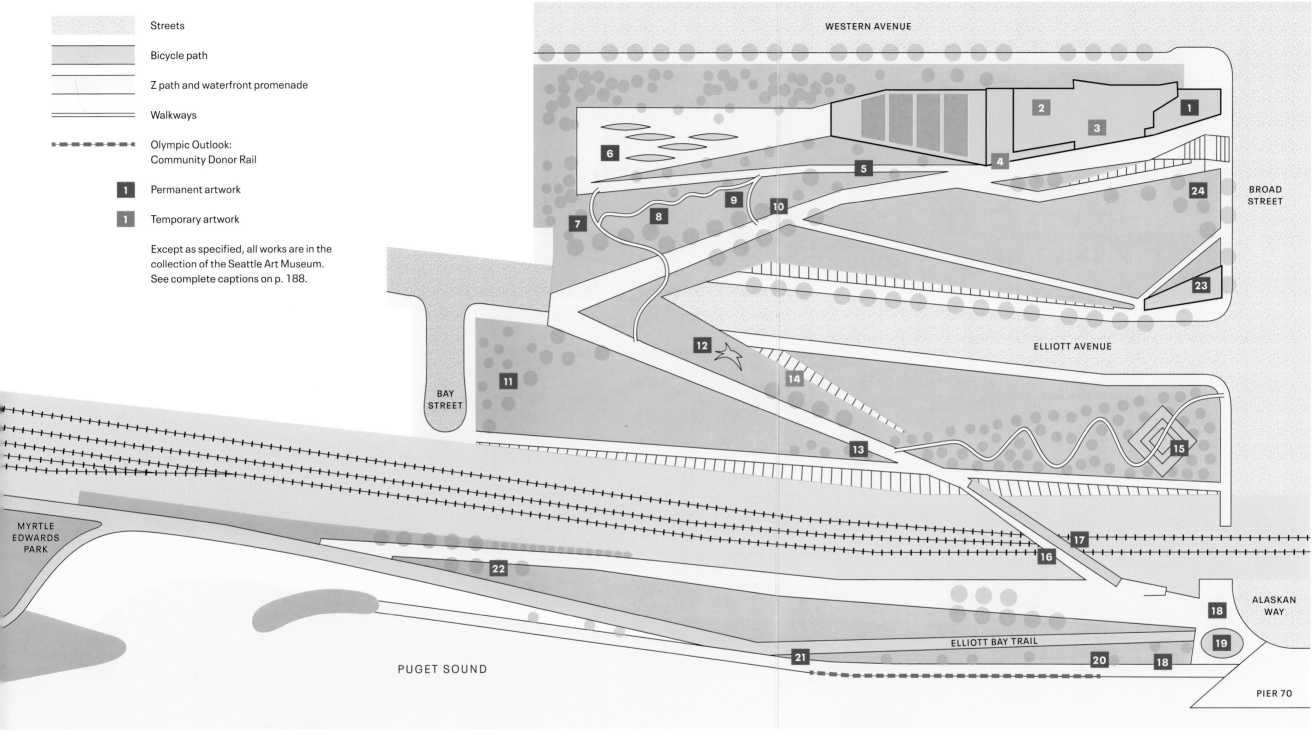

Streets

Bicycle path

Z path and waterfront promenade

Walkways

Olympic Outlook:
Community Donor Rail

**1** Permanent artwork

**1** Temporary artwork

Except as specified, all works are in the
collection of the Seattle Art Museum.
See complete captions on p. 188.

WESTERN AVENUE

BROAD
STREET

ELLIOTT AVENUE

BAY
STREET

MYRTLE
EDWARDS
PARK

ALASKAN
WAY

ELLIOTT BAY TRAIL

PUGET SOUND

PIER 70

 **21** Mark di
Suvero, *Schubert
Sonata*, 1992

 **22** Roy McMakin,
*Love & Loss*,
2005-6

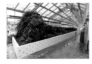 **23** Mark Dion, *Neukom
Vivarium*, 2004-6

 **24** Roxy Paine,
*Split*, 2003

# Blurring Boundaries, Designing Dialogues

## *Sculpture between Park and Landscape*

Barry Bergdoll

*Put simply, with the Olympic Sculpture Park, Seattle became a poster child for creating a hybrid urban project—a degraded, orphaned site that in its new life and remaking involved landscape, infrastructure, architecture, art, ecology, and the creation of a public realm.*

*—Michael A. Manfredi*

Twenty-one years after the idea was first floated, the Seattle Art Museum's Olympic Sculpture Park has matured, yet lost none of its youthful capacity to seduce. The aspen trees have grown in so fully that many nearby residents have forgotten how forlorn this post-industrial sector between the city grid and the working port was in the late 1990s. Sculpture has become such an integral part of the city's scenery that many visitors are scarcely aware that they have passed through part of the Seattle Art Museum (SAM) as they make their way down the zigzag path that connects Western Avenue to Elliott Bay, a trajectory unthinkable but a generation ago. The coastline at the foot of the steep slope has become a vital aspect of the way Seattle's citizens use their city, and the trains and highway that used to divide residents from the shoreline have now become scenic events. They are constituent elements in a design that brings constructed nature and found infrastructure into dialogue—one of the most engaging exchanges created during a period when landscape urbanism became the code word for a renewed alliance between living and landscape, which had eroded across decades of postwar urban boom and decay in the United States.

Architectural competitions that bookended the turn of the millennium in Seattle transformed a city best known for non-earthbound industries,

the Boeing Company and Microsoft Corporation, into an international paradigm for the topographic crafting of a new civic realm. Design juries for the new Seattle Public Library in 1999 and, two years later, for the Seattle Art Museum's sculpture park selected radical designs by architects unafraid to rethink two of the most venerable—and most democratic—cultural edifices of any city: the grand public library and the art museum. Both the zigzag circulation of Rem Koolhaas's winning design for the library (fig. 1.1) and the zigzag landscape of Marion Weiss and Michael A. Manfredi's winning project for the Olympic Sculpture Park (see fig. 3.9) broke with longstanding precedents for august civic institutions. Movement is central to both designs, activating the visitor's body along switchback paths through the library's book stacks and the park's blending of urban infrastructure and art. Each in its own way was at once rule breaking and trend setting. While the library is, by its very nature, a largely internalized monument, the landscape design has continued not only to grow but to have an impact on the surrounding landscape, notably the pedestrian and bike paths that now stretch for miles along the Elliott Bay waterfront.

The closing years of the twentieth century were marked by new paradigms for urban parks in which abandoned and underused tracts of

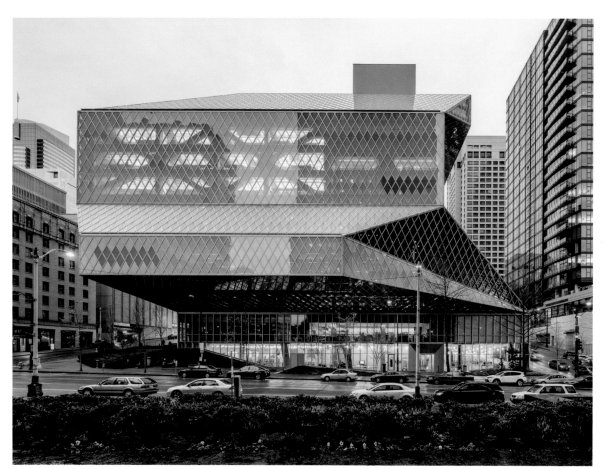

**FIG. 1.1**
Exterior view
of OMA / Rem
Koolhaas, Seattle
Central Library,
1999–2004.

inner-city land, uninhabited terrains created by the routing of rail lines and interstate highways through urban centers, and disused industrial sites were all targeted for landscape transformation. Yet in key ways this was a renewal of a tradition rooted in the parks movement in the mid-to-late nineteenth century, when the creation of large urban pleasure grounds was symbiotically linked to the evolution of municipal infrastructures, and even with the history of redemptive or reparative landscape design. In both Europe and the United States, the movement was as much involved with the creation of infrastructural systems for modernizing fundamental civic services as it was in crafting verdant escapes from the density and pressures of urban quotidian life. The rise of the landscape architecture profession was deeply involved in design solutions for crafting landscapes that answered a multitude of

criteria and demands simultaneously. One of the most famous of all early city parks, New York's Central Park (designed 1858), is a prototype for this. Calvert Vaux and Frederick Law Olmsted not only designed a veritable green oasis amid a city

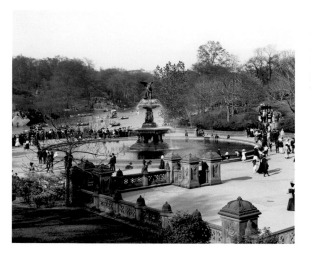

**FIG. 1.2**
Emma Stebbins,
Bethesda
Fountain, Central
Park, New York,
1905.

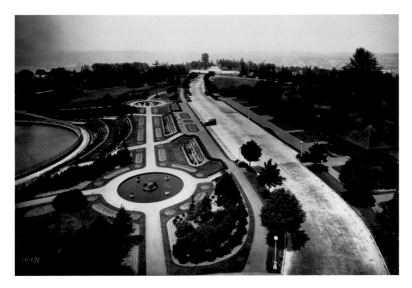

where real estate development filled nearly every square inch not given over to traffic, but they also provided a brilliant lynchpin for the city's developing municipal water system, bringing water from faraway streams and reservoir lakes in the Catskill Mountains. Central Park was, from the outset, the terminus for the waters of the Croton Aqueduct system, opened in 1842, which reaches its triumphant conclusion in the Bethesda Fountain topped by the bronze *Angel of the Waters* (fig. 1.2). A vision of the rural landscape inaccessible to the city was created at New Yorkers' doorsteps, but the site was also vital to the life of the city overall, and not simply during moments of respite and recreation. Sculpture, landscape, and urban infrastructure were thus intertwined at the very core of the first of multitudes of municipal park designs with which Olmsted and his sons, who continued the landscape business well into the twentieth century, were involved. Moreover, Olmsted and Vaux's project—like the design by Weiss/Manfredi Architecture/Landscape/Urbanism for the Olympic Sculpture Park a century and a half later—was chosen through the staging of a design competition, stimulating a vital debate on the nature of the urban park far beyond the terrain of the park itself.

Olmsted understood from the start that, just as Central Park linked large-scale urban greenery

with water management, the urban park was part of a system, a place of connections as well as a microcosm of the larger natural realm, artfully constructed with the very materials of nature. From the famous Emerald Necklace of interlinked parks and parkways Frederick Law Olmsted conceived for Boston to the park system Olmsted Brothers crafted in the opening decades of the twentieth century for Seattle, the concept of the municipal park comprised a planted ornament to the city and a complex nodal point where infrastructure at a regional scale was intertwined with the necessities of urban life (fig. 1.3). Olmsted, more than anyone, defined the American vocabulary for municipal parks, and his writings reveal the extent to which he was in contact with European movements—notably in his consideration of public parks in relationship to fundamental issues of public health. Municipal parks aimed to keep the public healthy, but equally to create a healthy landscape, one that could even repair the scars of a city's past. Famously, public cemeteries had been forerunners to public parks, combining nature and sculpture in places to gather, to remember, but also to confront the health threats posed by inner-city churchyards. Parks, too, could transform the most precipitous and difficult-to-use parts of the city's landscape into unforgettable urban promenades, a nineteenth-century civic tradition that resonates with the ethos of Weiss/Manfredi's design for what is arguably the twenty-first century's first great American urban park.

Morningside Park, just northwest of Central Park in Manhattan, looks nothing like Seattle's sculpture park, but more than a century earlier it set out to achieve some of the same ends. Unable to pierce the relentless New York City street grid through the rocky escarpment on which Morningside Heights sits above the Harlem plane, Olmsted

 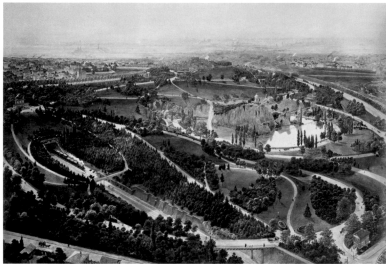

and Vaux worked on a plan to transform the cliff face into a public pleasure zone, laying out paths and stairs to connect two neighborhoods cut off by a stone precipice (fig. 1.4). Their plan was reworked by architect Jacob Wrey Mould before construction began in the 1880s. Mould brilliantly enhanced the sublime heights by raising a cyclopean buttressed wall at the upper reaches to create a promontory lookout over the cityscape. In this spirit of enhancing nature's qualities to greater effect, Olmsted, Vaux, and Mould subscribed to the great early nineteenth-century English landscape designer Humphry Repton's declaration that one could "sink the valley and raise the hill," since "it is sometimes possible for art to supply what nature seems to have denied."[1] A modern city was to be constructed with the artful redesign of the land just as much as with architecture.

Perhaps the most spectacular of nineteenth-century parks to restore a scarred landscape and craft a design relationship between modern technology and landscape was Paris's Parc des Buttes-Chaumont (fig. 1.5), realized during the radical transformation of the city under the Second Empire (1852–1870). Under the direction of Adolphe Alphand, director of parks and planted promenades for the French capital, a landscape of abandoned quarries at Paris's northeastern edge

was transformed into one of the most imaginative of park designs. The hardships of the site, from its pocked limestone cliffs and deep excavations to a rail line recently burrowed through the site, became sublime features of nature and technology. Alphand made them integral parts of a landscape palette that included a classical pavilion as belvedere, or lookout, at the park's highest point, as well as sinewy paths with views of speeding traffic safely removed from any pedestrian encounter, but thrillingly revealed and then hidden as one perambulated through the landscape. It is, in many respects, the nineteenth-century park design that most strongly anticipates Weiss/Manfredi's winning plan for Seattle's Olympic Sculpture Park over a century later in its simultaneous embrace of horticulture, land sculpting, and the infrastructures of modernization and transportation transformed into scenery.

Though in the opening years of the twentieth century Seattle took its cues from park developments further east (Boston, New York, Chicago)—notably by hiring Olmsted Brothers to develop a system of parks and boulevards—in the final quarter of the century the western city took the lead. Since the 1970s, Seattle has sponsored some of the country's most innovative park designs, responding to rising awareness that the post-industrial city required renegotiations

FIG. 1.4
Cliff face in Morningside Park, New York, designed by Calvert Vaux and Frederick Law Olmsted with Jacob Wrey Mould, 1873–95.

FIG. 1.5
Parc des Buttes-Chaumont, Paris, designed by Adolphe Alphand, 1864–67. Photo by Charles Marville (?), ca. 1853–70, albumen silver print mounted on cardboard, 9¹⁄₁₆ × 14¾ in. State Library Victoria, Melbourne: Gift, Government of France, 1880H88.19/79a.

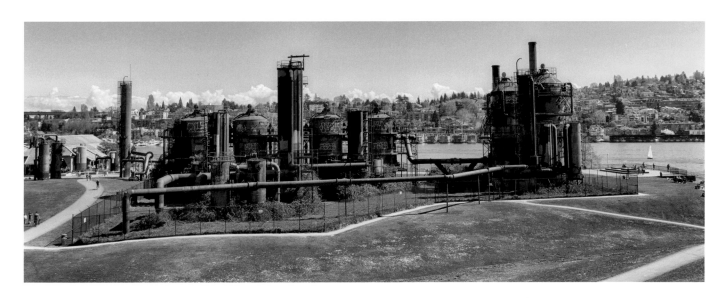

FIG. 1.6
Gas Works Park,
Seattle, designed
by Richard Haag,
2019.

between industry, infrastructure, and the landscape. Ironically, only three years after the city hired the Olmsteds to weave Seattle's individual parks into an urban system of green space set against the magnificent backdrop of Washington's natural landscape, the Seattle Gas Company built a large plant to manufacture coal gas for municipal lighting. Less than three miles away at Brown's Point, a peninsula on the north shore of Lake Union, and highly pollutive of both air and water, the plant was an integral part of the city's industry and economy until it finally closed in 1956. Now the plant sat abandoned on a prime scenic site. In 1975, twenty years before the celebrated transformation of power plants in Germany's deindustrialized Ruhr region into an extensive landscape park incorporating the ruins of abandoned blast furnaces made headlines, Seattle led the way with Gas Works Park (fig. 1.6). Designed by the Richard Haag, who founded the Department of Landscape Architecture at the University of Washington, Gas Works Park was one of the earliest urban parks to incorporate the ruins of the Industrial Age as objet-trouvé sculpture. Just as eighteenth- and nineteenth-century romantic parks in Europe incorporated the ruins of medieval monuments—for instance, the roofless ruins of Rievaulx Abbey at Rievaulx Terrace (1758) in Yorkshire in northern England—landscape

architecture in the twilight of the Industrial Age was embracing its own ruins. In a 1976 interview, Haag explained that he found a "dump heap" and an "industrial wasteland" and recycled it. He not only stabilized the machinery, and even the cooling towers, as "sculpture without sculpture," but also provided a very early example of bioremediation.[2] In restoring the polluted soil that is the park's other raw material, Haag opened a new era in which industrial brown sites would become the privileged, if damaged, slates on which a novel approach to urban landscape could be developed. Long past was the era of tabula rasa sites on the edges of growing cities; now metropolises began to reinvent themselves from within. Barcelona led the way to new municipal strategies for transforming the given landscape with a prizewinning series of projects leading up to its hosting of the 1992 Summer Olympics.

Seattle was also a pioneer in engineering new relations with the realities of urban infrastructure, perhaps nowhere in more unexpected and innovative form than with Freeway Park, opened in phases between 1976 and 1982. Here was a park with a non-site, suspended over a roadway to provide rest stops for pedestrians in a city sliced through by a multilane high-speed thruway. Not all innovation took place on newly conquered land, or even air space, however; in the mid-1990s,

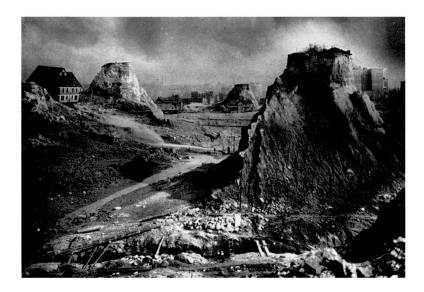

Seattle set out to rethink the place of open-air reservoirs in its parks, in large measure in response to the federal Clean Water Act. Since the nineteenth century, newly created parks had hosted large-scale reservoirs for municipal drinking water, sometimes with dramatic architecture and even didactic displays of public art. San Francisco's system, for instance, created veritable temples of municipal water, and Mexico City's aqueducts arriving in Chapultepec Park featured a phantasmagoria of sculptures by Diego Rivera. Seattle Public Utilities' reservoir-covering program, which ran from 1995 to 2012, produced some ninety acres of open space for recreation facilities, new lawns, and even site-specific art installations.

As the millennium came to a close, recuperating sites forlorn, fouled, or forgotten—even in the middle of residential zones—became an international leitmotif, from Paris's Parc de la Villette (1984–87) on the site of old slaughterhouses to Seattle's Olympic Sculpture Park (first conceived in 1995, and opened in 2007). As Peter Reed noted in introducing a selection of recent park designs in his seminal Museum of Modern Art exhibition *Groundswell: Constructing the Contemporary Landscape* (2005), "Nearly every significant new landscape designed in recent years occupies a site that has been reinvented and reclaimed from obsolescence or degradation as cities in the postindustrial era remake and redefine outdoor spaces."[3]

While Seattle's Gas Works Park anticipated the worldwide movement to rehabilitate old industrial sites through innovative park design, the city's landscape culture had long been built on radical reshaping of the land. The sculpture park site assembled between 1999 and 2001 by the Seattle Art Museum, in collaboration with the nonprofit Trust for Public Land, was anything but a piece of virgin nature; rather, it belonged to a complex terrain that had been formed over a series of operations to tame and urbanize the hilly landscape of the isthmus between Puget Sound and Lake Washington. The dramatic Denny Regrade of 1902 to 1911 (fig. 1.7) had remodeled some twenty-seven city blocks, much of it lying in today's Belltown neighborhood, including the coastal site of the sculpture park. SAM's purchase of this last piece of undeveloped waterfront property downtown was astute. The decision to create a third site for the museum, more or less midway between its two buildings—the original Art Deco building, today the Asian Art Museum, in Volunteer Park and the downtown museum building designed in a much-acclaimed Postmodernist idiom by Venturi, Scott Brown and Associates and opened in 1991—flew in the face of most urban museums' more campus-like approach to expanding their footprint. It was a gamble that turned the museum from a civic treasure house into a catalyst for the transformation of the daily experience of the city.

Outdoor sculpture had long been a feature of US art museums, primarily as a means for accommodating works too large to enter the spaces of the galleries. The sculpture garden brought art into the public realm, taking up the civic mission first

FIG. 1.7
Denny Regrade
in progress
(1902–1911),
Seattle, ca. 1910.
University of
Washington
Libraries, Special
Collections,
UW 4812.

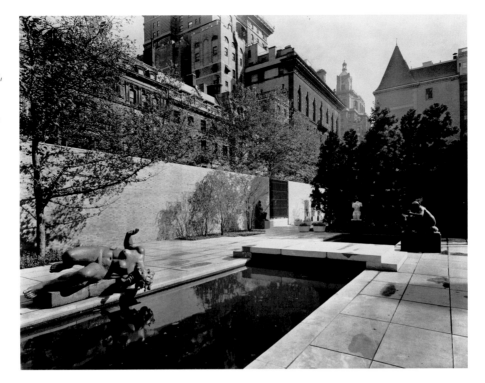

expounded in the nineteenth century of displaying art in the spaces of quotidian life and not simply in the sanctuary of the museum. Extending beyond the notion of public sculpture as honoring historic events or figures worthy of emulation, such spaces embody the idea that noncommissioned sculpture might bring aesthetic experience into the everyday realm. As early as 1928, Philadelphia's Rodin Museum—emulating its sister institution in Paris—laid out a classical garden design for the permanent exhibition of some of Rodin's bronzes on the museum grounds, an integral part of Philadelphia's Benjamin Franklin Parkway, the gateway to that city's Fairmount Park. This brought together the nineteenth-century tradition of placing sculptural monuments in public parks with the art of garden design, here a collaborative work between the architects Paul Philippe Cret and Jacques Gréber.

The choice between a roofless outdoor gallery and a more verdant park-like setting that merged seamlessly with the surroundings remained an open one. Different museums have opted—depending on the availability of land,

the immediate urban environment, or issues of security for artworks—for one model or the other. New York's Museum of Modern Art (MoMA) opened its first permanent building in 1939, the tenth anniversary of its founding, replete with an outdoor sculpture garden roughly equivalent in square footage to the enclosed ground floor of the museum. Two of the most celebrated sculpture gardens of the postwar period gave further prominence to this walled precinct model: Philip Johnson's complete redesign of the MoMA sculpture garden as a paved modernist composition in 1953 (fig. 1.8) and Ludwig Mies van der Rohe's sculpture garden for the Neue Nationalgalerie in (West) Berlin a decade later. But in the half century since these two canonic and influential designs emerged, landscape design approaches have increasingly gained the upper hand over architectonic ones—although no strict dichotomy has ever prevailed. Already in imagining that the post–World War II museum would require a totally different approach to both interior and exterior display of works of art, Mies van der Rohe explained the landscape dimension of his design for a "Museum

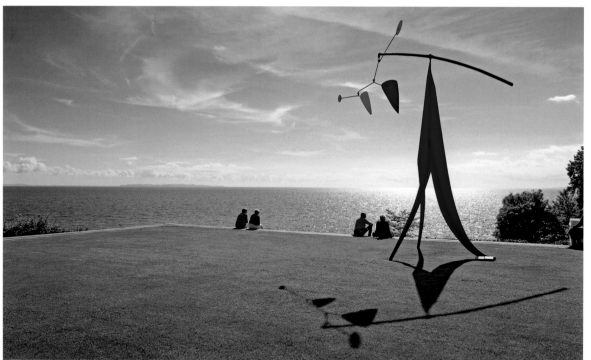

FIG. 1.9
View from the
sculpture park
at Louisiana
Museum, Den-
mark, designed
by Jørgen Bo
and Vilhelm
Wohlert, 1958–91,
with Alexander
Calder's *Little
Janey Waney*
(1976).

for a Small City," published in 1943 as part of an anthology of designs for how architects would redefine life with the return of peace. The floor-to-ceiling glass walls of his proposed museum, with its entirely flexible interior plan of moveable partitions, would create a sense of liberation for both viewers and artworks. As he explained, "The interior sculptures enjoy an equal spatial freedom, because the open plan permits them to be seen against the surrounding hills. And what could be a more appropriate setting for sculpture than the landscape? The architectural space, thus achieved, becomes a defining rather than a confining space, and the effect of the room as a container is destroyed."[4]

In both Europe and the United States, the outdoor display of sculpture became more and more common after World War II. Great enthusiasm greeted a large-scale display of Henry Moore's sculpture in London's Battersea Park in 1948. This carried over into the reception of deCordova Sculpture Park and Museum in Lincoln, Massachusetts, a mansion and private garden converted to an indoor-outdoor public museum of

contemporary art established in 1950, and into the planning in the 1950s for the renowned sculpture garden (opened in 1961) at the Kröller-Müller Museum in Otterlo, the Netherlands. The balance between architecture and landscape shifted notably, for instance, at the Storm King Art Center in Mountainville, New York, as the museum embraced the collecting of large-scale contemporary sculpture over the course of the 1960s and set its first sculptures against the backdrop of the Catskills. The waterfront siting of outdoor sculpture at Denmark's Louisiana Museum of Modern Art, founded in 1958, in a landscape with dramatic views across the Øresund to the nearby Swedish coast (fig. 1.9), was a particular inspiration for Weiss/Manfredi and the Design Selection Committee that worked with the architects to conceive Seattle's sculpture park. As at Louisiana, a large-scale stabile by Alexander Calder was made a dominant feature of the Olympic Sculpture Park (see fig. 2.13).

The most recent generation of landscaped museum sculpture gardens, which had proliferated in the United States in the 1980s and early 1990s,

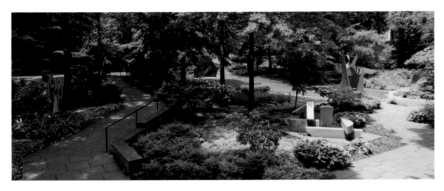

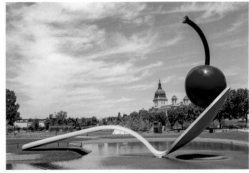

likewise served as a reference point for the clients in Seattle and the contestants in the design competition for SAM's sculpture park, which launched in 2001. Increasingly, museum sculpture gardens began to take on features of park design as the dialogue between architecture and landscape became more equal, or even tended to favor landscape design, a move that culminated not only in the Seattle project's design but in the name it bears: Sculpture *Park* rather than Sculpture Garden. Since the 1980s, landscape architects, accustomed to designing spaces with no fixed visual limits, have more often been involved in conceiving museum spaces for outdoor sculpture than in earlier projects, which were frequently entrusted—as in the case of Philip Johnson at MoMA—to the architect of the museum building (or expansion) itself. The decade opened with a modest-sized sculpture garden adjacent to the Baltimore Museum of Art (fig. 1.10), inaugurated in 1980 and designed by George E. Patton, a landscape architect from Philadelphia who had first gained national attention for his collaboration with Louis Kahn on the landscape design of the Kimbell Art Museum in Fort Worth, Texas. With elements reminiscent of MoMA's sculpture garden, notably tall walls to provide a backdrop to the sculptures and to control—or eliminate—views of nearby residential buildings, Patton's design also employed ground-plane shaping, as much as paving, to create distinct zones that define both viewing areas for individual works and spaces for seating. The atmosphere, in the tradition of Philadelphia's Rodin Museum, was contemplative, with design

gestures that sought to bring something of the qualities of viewing art in a museum into the landscape with its seasonal variations. Although outdoors, visitors were decidedly within a museum precinct, their attention turned to the work at hand, distracting views to any distant horizons discouraged.

The two American designs that garnered international attention for their contribution to the civic realm were the new outdoor sculpture landscapes at the Walker Art Center, opened in autumn 1988 in Minneapolis, and at the Nelson-Atkins Museum of Art in Kansas City, opened a year later. For the Minneapolis Sculpture Garden, Edward Larrabee Barnes, who had designed the Walker Art Center's new building (1971), collaborated with the landscape architects Quennel Rothschild and Partners. By its location, it is as much an urban park as a museum garden. The emphasis on tall hedges to create a series of outdoor rooms on an expansive flat site continued a museum tradition of roofless galleries and echoed the idea of a garden within a park reminiscent, for instance, of the formal Conservatory Garden created in 1937 by the landscape designer Gilmore Clark within Olmsted's Central Park. In Minneapolis, these bounded spaces or frames for outdoor viewing of sculpture are today juxtaposed with a wide-open terrain in which art and landscape converse on equal terms—a panoramic approach—since the expansion to the garden, opened in June 2017 and designed by Michael van Valkenburgh, erodes the boundary between the museum's garden and the surrounding city (fig. 1.11).

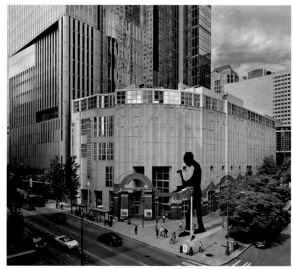

Three years in the making, the Henry Moore Sculpture Garden (later expanded and rechristened the Donald J. Hall Sculpture Park) in Kansas City pursued the latter ethos from the start. Covering extensive grounds immediately to the south of the Nelson-Atkins Museum, the original design, in 1988, was an unusual collaboration between one of the most celebrated twentieth-century American landscape designers, Dan Kiley, and the architect Jacqueline Robertson (fig. 1.12). Some twenty-two acres in extent and dotted with very large-scale works, the greensward not only functioned as an urban park and outdoor gallery; it would also advance the emerging practice of positioning a singular, monumental work of sculpture as the veritable icon of a museum—in this case, Claes Oldenburg and Coosje van Bruggen's site-specific *Shuttlecocks* (1994), installed in 1996. The artists' *Spoonbridge and Cherry* (1988) had similarly become a symbol of Minneapolis after the Minneapolis Sculpture Garden opened.

The City of Seattle soon chimed in even more spectacularly with the installation of *Hammering Man* (1991), a 48-foot-tall kinetic sculpture by Jonathan Borofsky. Part of an international brotherhood of versions of the same design in various sizes, *Hammering Man* was installed (after an initial mishap) in September 1992 in front of the recently completed Venturi, Scott Brown building that brought the museum from Volunteer Park to the downtown urban grid (fig. 1.13). The work was purchased by the city but placed in front of the museum, a collaborative ethos that would reach inventive new heights with development of the Olympic Sculpture Park. That ethos echoes in Borofsky's statement, "I want this work to communicate to all the people of Seattle—not just the artists, but families, young and old. I would hope that children who see the *Hammering Man* at work would connect their delight with the potential mysteries that a museum could offer them in their future. At its heart, society reveres the worker. The *Hammering Man* is the worker in all of us."[5]

A decade later, this spirit of collaboration fueled the unprecedented undertaking celebrated in this volume: the creation of a museum sculpture park that proved to be one of the most innovative landscape and ecological restorative designs of the turn of the millennium. A standout from many landscape projects of that fervent moment, it productively blurred the lines between landscape and architecture, between infrastructure and ecology, and between the museum's role to house and protect and its capacity as a civic catalyst. True, the cooperation between the Walker and the City of Minneapolis in the late 1980s offered an administrative model widely studied by those

FIG. 1.12
Donald J. Hall Sculpture Park, the Nelson-Atkins Museum of Art, Kansas City, Missouri, designed by Dan Kiley Jacqueline Robertson, 2015.

FIG. 1.13
Jonathan Borofsky's *Hammering Man* (1991) in front of the Seattle Art Museum, 2012.

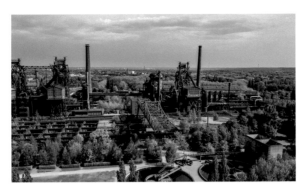

creating new urban parks, prompting study missions both from Chicago, in the early stages of planning its Millennium Park, and from the Seattle Art Museum. But the combination of complex factors addressed by Weiss/Manfredi's winning design in 2001 tied together numerous threads that I have been tracing here: the interdependence of park making and urban infrastructure, an ever-growing hunger for extending museum displays of art into the public realm, and the notion of landscape park as ecological remediation. The latter is more commonly associated with European efforts, notably in the industrial landscape projects associated with Germany's Internationale Bauausstellung (International Architecture Exhibition) Emscher Park in 1999, which yielded a series of transformed rust belt projects, chief among them the Duisburg Nord Landscape Park designed by Latz + Partner of Kranzenberg, Germany (fig. 1.14).

The Seattle site pieced together by SAM and the Trust for Public Land was slashed through by transportation infrastructure: the railroad tracks of the Burlington Northern Santa Fe Railroad and a four-lane, heavily trafficked surface road, Elliott Avenue (see fig. 3.1) The terrain in between was a dreary brownfield that had served for the better part of the century—from 1910 to 1975—as a petroleum transfer and distribution facility for the Union Oil Company of California (Unocal). Protracted cleanup operations had begun in the 1970s with a view to sale, and by the mid-1990s negotiations were underway between the oil company and a real estate developer eager to fill

the sloped site with the type of condominium apartment buildings that were quickly becoming the new vernacular landscape of Belltown, since the upper stories would offer commanding water views. Others recount in this volume the story of assembling the 8½-acre site, of raising the money to acquire the land and develop it as a non-revenue-producing public asset. Most remarkable is that the sculpture park resulted not simply in a terrain for placing the large-scale sculpture collections the museum was to receive from Bagley and Virginia Wright and Jon and Mary Shirley, but in a sculpted landscape that recalled the earthworks of the 1960s and 1970s.

Perhaps the most unexpected move of Weiss/Manfredi's solution, which among fifty-two submissions captivated the jury, was the reshaping of the terrain not—as would seem obvious—by minimizing the slope and gently covering over the interruptions of the car and rail traffic, but rather by dramatizing these features to link the site's separate zones while embracing the dynamic presence of the city. Tranquil pedestrian strolling and active vehicular traffic would coexist by folding the current into the new, much as one might blend different viscosities in baking. As Weiss/Manfredi have explained it (as recently as their acceptance lecture for the Thomas Jefferson Foundation Medal in Architecture in April 2020[6]), the challenge was to transform three sites into one. This led to the brilliant insight of scripting an almost cinematic journey that allows visitors to "wander from city to water edge," without hiding infrastructure, since the path would appear effortlessly "to slide over the highway."[7] Rather than treat the park as an assembly of parcels connected by bridges over the road and train tracks, the architects began by the audacious addition of nearly 200,000 cubic yards of

earth—just under half of it (91,986 cubic yards) obtained from the excavation of the museum's major downtown extension, by the Portland architect Brad Cloepfil of Allied Works Architecture, then under construction—to raise the level of the path and thereby convert the site into a unified landscape. The massive importation of terrain rendered feasible a design solution as seemingly simple as a great calligraphic gesture: the creation of a Z-shaped pathway connecting the residential neighborhood to a coastline that even longtime Belltown residents had never enjoyed. Evocations of Zorro, the swashbuckling hero emphatically tracing his trademark *Z*, abounded as critics began to praise the design even before it began to leave its mark on the terrain of Puget Sound's shoreline. But unlike Zorro's swift gesture, this signature element is remarkably complex and subtle both in its physical realization and in the effects it creates on the ground.

From the Z-shaped path, the design developed to encompass distinct zones with individualized plantings and ambiances and a continual blurring of the lines between architecture and landscape, nature and man-made, civic and scenic, ecology and infrastructure (see park maps on pp. 14–15 and 136–37). In this, Weiss/Manfredi's design resonated with the questioning of traditional dichotomies that invigorated everything in the closing years of the twentieth century, from deconstruction in philosophy and literature to art practices that defied medium specificity or even the distinction between artist and viewer. Weiss/Manfredi's work pursued a similar refusal of received boundaries, both literal and professional, into a practice of topographical design, neither traditional landscape design nor an architectural practice focused exclusively on the production of buildings. Things are not joined but synthesized.

Even with its new-built bridges, the site reads not as a sewing together of parts but as a continuous landscape, sculpted as an unfurling pathway set largely at the crest of a complex series of sloping planted areas on either side. The resulting path is elevated enough to leap over both the road and the rail line, which slip through the site, disappearing from and reemerging into view. This effect echoes the way views of the distant mountain ranges come into view and slip away through the nearby cliffscape of Seattle's increasingly high-rise downtown, as the path continually redirects the trajectory of both the feet and the eyes. The Z, in short, rejects the notion of a meandering, serpentine path as somehow the most "natural" in favor of a geometry of continuous lines and folded surfaces, creating perceptual richness and sequence in the tradition of the English picturesque movement without borrowing anything of the vocabulary of the picturesque. Although the path is never as clearly perceived as a Z from the ground as it is in the dramatic—and by now iconic—aerial photographs that swiftly emblazoned architectural periodicals around the world, it structures a journey through the park that takes visitors mellifluously through each of its zones and landscapes and extends the experience of continual rediscovery. Combined here are the Baroque principle that sculpture is best experienced where the space allows for viewing from diverse angles and the English picturesque notion of continually removing and returning from view key objects in a landscape, each time not only aligning with the viewer differently but also framing a changing foreground within a shifting distant prospect. Despite the almost effortless feel of the solution, Marion Weiss described the process of arriving at it in the architects' studio as a "head-scratching exercise."[8]

FIG. 1.15
Weiss/Manfredi
Architecture/
Landscape/
Urbanism,
Museum of the
Earth, Ithaca,
New York, 2003.

The experience of the sculpture park is carefully controlled, since despite its great visual openness to the city and to the landscape beyond, the park can only be entered from a few key points at the top and bottom of the site and via the aspen grove off Elliott Avenue, thus quickly aligning the visitor with the zigzag path and the idea of the journey. The designers summarized this journey through their "continuous constructed landscape for art" as follows:

> The 2,200-foot-long Z-shaped pedestrian route begins at the glass and steel pavilion that unfolds as an extension of the landscape. From the pavilion, visitors traverse the site on a pathway that opens to views of radically different prospects, from the density of the city to the open vistas of the bay and Olympic Mountains. As it descends to the waterfront, the path offers views of Richard Serra's *Wake*, Mark Dion's *Neukom Vivarium*, [Alexander] Calder's emblematic *Eagle*, Mark di Suvero's *Schubert Sonata*, Teresita Fernández's *Seattle Cloud Cover*, Roy McMakin's *Love & Loss*, and Louise Bourgeois's *Father and Son*. This pedestrian infrastructure allows the movement long denied between downtown Seattle and the newly created beach and waterfront.[9]

Another object of the design is to "slow down this city," as Weiss told one interviewer shortly after the park's inauguration in 2007.[10]

Equally blurred is any distinction between nature and infrastructure, a refusal already captured in the idea of "Constructing the Site," a rubric the architects often used to describe the approach that came to maturity in their work at the turn of the millennium in two contemporaneous projects on opposite sides of the continent: the Museum of the Earth in Ithaca, New York (fig. 1.15), and the Olympic Sculpture Park. In both cases, architecture and landscape entered into a reciprocal relationship, almost learning from one another—and not simply in the obvious ways in which the projects handle each site's existing infrastructure, interweaving past with present in the new design rather than treating it as an impediment to be overcome. For the new landscape itself in both projects is an engineered, constructed nature—dramatically so in Seattle, where with the input of engineers, the park's new bridge was built to move seismically without risk of collapse. Weiss/Manfredi have enunciated this approach as a veritable mantra: "As the very momentum of exchange incrementally overwhelms our urban landscapes, we wonder what new forms of public nature might emerge if highways, communication rights-of-way, flood-resistant structures, railways, subway lines, and distribution grids were to become institutions of culture and recreation."[11] In Seattle, landscape, art, and infrastructure are all so dramatically integrated in both design conception and visitor experience that oppositions are declared obsolete. The sight and sounds of the passing traffic and the drama of the occasional train gliding through the site, progressively veiled and unveiled, are as much a part of the architecture

as the landscape, with its changes both seasonal and gradual in nature, from the tides lapping at the recreated shoreline to the wind blowing through the leaves of the aspen trees (fig. 1.16). Mark Dion's *Neukom Vivarium* (2004–6, see figs. 4.7–8, 4.10), a piece of growing nature installed as art, is almost emblematic of the larger work of art—the park itself—in which it is situated. And some of the key moments in the park are likewise in flux, oscillating between moments of escape and repose, of community gathering, activation, and performance. At the top of the site, for instance, in a valley created below the pavilion, stand the undulating steel plates of Richard Serra's *Wake* (2002–3, see fig. 2.8), its resonance with the waves of the shoreline grasped only from the uppermost terrace of the pavilion. Here, the terraced lawn leading down to Serra's work, which is set in gravel, provides at times a tranquil escape

from the working city and its bustle and sounds, at times a gathering place for community events and performances. But this landscape itself here is infrastructure, the architects working not only with structural engineers but soil engineers to create what John Pastier in *Metropolis* magazine rightly called "an immense earthwork in its own right," recalling the art movement current in the architects' formative student years.[12] With a change in grade of some forty feet, Weiss/Manfredi's collaborator Magnusson Klemencic Associates created lawns that are not simple greenswards but complex systems of mechanically stabilized earth. Ironically enough, this site, which long served as a parking lot, is transformed for pedestrian use by exploiting aspects of late twentieth-century highway construction: crushed rock and gravel held in steel mesh baskets, anchored in turn, as the architects explain in their

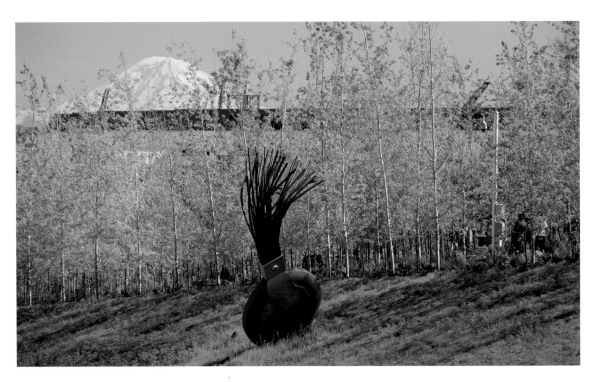

FIG. 1.16
Claes Oldenburg and Coosje van Bruggen's *Typewriter Eraser, Scale X* (1999) with the aspen grove and Mount Rainier in background, 2007.

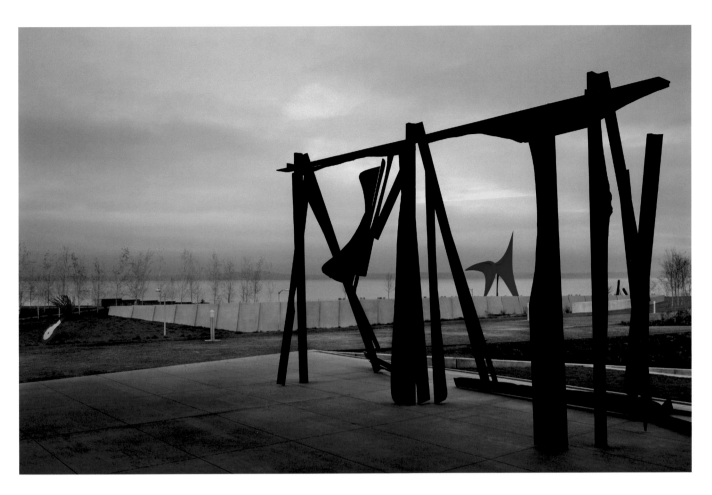

FIG. 1.17
View from the
pavilion atop
the Olympic
Sculpture Park,
with Anthony
Caro's *Riviera*
(1971–74) in
the foreground
and Alexander
Calder's *The
Eagle* (1971) in
the background,
2008.

aptly titled monograph *Surface/Subsurface*, "by
alternating layers of engineered plastic sheets
and highly compressed soil."[13]

If the 2,200-foot-long zigzag path is at once
the icon and the organizing principle of this
landscape, similar compositional strategies are
announced in the entry pavilion, where the play of
diagonal retaining walls and roof lines echoes the
tilting planes of the sloped lawns of the park.
Pragmatically, the architects took advantage of
the steep downward slope to tuck a parking lot
under both the pavilion and its terraced "back
lawn," even providing natural lighting for the
drivers along the pavilion's street facade along
Western Avenue. With its unpretentious vocabu-
lary of white-painted steel columns and unadorned,
poured-in-place concrete walls and floors, the
pavilion marries the industrial aesthetic of the
nearby Seattle waterfront with the loft-like spaces

favored by contemporary artists and galleries
worldwide in recent decades (see fig. 4.16).
Compression and release, veiling and revealing,
which will be the experiences of visitors on the
park's paths, are announced already here; the
diagonal gestures of the building's elevations,
and of its section worked into the site, are echoed
in the floor plan. Visitors enter under the lowest
point of the great seesawing shed roofs over the
pavilion and quickly follow the space as it opens
laterally and vertically toward great double-height
glazed walls taking in the dioramic views of the
water and mountains that form the backdrop to
Alexander Calder's *The Eagle* (1971, fig. 1.17). The
dramatic red of Calder's sculpture, its curved
profiles set against the hard-edge linearity of
Weiss/Manfredi's zigzag, provides another
unifying element for the park: red chairs, both in
the pavilion and on the terrace, which provide a

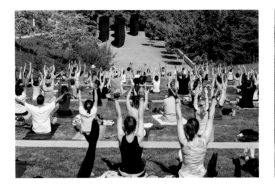

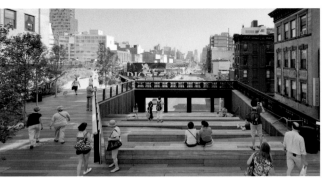

FIG. 1.18
Participants in
Yoga in the Park in
the amphitheater
with Richard
Serra's *Wake*
(2002–3) in the
background, 2011.

FIG. 1.19
Bleachers
suspended over
traffic on Tenth
Avenue at the
High Line, New
York, designed
by James Corner
Field Operations,
Diller Scofidio +
Renfro, and Piet
Oudolf, 2004–19.

panoramic resting place midway along the path and tie the composition together with a cue that comes this time from the art rather than from the constructed or natural landscape. No less is the interplay between architecture and landscape— or rather the fusion of the two in almost all of Weiss/Manfredi's projects then and since— announced at the very moment visitors step out of the pavilion onto the uppermost tier of the grassy stepped terrace that climbs down to the valley occupied by Serra's *Wake* (2002–3, fig. 1.18). Here, we are at one of those junctures between sloping surfaces, where subtle rises and falls of the folded planes of the new landscape radiate out from below our feet. We are at a point where we command not only the broader composition of the new park, but its wider geographical setting. A harmonious dialogue with both cultivated nature and majestic landscape derives neither from recourse to the geology of stone architecture nor from the application of planted vines as "natural architecture," as often interpreted in the history of park design, but rather from a clarity of geometry that pulls the forms of the constructed foreground and the distant Olympic Mountains into conversation.

In Weiss/Manfredi's park design, time is as much a material as concrete and glass, trees and grass. Seasons alter the arboreal palette, notably among the copse of aspen trees set against the shifting moods of the Pacific Northwest's often moist skies, transforming the backdrop against which we experience the works of sculpture. Subtle changes of grade in the pathway invite different gaits as it suddenly shifts direction and reorients our attention from cityscape to landscape. As we progress along the path, moments of slow-paced removal from the city give way to intense encounters with mechanical speed signaled by the whoosh of passing cars (especially when the city's streets are wet) or the whistles and clank of a train determinedly making its way along the coast, engaging the full range of the senses.

As much as the path seems in aerial view to be insistent, diagrammatic even, it provides users a range of choices—to find the places where cars and trains are obscured, or to divert to places where they seem almost to have been staged by the architects. It is a sensibility with roots in the Parisian Parc des Buttes-Chaumont, as we have seen, but also parallels the development, a few years after the Olympic Sculpture Park, of an urban park on New York's disused High Line elevated train system (fig. 1.19). If the New York design, by Diller Scofidio + Renfro with landscape architect James Corner, stages views of urban traffic below on New York's Tenth Avenue theatrically and self-consciously, in Seattle the effects are achieved sotto-voce. A shortcut to Elliott Avenue provides a place to step off the twenty-first-century constructed landscape back onto a municipal sidewalk; the second overpass, which traverses the rail tracks, affords views of the train in one direction, but obscures the tracks opposite behind Teresita Fernández's *Seattle Cloud Cover* (2004–6, see figs. 5.4–6), an installation commissioned by the Seattle Art Museum.

Fernández's work invites us to slow our pace on this bridge over the tracks, the last obstacle before we reach the shoreline. With its images, layered between laminated sheets of glass, of a "changing sky discovered in nature and art,"[14] it participates in the blurring of the boundaries between art, landscape, and infrastructure that is the essence of Weiss/Manfredi's architectural design.

The bridge crossed, the visitor is offered a new choice at a complex fork in the path: to venture onto a cantilevered, extruded concrete viewing platform parallel to the tracks below and wait for the next train, gazing back at the cityscape with its iconic Space Needle now framed by Calder's equally iconic *The Eagle* to rapidly descend a stair to the corner of Broad Street and the Alaskan Way at the train's level crossing and slip back into the working waterfront; or to proceed along the gentle ramp facing northwest toward the boulders, driftwood, and sand of a natural cove, having traveled from the urban bustle to a fragment of the primordial Pacific Northwest (see fig. 6.15). Except that the cove is every bit as engineered as the slopes and bridges over which we have just passed, a piece of hydrologically engineered landscape where previously there had been only a breakwater, providing for what Weiss/Manfredi have characterized as a "new underwater garden."[15] Industrialization having imperiled some of the fishing industry for which the Pacific Northwest is so famous, it is poignant that the end of the zigzag path from the region's largest city takes us to this meticulously designed habitat for Chinook salmon. Here, the park's diurnal and seasonal rhythms meet the longer-term negotiation of a renewed coexistence between nature and the urban. As city planner Ray Gastil noted in 2002 as

Seattle's sculpture park was just starting to take shape, "The salmon has called forth most sophisticated design intelligence—one in the service of a cultural enterprise, no less—to design the interface between land and water ecosystems."[16] In the end, the continual blurring of old binaries—human versus animal, landscape versus architecture, nature versus industry, urban versus rural, progress versus ecology—is a complex design act that serves to craft new productive harmonies.

In the Olympic Sculpture Park, architecture and landscape, the found and the newly created, enter into a conversation of mutual respect, each taking cues from the other, to create a place for what Marion Weiss and Michael Manfredi have described as "Public Natures."[17] Their vision dissolves a final binary, between the collective and the individual, with important implications for the ways cities, museums, and the larger natural realm bring these interests together productively. In the sculpture park, visitors navigate the layered pathways at their own pace, taking in the scenery even as they become part of it. The roles of sculpture gardens to foster individual contemplation of works of art and of public parks to accommodate the collective needs of urbanites here coexist by design (fig. 1.20). The structure of the landscape facilitates the dialogue between the individual and a larger society that is the basis of urban democracy. This public stage not only emerges from Seattle's long history of transforming the very ground on which it lives, but serves as the point of departure for further dialogues between nature and the city. The Olympic Sculpture Park rapidly became one of the most admired—and most visited—of the innovative designs that made the turn of the millennium a golden era of landscape thinking. Moreover, it completely transformed the American paradigm

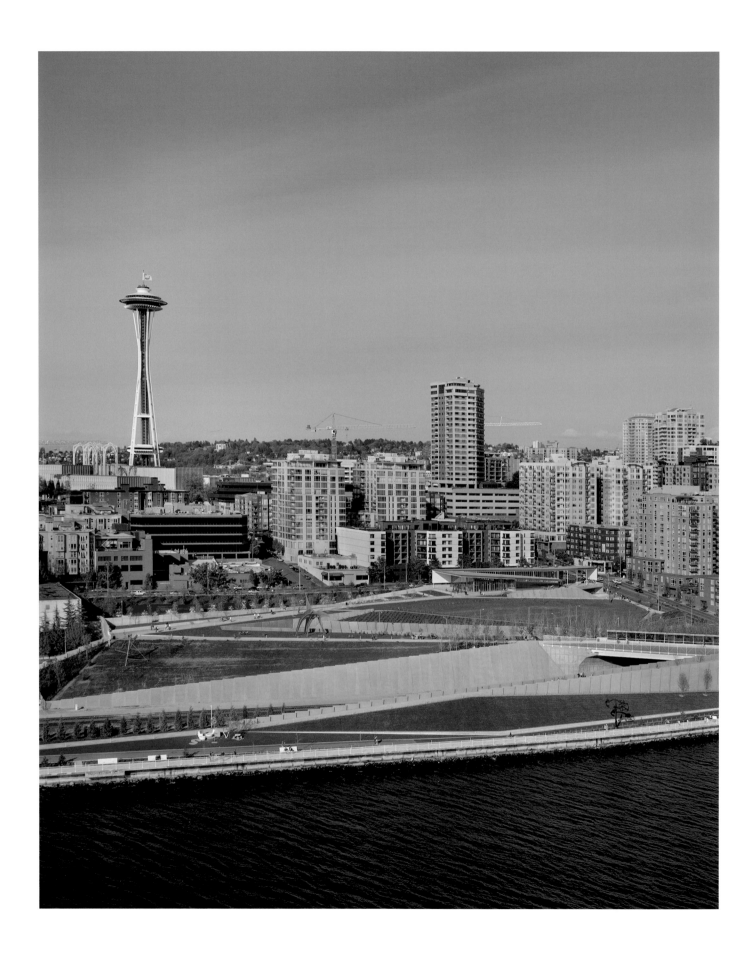

of the museum set in the park—as in New York's Central Park, Brooklyn's Prospect Park, San Francisco's Presidio, Seattle's Volunteer Park, or countless others—in favor of a complete merger of museum and park, the park as museum or the museum as park. Beyond providing a model for the display of works of art in a majestic natural and civic setting, the project provides a model of urbanism. The sculpture park is, as this volume goes to press, a lynchpin in Seattle's ongoing transformation of its relationship to its spectacular natural setting, creating ways of moving through the city with the Waterfront Seattle project extending the park's paths north and south. The Seattle Art Museum's audacious act of urbanism offers new ways of thinking about museums, parks, and cities that it is perhaps too early to assess fully. After all, the park is scarcely two decades old.

## Notes

Epigraph: Michael A. Manfredi, in "Design Vision for the Olympic Sculpture Park," this volume, 73.

1. Humphry Repton, *The Art of Landscape Gardening* (1840; Boston: Houghton Mifflin, Riverside Press, 1907), 28, 30.

2. *10 Parks That Changed America*, web exclusive episode, "Gas Works Park, Seattle, WA," interview with Richard Haag by Annie Marlow, conducted September 25, 1976, http://www.gpb.org/television/show/10-changed-america/season/1/10-parks-changed-america/extras/web-exclusive-gas-works.

3. Peter Reed, "Beyond Before and After: Designing Contemporary Landscape," in *Groundswell: Constructing the Contemporary Landscape*, ed. Peter Reed (New York: Museum of Modern Art, 2005), 15.

4. Ludwig Mies van der Rohe, "Museum for a Small City," *Architectural Forum* 78, no. 5 (1943): 84–85.

5. Ann Curran, "Jonathan Borofsky: Nobody Knows His Name, Everybody Has His Number," *Carnegie Mellon Magazine*, Spring 2002, http://www.cmu.edu/magazine/02spring/borofsky.html.

6. Marion Weiss and Michael Manfredi, "2020 Thomas Jefferson Foundation Medalists in Architecture—Public Talk," University of Virginia School of Architecture, April 20, 2020, video, http://www.youtube.com/watch?time_continue=7&v=1-jlBAt75yo&feature=emb_logo.

7. Weiss and Manfredi, "2020 Thomas Jefferson Foundation Medalists."

8. Weiss and Manfredi, "2020 Thomas Jefferson Foundation Medalists."

9. Marion Weiss and Michael Manfredi, *Weiss/Manfredi: Surface/Subsurface* (New York: Princeton Architectural Press, 2008), 20.

10. Marion Weiss, quote in Hilarie M. Sheets, "Where Money's No Object, Space Is No Problem," *New York Times*, January 14, 2007.

11. Marion Weiss and Michael Manfredi, *Public Natures: Evolutionary Infrastructures* (New York: Princeton Architectural Press, 2015), 8.

12. John Pastier, "Zorro-Like Audacity," *Metropolis*, May 1, 2007, http://www.metropolismag.com/uncategorized/zorro-like-audacity/.

13. Weiss and Manfredi, *Weiss/Manfredi: Surface/Subsurface*, 186.

14. Catalogue entry for Teresita Fernández, *Seattle Cloud Cover*, Seattle Art Museum online catalogue, accessed September 16, 2020, http://art.seattleartmuseum.org/objects/32047/seattle-cloud-cover?ctx=32c7f798-0117-4574-b944-f02849e19a3d&idx=0.

15. Weiss and Manfredi, "2020 Thomas Jefferson Foundation Medalists."

16. Ray Gastil, *Beyond the Edge: New York's New Waterfront* (New York: Princeton Architectural Press, 2002), 178.

17. Weiss and Manfredi, *Public Natures*, see note 6.

FIG. 1.20 Aerial view of the Olympic Sculpture Park with the Seattle Space Needle, 2007.

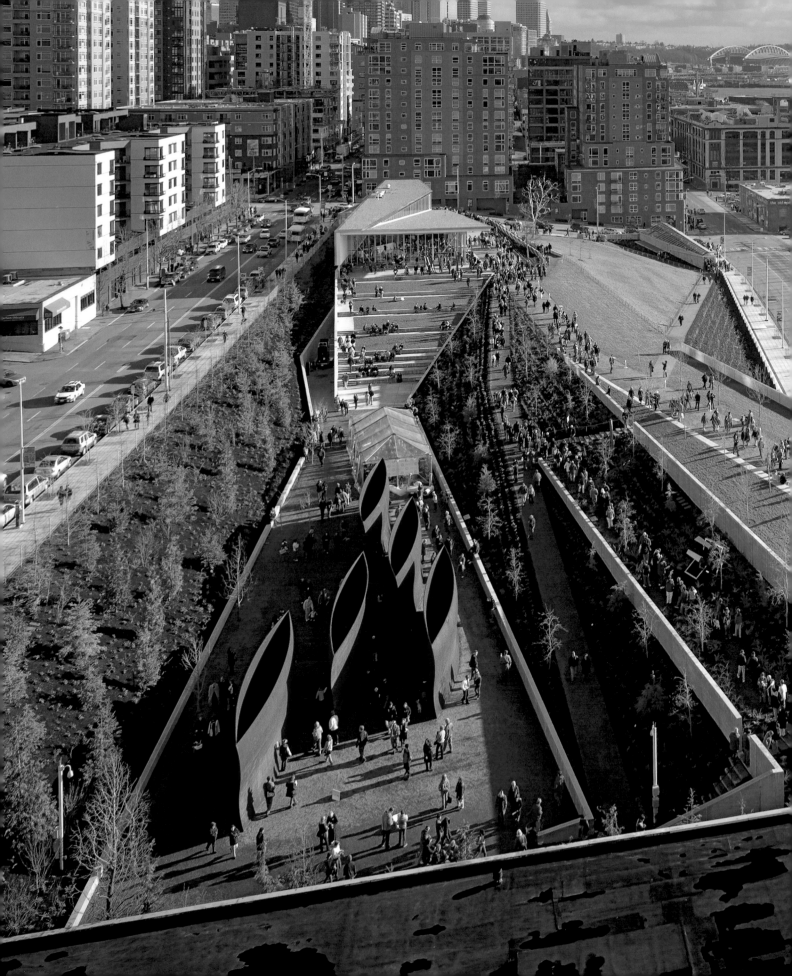

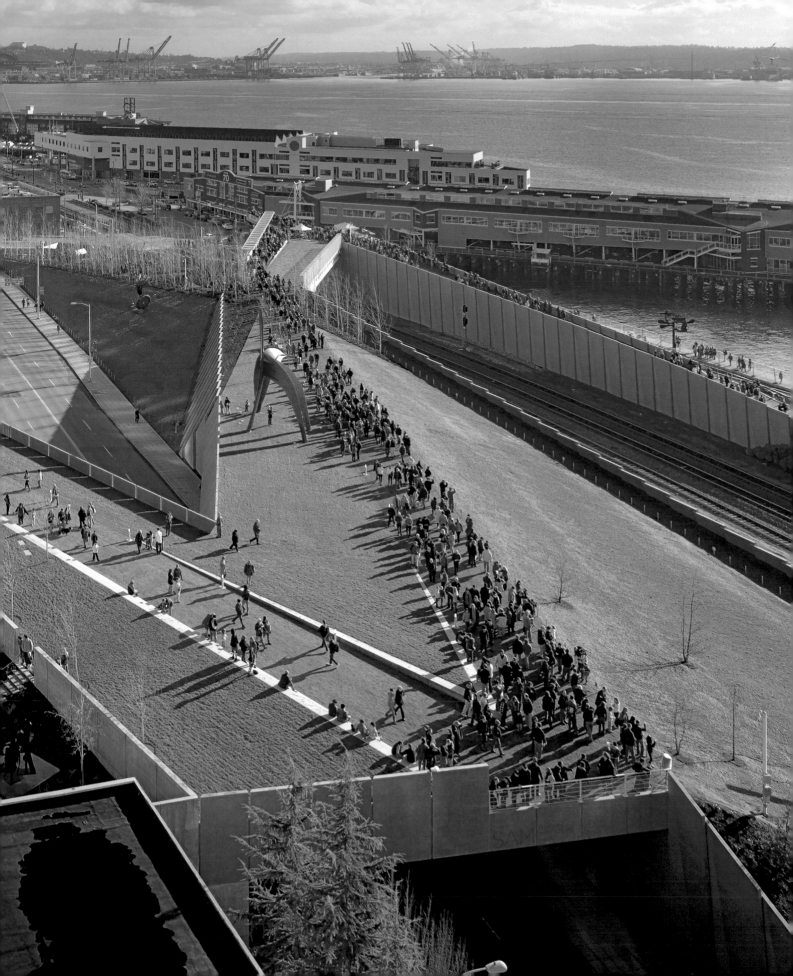

# The Birth of the
# Olympic Sculpture Park

*Creativity,
Determination,
and Grit*

Mimi Gardner Gates in
association with
Renée Devine

*We shape our public spaces, and afterwards our public spaces shape us.*   —Winston Churchill

How did Seattle's Olympic Sculpture Park come into being? How was a forlorn industrial brownfield, cut into three parcels by a roadway and a railroad, transformed into a brilliantly designed sculpture park, perfectly situated on the waterfront with stunning views across Puget Sound to the Olympic Mountains? Why did a private art museum construct a park, at a location far from its primary buildings, that is open, free, and safe for everyone? Who created the sculpture park's innovative design? And what obstacles were overcome to make the park a reality? This is a narrative of unlikely partnerships and unstoppable determination. We hope that it may inspire civic leaders and citizens of other towns and cities to break the box (not just to think outside it), to form unexpected alliances, and to meet seemingly insurmountable challenges in order to create an enduring asset, an artful green space that benefits the environment and—most importantly—the community.

### Genesis of the Idea

In a most unlikely spot on the other side of the world, in the grasslands of northern Mongolia, the possibility of a sculpture park happening in greater Seattle gained traction in the summer of 1996, when I was two years into my fifteen-year directorship (1994–2009) at the Seattle Art Museum (SAM). I was among twelve American women—including SAM trustees Ann Wyckoff and Jane Lang Davis—who embarked on a Mongolian fly-fishing adventure infamous for a helicopter crash, euphemistically known as a hard landing, in which no one was injured (fig. 2.1). During the trip, I spoke at length with Martha Wyckoff, a Seattleite and member of the national board of the Trust for Public Land (TPL). At home in the out of doors and a civic-minded thinker, Martha is fearless, blessed by a can-do spirit, and determined to triumph over adversity. Prior to the crash, sitting on an airport bench in Moran, Mongolia, and later, after the crash, standing in a remote field far removed from the distractions of daily life, we discussed Seattle's need for green space, for parks, and our disappointment at the recent failure of the Seattle Commons proposal. (The project would have provided a generous swath of green space, a new sixty-one-acre park, running through the center of the city [see fig. 7.10]. However, Seattle voters had twice voted down tax levies to fund the Commons, most recently on May 21, 1996.) Through that conversation, and others on our trip, Martha and I decided, "Let's do something about it."

This moment in the wilds of Mongolia, where we could think freely and broadly, is a benchmark in both my personal storyline and Martha's—the

41

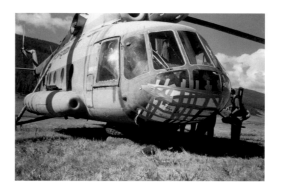

start of the unprecedented partnership between SAM, an art museum, and TPL, a nonprofit land conservation organization that specializes in the creation and protection of parks. Before going any further, however, we need to return to the previous year, when Jon Shirley and his late wife, Mary Shirley, initiated the idea of an outdoor sculpture park in Seattle (fig. 2.2). Discriminating collectors of modern and contemporary art as well as vintage cars, they would provide leadership and funding that ensured the park would become a reality. They are the heroes of this story.

By 1995, the Shirleys had acquired a substantial number of significant works of art, including many large-scale outdoor sculptures. Always thinking ahead, they began to discuss the future of their collection and their desire for it to become a part of Seattle. While the majority of their paintings and small-scale sculptures could easily find a home, most likely at the Seattle Art Museum, where their friend Patterson Sims was chief curator, their outdoor sculpture posed a conundrum because there was no appropriate place for it at the museum.[1] But Jon and Mary had visited sculpture parks wherever they went, from the Storm King Art Center in Upstate New York to the Hakone Open-Air Museum in Japan, sparking their interest in creating a park for outdoor sculpture in greater Seattle.

The first person the Shirleys approached to discuss this idea was their natural ally and friend Virginia "Jinny" Wright, another hero in the creation of the park (fig. 2.3). Together with her husband, Bagley Wright, she had formed a distinguished art collection including outdoor sculpture, such as Mark di Suvero's *Bunyon's Chess* (1965, fig. 2.4). They, too, wanted their art to stay local. Jinny, a Seattleite, had previously worked at the Sidney Janis Gallery in New York. After returning to Seattle, she had the vision to enhance the campus of Western Washington University in Bellingham by establishing its internationally recognized Outdoor Sculpture Collection, which started in 1969 with the commission of Isamu Noguchi's *Skyviewing Sculpture*.[2] On July 25, 1995, when Jinny joined Mary and Jon for lunch, she immediately embraced their idea of a sculpture park in Seattle—a project she would champion for more than a decade. Since Jinny was a leading force at the Seattle Art Museum, she suggested the next step be to approach me, as the museum's director. My wholehearted, enthusiastic response to the

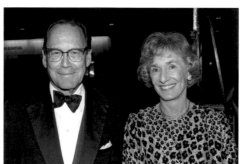

FIG. 2.2
Olympic Sculpture Park founding donors Jon and Mary Shirley.

FIG. 2.3
Bagley and Virginia "Jinny" Wright.

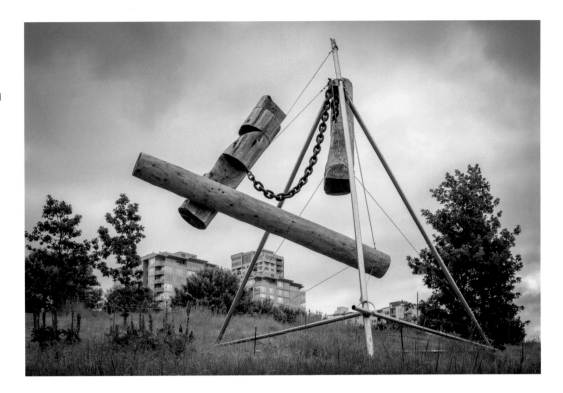

proposal of creating a park for art and for people was, "Let's do it."

The idea of a sculpture park was perfectly aligned with my belief in the civic responsibility of arts organizations to strengthen community, as well as my desire to integrate art and architecture of the highest caliber into the daily lives of Seattleites, and to enhance the cultural fabric of greater Seattle and the rapidly developing Pacific Northwest. A sculpture park would bring art out into the city, beyond the four museum walls. Being an impulsive risk-taker—pursuer of a calculated risk in the case of the sculpture park—I instinctively seized the opportunity to work with Jon and

Mary Shirley and Jinny Wright, passionate collectors, generous philanthropists, and people of integrity, to initiate a project that would have lasting benefit. A sculpture park would indeed be an invaluable community asset, combining great art and fast-disappearing urban green space. Many surprises, adventures, and challenges lay ahead.

### Selecting the Waterfront Unocal Brownfield

Unbeknownst to me, Martha Wyckoff (fig. 2.5), after returning from Mongolia to Seattle in 1996, promptly took up the idea of securing more park space and creating a place for sculpture. She brainstormed with Chris Rogers (fig. 2.6), an

employee of the Trust for Public Land and savvy negotiator who would later become a critical member of our team as SAM's director of capital projects and government affairs and project manager for the park. Chris was a perfect fit for the job because, undaunted by adversity, he constantly collaborated, sought creative solutions to seemingly intractable problems, helped to build broad community support, and conscientiously addressed every aspect of the project, thus ensuring excellence. Excited at the prospect of a sculpture park, Chris began to inventory potential sites such as Battelle, a green space in the upscale residential neighborhood of Laurelhurst, and several possibilities in the heart of the downtown, including a postage stamp–sized vacant lot at the corner of First Avenue and Seneca Street, a lot at First Avenue and Madison Street and one at Third Avenue and Union Street, the Mann building with its landmarked facade, now Wild Ginger restaurant. Chris and Martha also explored more spacious possibilities outside the urban core on Bainbridge Island and in the nearby city of Issaquah, east of Seattle. They biked and explored places from the Mountains to Sound Greenway to city-owned land adjacent to Gas Works Park. Even in the mid-1990s, suitable sites were surprisingly scarce. Meanwhile, the Shirleys, Jinny, and I continued to talk, keeping alive our dream of a world-class sculpture park.

Perseverance paid off in the summer of 1997. On a gray, dank Seattle day, Chris took our small group of sculpture park dreamers, including Jon and Mary, Jinny, TPL board member Douglass ("Doug") Raff, and me, to see several potential sites. Our final stop was the last parcel of undeveloped downtown waterfront, a forlorn industrial brownfield in no-man's land north of Pier 70 (see fig. 3.1). Fenced and muddy, this relatively large,

six-acre parcel adjacent to Myrtle Edwards Park was the last remaining undeveloped waterfront property within the urban core of Seattle, and it was on the market.

Divided into three sections by a major roadway and railroad, the land was owned by Union Oil of California (Unocal) and included a small portion of city-owned right-of-way. Until 1975, it had functioned as Unocal's Seattle Marketing Terminal, a waterfront storage facility where underground pipes moved petroleum products from tankers parked at Pier 71 to large fuel-storage tanks above ground, which held the fuel until it was distributed by trucks to gas stations. This fuel transfer and distribution site had been active since the early 1900s, expanding in phases between 1910 and 1940 (see figs. 6.3 and 7.5), operating at maximum capacity in the 1960s, and was closed in 1975 when Unocal was getting out of the retail gasoline business. For more than a decade, since 1988 when Unocal entered into a consent decree (amended multiple times) with the Washington State Department of Ecology, the company had taken remedial action to address contamination by a variety of petroleum hydrocarbon products, removing approximately 127,000 tons of petroleum-contaminated soil and 76 million gallons of contaminated groundwater. Although the site still posed environmental concerns, it was up for sale. In 1996–97, Unocal circulated a request for proposals (RFP), and potential commercial and residential buyers were lined up, salivating to purchase this prime site with waterfront views on the northern edge of downtown.

On that gray, drizzly Seattle day in 1997 when we first experienced the site, what we saw was a spacious, muddy pitch, fragmented by major thoroughfares and bereft of beauty, except for the

view to the west across a vast expanse of blue water and forested islands to the Olympic Mountains. Expressing the group's immediate enthusiasm, Jon remarked, "I think this is great. Let's go for it."

**An Extraordinary Gift**

Not long after our visit to the Unocal brownfield on the water, another landmark moment took place. Jon Shirley, a visionary and an action-taker, challenged the museum—and me. If we would raise the funds to purchase the Unocal property and develop the site, he and Mary would endow the operations of the sculpture park, which would be owned and operated by the Seattle Art Museum. For a split second, I wondered if I should ask how much money he was thinking of giving for the endowment, but I quickly rejected the idea because Jon is a man of his word, an exemplar of generosity and trustworthiness. Moreover, we had no idea what the cost to acquire the land and develop the park would be. Nonetheless, inspired by the Shirleys' remarkable commitment, TPL optioned the property, and the museum's senior leadership, board, and staff were emboldened and determined to raise the significant funds necessary to purchase the land and develop the site into a free, one of a kind sculpture park. Despite periodic setbacks, the project team ran at top speed for the next ten years, until the Olympic Sculpture Park opened in January 2007.

Central to our success was the confluence of good timing (one month later, no downtown waterfront property would have been available for a park) and an exceptional board and staff leadership team of optimistic, energetic people, all skilled at what they did and respectful of one another. SAM's board leadership not only was

generous in spirit and civic minded but also possessed significant financial resources and management experience. Everyone was determined to create a well-designed sculpture park that reflected Seattle's urban vitality, passion for public art, and the natural beauty of the city's setting at water's edge surrounded by mountains and greenery. What could be more impactful than to turn a contaminated brownfield into a vibrant waterfront green space to be enjoyed freely by present and future generations?

**TPL and SAM Negotiate with Unocal**

In 1997, once the Shirleys made their extraordinary pledge to endow the sculpture park, the first order of business was to convince Unocal to consider a proposal from the Trust for Public Land and the Seattle Art Museum. A series of purchase agreements followed, carefully negotiated between the TPL, SAM, the City of Seattle, the Washington State Department of Ecology, and Unocal. These documents proved to be extremely important, as they laid the groundwork for the sale, completed December 8, 1999, and clearly established the distribution of liability. But before those negotiations began, the park project faced its first major hurdle.

When Chris Rogers, TPL's transaction specialist and future SAM project manager, initially approached Unocal staff in Edmonds, Washington, they told him that the deadline of their request for proposals to buy this parcel of land had already passed. Undeterred, Chris persuaded them that Unocal had not previously considered green space—particularly a sculpture park open to the public—and they needed to think seriously about this potential community use for Seattle's last undeveloped waterfront property. By contrast, one developer was proposing eight hundred

condominium units, a gym, and retail shops. Throughout Chris's arguments to the Edmonds Unocal staff, he intimated, "Do you really want people living on this contaminated land, even after remediation?" Having made a good case for an alternative, a park open and free to the community, Chris was referred to Unocal's Los Angeles office for further consideration of the park proposal. There, Chris and environmental attorney Lynn Manolopoulos met with employees of Unocal's real estate division and with environmental scientists. After a long day of face-to-face meetings and subsequent video conferencing, it became clear that while Unocal was committed to doing well by its shareholders, they also wanted to work with SAM and TPL to transform the waterfront brownfield into a green space for art and people.

What factors convinced Unocal to take seriously the Trust for Public Land's offer on behalf of the Seattle Art Museum and permit us to option the land for a waterfront sculpture park? First, our two-person negotiating team, Chris and Lynn, was formidable. Lynn's extensive legal experience in environmental matters inspired confidence, and Chris complemented her expertise with his sharp negotiating skills, knowing what questions to ask and how to work behind the scenes. Their sheer grit, perseverance, and belief that anything is possible gave rise to inventive solutions for a long series of roadblocks that stood in our path. The Olympic Sculpture Park would not have been realized without their creativity and commitment.

In addition, two Unocal board members advocated for the sculpture park project, underscoring the credibility of our proposal. Jill Barad, a former Microsoft board member, had worked for John Amerman, who served on Unocal's Board of Directors, and Jon Shirley asked her to encourage Amerman to have Unocal sell the property to us for a favorable price. Meanwhile, another influential Unocal director, Seattleite Jack Creighton, received persistent pressure from his close friends Doug Raff and Seattle Mayor Paul Schell—both strong advocates for the sculpture park—during weekends the three spent together with their spouses on Whidbey Island. This cultivated support from Unocal's board, coupled with the fact that the Trust for Public Land could be counted on to help work through complex environmental liability issues, gave added weight to our offer. Also important was the appeal to Unocal of a civic-minded project driven by community nonprofits. On February 28, 1999, TPL secured an option to purchase the land for $16.5 million with a deposit of just one hundred dollars, a shockingly modest sum. They agreed to pay an additional $1 million six months later, and to conduct due diligence on the environmental condition of the property.

### Environmental Due Diligence and Distribution of Risk

From the very beginning, the president of SAM's Board of Trustees, Brooks Ragen, a Yale graduate, investment advisor, civic leader, and environmentalist, was adamant that the project not put the art museum at risk. When Brooks met with Chris Rogers and Lynn Manolopoulos at the law offices of Davis Wright Tremaine shortly after Lynn joined our team, he made it very clear that their job was to find a way for SAM to bear no risk—or, if risk was unavoidable, it must be clearly defined. This was a tall order, because the park site was still contaminated, and Unocal wanted to rid itself of all liability. Naturally, the City of Seattle was also a risk-averse partner. The question was: How could we divide up the environmental risks so that

everyone—Unocal, the Trust for Public Land, the Seattle Art Museum, and the city—would be comfortable and willing to proceed?

Through lengthy negotiations between TPL, SAM, Unocal, and the city, and with the approval of the Washington State Department of Ecology (hereafter Ecology), we agreed that the museum would take responsibility for the upper and lower yards, because we were going to develop those areas as parkland; the City of Seattle would be responsible for the rights of way (Elliott Avenue and the Alaskan Way), with the exception of groundwater, which Unocal would maintain and monitor; and responsibility for the tidelands, which were an integral part of the property, was divided between Unocal and the city. Reaching this agreement was a key moment, a testament to Chris's and Lynn's expertise and determination.

Enter another hero: Paul Schell (fig. 2.7), who was mayor of Seattle from 1998 to 2001. Paul was an urban visionary, lawyer, shrewd real estate investor, civic activist, practitioner of real politics, and preservationist, a strong advocate for art and culture and, later, interim dean of architecture at the University of Washington. Among other achievements in his all-too-brief term as mayor, he fought successfully for the preservation of the historic Pike Place Market (see fig. 7.9) and built the new downtown Seattle Public Library

designed by OMA / Rem Koolhaas (see fig. 1.1). Paul understood the brilliance of the sculpture park project, instructing his staff to do everything they could to help make it happen. His enthusiastic, unwavering support was critical. For example, in the early stages of negotiating the potential purchaser agreements, some city staff were reluctant to accept environmental liability for the rights of way, but the mayor prevailed. This early environmental compact constituted the foundation of all future agreements related to the project; afterward, the Trust for Public Land and the Seattle Art Museum stalwartly refused to compromise and alter any of its provisions, particularly the distribution of risk, regardless of how much pushback we received from cautious city staff. A host of environmental agreements followed.

Ecology, Seattle City Hall, and King County were all constructive players in this process. By committing significant resources to expediting research, analysis, and decision making regarding Unocal's contaminated property, Ecology enabled our environmental agreements to move forward at an unprecedented pace—three to four months for what often takes years to accomplish.[3] Ecology's role is just one example of how good relations between parties facilitated complex negotiations and how, as the project progressed, everyone involved became invested in the miraculous transformation of a muddy parcel of contaminated land into an inspired urban park.

Throughout 1997–98, informal discussions about the project took place among SAM's Board of Trustees, a group of supportive, big-picture thinkers willing to seize an extraordinary opportunity. Although the museum already had a $35 million endowment campaign underway, the majority of trustees agreed that the sculpture park was a once-in-a century opportunity and that

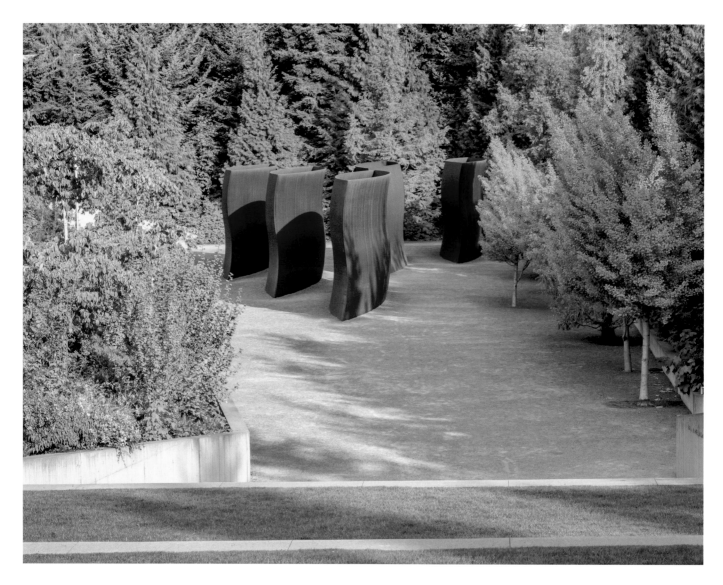

FIG. 2.8
Richard Serra's
*Wake* (2002–3)
sited in the valley
precinct, 2019.

we should proceed with pursuing it. An ad hoc sculpture park advisory committee composed primarily of trustees and staff formed, meeting regularly as we began to envision what the park would become.

At that time, it was exceptional, indeed unprecedented, for a museum to have a sculpture park separate from its main facility. However, since SAM already had two sites—the 1990 flagship building, designed by Robert Venturi, in the heart of downtown, and the Asian Art Museum housed in the original 1933 Seattle Art Museum building, by Carl Gould, in Volunteer Park—why not add a third location? Moreover, by creating

and operating the sculpture park, we realized that the museum could expand its mission, championing the environment as well as art while making a meaningful commitment to improving our city and the Pacific Northwest. A few doubters expressed concern because the site had long been inhabited by an unhoused and transient population of individuals living on the margins of society, as captured in moving images by Seattle photographer Glenn Rudolph (see figs. 4.17–19). Today, the park's 24/7 security guards open the Olympic Sculpture Park one half hour before sunrise, close it a half hour after sunset, and maintain constant vigil, ensuring a safe environment where

all are welcome to experience great art and open space (fig. 2.8). Although the Executive Committee of SAM's board followed the sculpture park project closely as it evolved, only on May 18, 1999, did the museum's Board of Trustees formally approve the purchase of the Unocal land.

## The Trust for Public Land and the Seattle Art Museum Seal the Deal

Property negotiations had been confidential, but in early 1999, news of the project began to leak.[4] Shortly thereafter, in quick succession, the Trust for Public Land signed a $16.5 million[5] purchase and sale agreement with Unocal for the waterfront property on February 19, 1999, contingent upon raising the necessary funds by October 1999 (later extended to December 1999); on March 8, 1999, the Executive Committee of the museum's Board of Trustees unanimously approved the agreement; and on March 29, 1999, the museum held a press conference to publicly announce SAM's intent to purchase the property as the future site of a sculpture park, open to all. Speakers included Mayor Paul Schell, King County Executive Ron Sims, and City Councilor Richard Conlin, among others.

From the outset, we strove to create widespread enthusiasm throughout the community and harness that energy to make the park a reality. Shortly after Unocal granted us the right to purchase the property, I cohosted a breakfast at the downtown museum with the savvy Seattle City Council president, Sue Donaldson, a strong advocate for the park, in order to dispel disappointment among developers who had made significant investments in submitting proposals to purchase the Unocal property. Chris Rogers presented the early plans for the waterfront sculpture park to the developers, who had been enthusiastically buying land in Belltown, where the sculpture park is located—a neighborhood ripe for redevelopment. No doubt realizing that the sculpture park would greatly enhance property values, they responded positively to our plans, thus diffusing anger and increasing public support.

## Fundraising and Purchase of the Unocal Brownfield

The sculpture park now had a green light, but would SAM be able to raise $17 million in five months?[6] The challenge was immense. As the urgency and pace of fundraising intensified, our earliest brochure cried out, "Seattle's last chance for a downtown park."[7] Our fundraising strategy, designed by Senior Deputy Director Maryann Jordan, a dynamic leader central to the museum's senior team, was two pronged, tightly focused on private giving while at the same time building broad-based support for the project throughout the city and surrounding community. The rare waterfront location and the idea of reimagining an abandoned industrial site as an inspired green space filled with art and people galvanized Seattleites. It felt right from the outset.

One critical moment in the success of the fundraising effort—and a significant moment in my personal story—deserves mention. Seeing me pace around our bedroom at three in the morning, anxiously mulling over how to secure funds in time to meet the Unocal deadline, my husband, Bill Gates Sr. (fig. 2.9), took the initiative. Without saying a word to me, he met with his son, Bill Gates, who agreed that he and his wife, Melinda, would donate $4 million to the sculpture park project. My stepson also challenged his good friend Paul Allen to provide a matching gift; Paul's sister, Jody Patton, handled the Paul Allen

Foundation buy-in. Their two gifts, totaling $8 million, together with those of many other generous Seattleites, placed the land purchase from Unocal within reach, but we still needed to raise $4 million.

We held lively fundraising events at the site, such as an evening for potential donors on June 29, 1999, that featured *The Wizard of Us*, a marvelously creative musical parody of *The Wizard of Oz* created by Arne Zaslove and Claire Vardiel Zaslove and commissioned by Martha Wyckoff. The script and songs, chock-full of rhyme and wordplay, imaginatively told the story of our ambitious efforts to create a six-acre sculpture park in the Emerald City. The song "Follow the Yellow Brick Road" began, "Only four million to go, only four million to go, only, only, only, only . . ." This event and many others embodied our shared vision of what the park would be: a nontraditional outdoor museum space full of fun, spontaneity, and high spirits, celebrating art and architecture, the natural environment, and community in Seattle and the Pacific Northwest.

In mid-July 1999, the Trust for Public Land reported that $14.7 million had been raised (or pledged) toward the land purchase. In a museum press release dated July 12, 1999, Luis Weiss, general manager of Unocal's Asset Management Group, announced that the company was extending the deadline for purchase until July 30 because there had been "a clear show of public support and enthusiasm for this magnificent project." In fact, the deadline would be extended multiple times before the Seattle Art Museum's purchase of the Unocal property was consummated on December 8, 1999, but our commitment never wavered. TPL's goal was to ensure purchase of the site for a park; therefore, once the museum owned the land, the trust stepped back.

Nonetheless, the partnership between the Trust for Public Land and the Seattle Art Museum was fundamental to our success.[8] Without that collaboration, the Olympic Sculpture Park most likely would not have come into being. To ensure continuity with those initial joint efforts as SAM assumed the lead, Chris Rogers transitioned from the Trust for Public Land to the Seattle Art Museum on September 20, 1999, becoming the museum's director of capital projects. His first and major task was to manage the design, planning, and building of the Olympic Sculpture Park.

## Naming the Olympic Sculpture Park

Enhancing our success, Jon and Mary Shirley not only pledged $20 million to endow the park's operations but also made an additional major gift of $5 million toward its design and development. In gratitude for their generosity, SAM offered the Shirleys naming rights for the venture. Eschewing personal aggrandizement, the Shirleys, rather than place their own names on the park, chose to honor the stunning Olympic Mountains that frame visitors' distant watery view to the west, dubbing it the Olympic Sculpture Park. Much to our surprise, the name required permission from the US Olympic Committee, which graciously granted approval.

FIG. 2.9
Bill Gates Sr. and son, Bill Gates III, at the Olympic Sculpture Park, January 20, 2007.

## Museum Development Authority

Private funds enabled the museum to meet Unocal's demanding timeline for the purchase of the two parcels of contaminated land and the adjoining tidelands; however, everyone was aware that public funds would be essential to realizing this ambitious project—and that the Seattle Art Museum, a private entity, was not eligible for such funds. The Museum Development Authority, a public body chartered in 1985 by the City of Seattle specifically to facilitate SAM's capital projects to benefit the public, came to play an important role. As soon as the museum purchased the Unocal site, it transferred ownership to the Museum Development Authority; the Seattle Art Museum then subleased the land from the Museum Development Authority for 150 years. Adding the Museum Development Authority to all environmental agreements made the park eligible for public financing, including the Washington State Remedial Action Grant Program and the Ecology Grant Program.

In July 1999, Sue Donaldson helped the Seattle Art Museum identify another significant potential public funding source: transferable development rights (TDR). The City of Seattle created its TDR program to save historic buildings, create low-income housing, and fund open space—though before the Olympic Sculpture Park, no open-space projects had been realized. Under the program, a developer could sell the air rights from one site to the developer of a different site. Because the Seattle Art Museum's site was outside of the geographic limits of the downtown TDR program, Sue and Chris Rogers worked with the city to extend it to include the Belltown neighborhood and negotiated for the

sculpture park to be authorized under the program. This funding source raised over $2 million.

## Completing the Land Purchase: 10 Broad Street

To complete the park, the Museum Development Authority also received public funds to purchase and clean up a one-third-acre parcel at the corner of Elliott and Broad streets, the site of RC's Billiards sports bar, formerly Shakey's Pizza. Adjoining the lower yard along Broad street, this small bite of land had been approved for a thirteen-story, eighty-nine-unit condominium and mixed-use building designed by the Fortune Group. If built, it would have thrown dark shadows across the sculpture park as the sun made its daily journey across the sky. Neighborhood business associations and individuals who avidly supported the park offered their help, urging Mayor Schell and the city to ensure that 10 Broad Street became part of the park.[9] After well over a year of negotiations, through a public-private partnership involving the City of Seattle ($2 million), King County ($1 million), and a federal economic development grant ($500,000), as well as private contributions, the Museum Development Authority purchased the 10 Broad Street parcel for $3.56 million on June 5, 2001, and immediately subleased it to the Seattle Art Museum for 150 years, ending the land acquisition phase of the park (and securing the future site of Tony Smith's monumental *Stinger* [1967–68/1999, fig. 2.10]).[10] City Council member Jan Drago declared, "The acquisition of the 10 Broad Street property is an important step toward protecting critical open space and establishing a cultural resource that inspires regional pride."[11] On January 7, 2002, museum trustee Ann Wyckoff, perched high atop

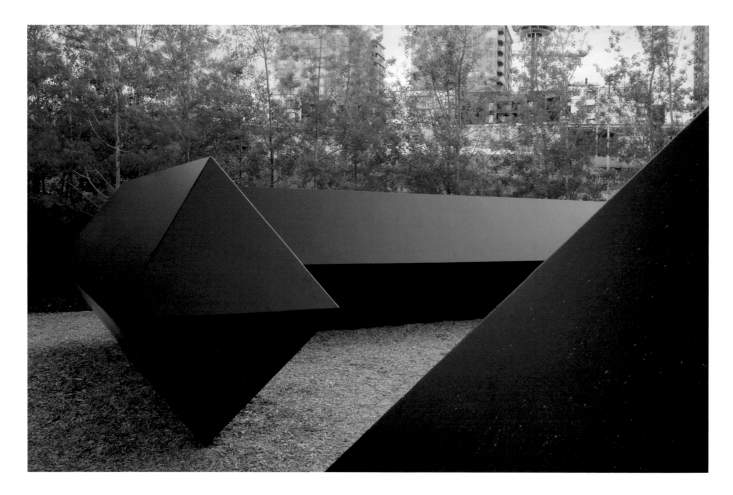

a backhoe, took a ceremonious swing to begin the demolition of RC's Billiards. Five days later, demolition was finished.

## Art and Connectivity on the Seattle Waterfront

Although the lower yard of the Unocal property was made whole only in 2001–2 with the purchase and demolition of 10 Broad Street, TPL and SAM, represented by Chris Rogers, the museum board leadership, and me, had been working closely with the City of Seattle since 1998. Together, we laid the groundwork for an integrated public waterfront joining the Olympic Sculpture Park site with two adjacent open spaces: Myrtle Edwards Park and Elliott Bay Park (now Centennial Park), then the largest open space on the downtown waterfront, which hitherto had been underknown, underused, and difficult to access; and an

underutilized portion of the Alaskan Way right-of-way, then occupied by an unattractive parking lot, portable toilets, and Waterfront Streetcar's maintenance barn.[12]

Together Myrtle Edwards Park, Centennial Park, and the Olympic Sculpture Park, minus the watery tidelands, total approximately twenty-five acres of contiguous green space with paved paths for joggers and bikers to access the north end of the city.[13] At intervals, major works of art enhance the visitor's experience, each occupying its own generous space near the water's edge. These shorefront works include Louise Bourgeois's *Father and Son* fountain (2005, see fig. 5.11), along with her three pairs of whimsical *Eye Benches* (1996–97, see figs. 5.12–13) in close proximity; Jaume Plensa's towering head of the goddess *Echo* (2011, fig. 2.11), staring at the distant horizon; Mark di Suvero's *Schubert Sonata*

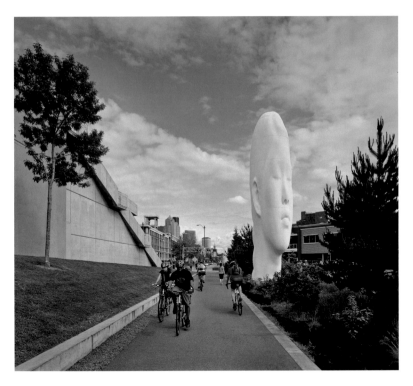

(1992, see pp. 158–59); Roy McMakin's *Love & Loss* (2005–6, see figs. 5.7–8), an imaginative interplay of words with a single V-shaped tree, table, and sculptural seats forming letters; and, further north, Michael Heizer's *Adjacent, Against, Upon* (1976), a major site-specific work in the center of Myrtle Edwards Park.

The City of Seattle's visionary leaders, particularly Mayor Schell and the members of the Seattle City Council, deserve credit for their sustained work with the museum to ensure seamless connectivity along the north waterfront in the area of the Olympic Sculpture Park. Two agreements between the Seattle Art Museum and the City of Seattle, signed on December 7, 1999, and on June 12, 2000, cemented the division of responsibilities regarding not only environmental cleanup and liabilities but also master planning for the Olympic Sculpture Park, Myrtle Edwards Park, and the contiguous section of the Alaskan Way. The museum and the city agreed to partner in covering the cost of initial concept design ($500,000), the city's $150,000 being an important investment that

Chris Rogers later cited as proof of the city's commitment to the overarching vision when reluctant city staff and officials considered backpedaling. The agreement also acknowledged that the museum would select the lead designer for the Olympic Sculpture Park, as well as manage and administer the design process and the development of the park.

Through our strong partnership with the City of Seattle, SAM creatively resolved numerous project challenges, such as securing the aerial crossings required to bridge the park's three parcels of land. Seattle policy required SAM to petition for vacations, in which the city relinquishes its use of public rights-of-way, to acquire ground-level rights along the Alaskan Way and aerial rights for the crossings over Elliott Avenue and the Alaskan Way. (The same had to be negotiated separately with the Burlington Northern Santa Fe Railroad to cross over the railroad tracks that pass through the site.) These aerial and street vacations would have required annual permit payments of between $100,000 and $200,000 per year; instead, the city and the museum negotiated a property use and development agreement to grant the city a pedestrian easement through the park as a way to obtain these rights free of charge.

### Planning for the Design Stage

As a new millennium began and excitement about the waterfront art park grew, we faced a critical question: How to structure a selection process that would enable us to identify an excellent lead design firm that was the right fit—that would not only provide engaging settings for works of art and people, but also capture the character of Seattle, our love of nature and innovation?

On March 25, 2000, to spark thinking about next steps and broaden our vision of the park, SAM held a lively board retreat near the sculpture park site. Breaking up into teams alongside key community members, museum trustees stepped outside their comfort zone, walking the unfamiliar neighborhood, interviewing whomever they met about their thoughts on the creation of a free sculpture park, and reporting back to the group. Unexpected and sometimes amusing encounters occurred. In one case, a man living on the street told a museum trustee that he was worried that the park would mean he would lose his place to smoke pot.[14] Breathlessly, she raced back to report. Despite—or perhaps because of—such encounters, the retreat was a success, as the firsthand experience increased board members' investment in the site and enhanced the program for the park.

In addition, professionals with specialized expertise spoke at the retreat. Mark Robbins, director of design at the National Endowment for the Arts (NEA), presented a lecture titled "Achieving Excellence in Contemporary Design"; Mary Beebe, director of the Stuart Collection, University of California, San Diego, addressed the imaginative collection of outdoor sculpture; and Kathy Madden and Fred Kent, principals of the New York firm Project for Public Spaces, in a talk titled "Creating Successful Public Spaces," cogently made the point that people have a strong preference for movable chairs, not stationery benches—they want to determine where they sit and what they see.[15] Never forgetting this point, I championed the red-orange chairs from Design within Reach that today populate the park (fig. 2.12).[16] Skeptics worried that people would steal the chairs, but that has not come to pass. In sunny

FIG. 2.12
Red chairs by Design within Reach at the Olympic Sculpture Park, spring 2008.

weather, people choose a red chair, place it where they wish, read a book or socialize with friends, or simply sit quietly, delighting in the view, a welcome respite from the urban frenzy.

### Acquiring an Iconic Masterwork

In early summer 2000, I received a telephone call from Jon Shirley, who asked, "Could SAM transport a monumental sculpture across the country?" My response, "Sure." Sotto voce, I asked, "May I ask which work of art?" Jon replied, "The monumental stabile *The Eagle* by Alexander Calder." I was thrilled. Jon and Mary generously donated funds to SAM,[17] enabling the museum to purchase the sculpture, which at the time was owned by a group of investors and installed on the steps of the Philadelphia Museum of Art. Shortly thereafter, I telephoned the museum's director, Anne d'Harnoncourt, who graciously gave her blessing, saying if this majestic orange-red stabile was not to reside in Philadelphia, she could not think of a better place for it than Seattle. Today, Calder's *The Eagle* (1971, fig. 2.13)

FIG. 2.13
Alexander Calder's *The Eagle* (1971) with the Olympic Mountains in the background, 2013.

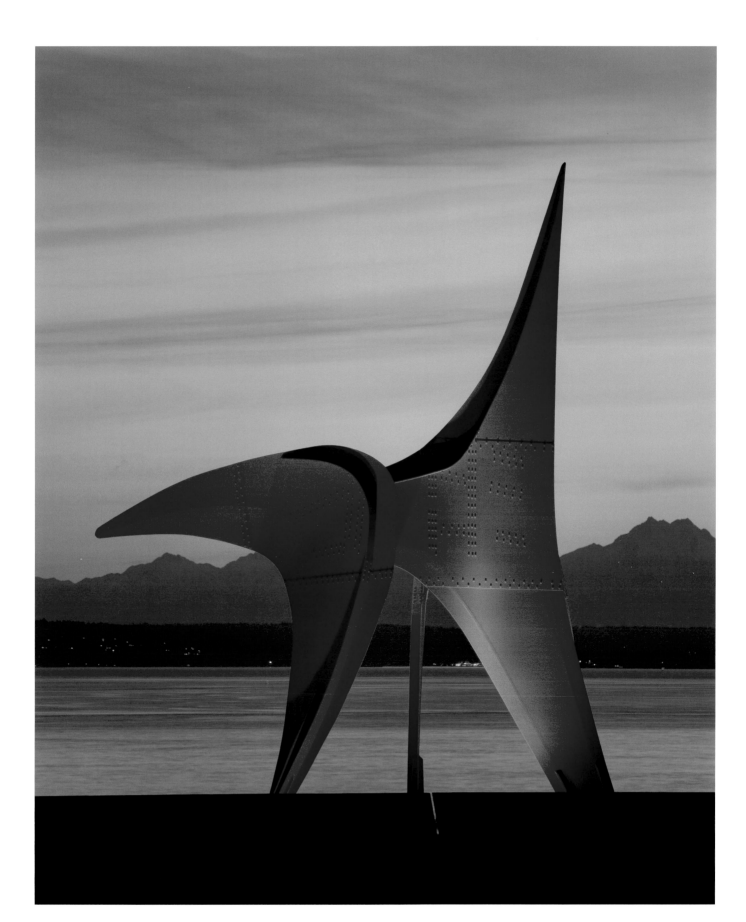

is a Seattle icon, presiding over the Olympic Sculpture Park.

## Program Goals and an International Lead Designer Competition

The design and development of the sculpture park proceeded apace in the summer of 2000 thanks to Chris Rogers's efforts as project manager. Over an extended period of time, Chris worked tirelessly with the Sculpture Park Committee, museum trustees and staff, community organizations and park neighbors, City of Seattle staff, and many other constituencies to develop a program that would reflect our wish list for the park and serve as a guide for the yet-to-be selected lead design team.

The *Program for the Olympic Sculpture Park, Seattle Art Museum*, completed in October 2000, set out the following six general design principles:

1. Showcase outdoor sculpture as a vital art form.
2. Expose people to the arts in a comfortable, inviting civic space.
3. Celebrate the park's spectacular natural setting.
4. Create a pedestrian-friendly, contiguous waterfront open space.
5. Provide a unique venue for educational programs and special events.
6. Contribute to recovery and conservation of the natural environment.

The plan also described three programmatic elements: an artistic program that included both site-specific, permanent works and temporary installations; a landscape program featuring native vegetation and providing connectivity to the adjacent Myrtle Edwards Park; and a building program for a park pavilion to house changing artwork, a café, restrooms, and a below-grade parking garage. A summary of the program was included in the request for qualifications the museum ultimately released.

In June, we hired Barrientos LLC, project management consultants, led by principal Maria Barrientos, to oversee the budget and advise on all stages of the park's development from programming through design and construction.[18] Shortly thereafter, on June 27, 2000, the Design Selection Committee formed to select the lead designer of the park.[19]

By the end of August 2000, the Target Foundation and the NEA New Public Works program, each with a grant of $50,000, announced that they would fund the international competition to select the lead designer of the Olympic Sculpture Park. The public works grant was one of only ten awarded nationwide. NEA Chairman Bill Ivey underscored the importance of the design grants, stating, "From schools to housing to parks, good design is essential to the physical and social fabric of our communities."[20] As I noted at the time, "Receiving the National Endowment of the Arts grant is a strong validation of the future of the Olympic Sculpture Park's artistic and environmental importance, not only to the city and region but also to our nation."[21] This national endorsement reassured funders of the park and inspired new supporters.

Under the leadership of Robert Ulrich, Target Corporation was in its heyday, stores popping up everywhere, and the company, through the Target Foundation directed by Gail Dorn, not only provided financial support, but also made

available the company's creative talent to urban art projects—especially those that were ambitious, pursued excellence, and promoted the integration of the arts and education.[22] The Olympic Sculpture Park project was a perfect fit with Target's priorities, and as a result, SAM benefitted from the company's largesse in multiple ways, including their design for the handsome poster that featured Calder's *The Eagle* and announced the competition for lead designer of Seattle's Olympic Sculpture Park.

What qualities and experience were we searching for in a lead designer? The members of the Design Selection Committee discussed this question extensively. Many museums choose architects for their buildings from among a small group of well-known names; instead, we boldly reached across disciplines, opening the competition to creatives from multiple fields.[23] As a result, responses came from artists and designers, architects and landscape architects, some of whom applied as teams of professionals with complementary expertise who had worked together in the past. Benefiting from the advice of Peter Reed, then curator of architecture and design, Museum of Modern Art, New York, and a member of the committee, we focused our international search on identifying a team of experts, firm, or individual who had demonstrated design excellence in built projects of comparable complexity—and with whom we wanted to work.

Since we were not asking for a specific design concept, we did not issue a request for proposals (RFP), but rather a request for qualifications (RFQ), released on October 3, 2000, with a submission deadline in mid-December. The call for submissions was announced in the media, posted on the Competitions website and the Seattle Art Museum's website, and advertised in *Architecture*, *Landscape Architecture*, and *Competitions* magazines, as well as in Seattle's *Daily Journal of Commerce*. To promote the competition, Chris Rogers also traveled nationally and internationally and sent letters to firms and individuals who had already expressed interest, as well as to stock mailing lists.

The response to our call was impressive. By our deadline of December 15, 2000, we had received responses from fifty-two architects, landscape designers, and artists, both individuals and teams, including architects Steven Holl, Zaha Hadid, Richard Meier, and Tod Williams and Billie Tsien, as well as artist James Turrell. The success of our international design competition exceeded our wildest expectations.

### Finalists, Travel, and Selection of Lead Designer

After a preliminary review of the fifty-two submissions, the Design Selection Committee evaluated thirty-one qualified candidates and narrowed the field to six finalists: Adriaan Geuze / West 8 (Rotterdam, the Netherlands), Julie Bargmann / D.I.R.T. Studio (Charlottesville, Virginia), Michael Maltzan Architecture, Inc. (Los Angeles), Michael Van Valkenburgh Associates, Inc. (New York), Tom Leader Studio (Berkeley, California), and Weiss/Manfredi Architecture/Landscape/Urbanism (New York). This was a unique list, composed primarily of emerging architects, not the usual list of well-known museum architects. Michael van Valkenburgh was a well-established landscape architect, and Weiss/Manfredi was a firm gaining increasing attention and known for their imaginative work unifying architecture, landscape, and urban infrastructure.

Once the six finalists confirmed their interest (and prior to their public presentations May 8–9,

2001), we made a whirlwind trip from February 15 to 22, 2001, to visit each finalist.[24] We used our initial stop in Washington, D.C., to advantage, pursuing federal funding for the park with members of our State of Washington congressional delegation, including Senator Maria Cantwell, as well as staff members of Senator Patty Murray and Representatives Jim McDermott and Norm Dicks. Our purpose was to ask for $1 million in Housing and Urban Development funds for park site development and $2 million in transportation funds for the development of the Alaskan Way. They promised help, but also advised us to build bipartisan support from Republicans such as Washington Representative Jennifer Dunn. Despite Iowa Senator Chuck Grassley citing Patty Murray's support of the park project as "pork," federal funds for the project eventually amounted to $4,844,647.[25] With federal dollars added to City of Seattle, King County, and State of Washington support, public funding for the Olympic Sculpture Park totaled almost $21 million.[26] The fact that admission to the park, owned and managed by the Seattle Art Museum, would be free of charge—a rare offering for a nonprofit—helped secure public funds through the Museum Development Authority, thus creating a strong private-public partnership.

At the National Gallery of Art, joined by John Beardsley and Peter Reed, we met with Julie Bargmann of D.I.R.T. Studio. She presented slides of her work, which features reclamation of polluted sites, since we were not able to visit any examples of her work. The remainder of the day we spent exploring the Women in Military Service for America Memorial at Arlington National Cemetery, a stunning project designed by Weiss/Manfredi.

We next flew to Amsterdam to meet urban designer and landscape architect Adriaan Geuze of West 8, visiting his offices and celebrated design work in Amsterdam and Rotterdam, notably the Schouwburgplein (Theater Square, 1991–96), "the traditional town square reinterpreted" above an underground garage and dominated by towering kinetic sculpture recalling the cranes of the port. In the late afternoon, we returned to our hotel by boat along the canals, with memorable views of architecture in the evening light, and the following day we flew to New York City.

In New York we visited two finalists. First, we met with landscape architect Michael van Valkenburgh at his offices and then went to see the Vera List Courtyard (1990–97) at the New School, which he redesigned in collaboration with artist Martin Puryear, who created the three sculpted seating elements. The combination of Puryear's art and nature, in the form of dense maples and pygmy bamboo, was striking. After lunch, we met Marion Weiss and Michael A. Manfredi of Weiss/Manfredi Architecture/Landscape/Urbanism at their offices and were impressed by their energy and intelligence, the manageable size of the firm, and their innovative realized projects. As Jon Shirley noted, "We arrived in Seattle feeling it was a worthwhile trip."[27] Subsequently, on February 27, 2001, we traveled briefly to visit the rising Los Angeles architect Michael Maltzan and see built projects he designed. Maltzan had worked in Frank Gehry's office and later designed MoMA Queens and the Hammer Museum, Los Angeles.

Shortly thereafter, reflecting on our travels and discussing the candidates with the full committee, we concluded that, as much as we admired the work of Adriaan Geuze and Julie Bargmann, their two design firms were not a good fit for our project, thus narrowing the competition for lead designer of the Olympic Sculpture Park to four finalists: Tom Leader, Michael Maltzan,

Michael van Valkenburgh, and the team of Marion Weiss and Michael Manfredi. In addition, when Lisa Corrin was appointed SAM's new deputy director for art and Jon and Mary Shirley Curator of Contemporary Art in March 2001, she added the London-based firm Caruso St. John Architects, founded in 1990, known for cultural sector commissions, quality work, and sensitivity to place. Lisa's unbridled enthusiasm and well-conceived artistic vision for the park was invaluable.[28] Although scheduled to start work at SAM in September 2001, Lisa joined the Design Selection Committee on May 8 and 9 for the public presentations and reception, as well as the interviews of the five finalists and final decision-making session.

Anticipation was high on May 8, 2001, as the downtown museum lecture hall filled to capacity, reflecting strong interest among many different stakeholders, from SAM board, staff, museum members, and funders to Belltown neighbors, city officials, artists, environmentalists, park lovers, and the simply curious. The Sculpture Park Committee, including members of the Design Selection Committee, were all in attendance. As requested, within 45 minutes, each of the five finalists introduced their firm and its history; discussed the firm's built projects (no more than 24 slides) and their relevance to the Olympic Sculpture Park project; and articulated their approach to the sculpture park's key design issues, including landscape, urban infrastructure, artistic program for sculpture, park pavilion, and its relationship to the surrounding neighborhood and transportation systems. A moderated 15-minute question-and-answer period followed each presentation, and after the event concluded, SAM hosted a reception to allow stakeholders to meet informally with the architects. The next day, May 9, 2001, the Design Selection Committee conducted interviews with the architects and subsequently voted unanimously in favor of Weiss/Manfredi working with the museum on the creation of the Olympic Sculpture Park, a decision formally approved by the Seattle Art Museum Board of Trustees on June 6, 2001, and publicly announced June 19, 2001. The Olympic Sculpture Park would be the breakthrough project for Weiss/Manfredi, launching this architectural firm into the majors.[29]

## Lead Designers: Marion Weiss and Michael Manfredi

Why did we select Marion Weiss and Michael Manfredi, whose architectural firm Weiss/Manfredi Architecture/Landscape/Urbanism was just twelve years old, and who did not have the well-established reputation and extensive experience of some other finalists? What factors informed our choice?

We were impressed by their ability to come up with innovative design solutions to the challenges posed by each site, each project, and to view challenges as opportunities. Unlike many designers, Marion and Michael are not predisposed to a single aesthetic. Instead, their design process is organic, a response to the unique attributes of a particular site and an effort to maximize its possibilities. The brownfield that was the future Olympic Sculpture Park excited them. Prior to the competition, they made numerous trips to Seattle to experience and listen to the site, research its distinctive history, and explore adjacent sites on the waterfront, particularly the Alaskan Way and Myrtle Edwards Park, always looking for ways of "making infrastructure a seminal design opportunity" (see fig. 3.3).[30] Marion and Michael stood out among the lead designer finalists not only for the freshness of their design work,

FIG. 2.14
PACCAR Pavilion
entry plaza
with Ellsworth
Kelly's *Curve
XXIV* (1981),
2007. Alexander
Calder's *The Eagle*
(1971) is visible in
the background.

including their Z-shaped continuum for the sculpture park (see fig. 3.5), but also for their open-minded thinking, knowledge based on thorough research, and unrelenting commitment to transforming this last parcel of downtown Seattle waterfront into a one-of-a kind sculpture park. Speaking of their innovative Z-shaped design concept for Seattle's sculpture park, which they featured at the competition, Michael Manfredi stated, "For us, our proposal was a love letter to Seattle."[31]

At the time we selected a designer in late spring 2001, Weiss/Manfredi's built projects included two public facilities: Olympia Fields Park (1994), Olympia Fields, Illinois; and most importantly, the Women's Memorial and Education Center (1997), Arlington, Virginia, a hybrid architecture and landscape project that was fresh in the minds of members of the Design Selection Committee from our recent visit and had left a strong positive impression. In addition, the Museum of the Earth, Ithaca, New York, and the Smith College Campus Center, Northampton, Massachusetts, were both under construction in 2001.

Landscape and environmental concerns are an integral part of Weiss/Manfredi's architectural practice, as demonstrated by the Museum of the Earth, where sculpted land around its entry plaza conceals and channels groundwater. Similarly, in Seattle, Weiss/Manfredi integrated native plants and sculpted soil to create natural drainage on the Olympic Sculpture Park site, reestablishing a landscape progression from upland to shoreline in four distinct precincts: valley, grove, meadows, and shore (see pp. 136–37). Weiss/Manfredi worked closely with Charles Anderson Landscape Architecture on the planting plan and selection of 80,000 native plants that comprise the distinct landscape precincts.

Consciously maintaining a midsize firm, Marion and Michael were and are rigorously selective about the projects they undertake in order to maintain an intensive focus on each commission, rather than overextend themselves and their staff. They are also naturally good listeners, modest and collaborative. We were searching for lead designers with whom everyone could work effectively, who could build and lead

a multidisciplinary team of experts to construct the park, a complex project.[32] In addition, we knew that partnering with artists on installations and their placement would be key—as proved by Weiss/Manfredi's successful collaboration on permanent infrastructure works of art for the park such as Mark Dion's *Neukom Vivarium* (2004–6, see figs. 5.1–3) and Teresita Fernández's *Seattle Cloud Cover* (2004–6, see figs. 5.4–6).[33] Moreover, the dynamic Z-shaped design that joins the three parcels of the sculpture park into a continuous landscape accommodates a wide range of artistic expression (see pp. 14–15). As sculpture park visitors progress down pathways, they catch glimpses of works of art that lie ahead, an experience Marion Weiss, during construction, often likened to lingerie, which seduces with a peek rather than full revelation (fig. 2.14).

With cross-discipline expertise in architecture, landscape architecture, and urban design, Weiss/Manfredi's practice exemplified the criteria listed in our request for qualification: design excellence and appropriateness for the Olympic Sculpture Park project; ability to design a suitable setting for a broad range of outdoor sculpture; experience completing built projects of similar scale, complexity, and budget; experience designing landscape projects, especially parks and public facilities; proven ability to work collaboratively with a broad design and construction team; and ability to work with public and private stakeholders in a high-profile environment. Weiss/Manfredi not only satisfied all criteria listed in our RFQ, but by 2001, their work had also begun to

garner a host of awards. The unqualified success of the built Olympic Sculpture Park affirms the brilliant choice of this talented duo as lead designers (see Awards list, p. 177).[34]

In early November of 2007, when New York Mayor Michael Bloomberg was in Seattle for a climate conference, he visited the recently completed Olympic Sculpture Park, staying longer than expected (fig. 2.15). While crossing over the railroad tracks under Teresita Fernández's luminous work, Mayor Bloomberg looked out over the park, declaring to Maryann Jordan, Chris Rogers, and me, "New York City needs one of these."[35]

## Surmounting Unanticipated Challenges

Why was the Olympic Sculpture Park completed only in 2007 and not in 2004, as initially planned? How did we turn obstacles into opportunities? The solidarity of the team, our determination, and our creativity were constantly tested. Hurdles, too many to count and many unforeseen, popped up, one after another. Nevertheless, we persevered, we were nimble, we never wavered. I will briefly mention only three major unanticipated challenges, among the many we faced.

The Nisqually earthquake, magnitude 6.8, occurred on February 28, 2001, at 10:54:32, its epicenter located in the southern Puget Sound. Earthquake damage to the aging Alaskan Way aerial viaduct structure and the Seattle seawall necessitated replacement and triggered lengthy debate. The Olympic Sculpture Park project was put on hold as the City of Seattle, King County, and the State of Washington conducted a replacement study. Because locating a tunnel directly under the sculpture park was one of three alternatives for viaduct replacement being considered by the city/state team of engineers, the Seattle Art Museum staff and Weiss/Manfredi worked

patiently with public agencies on a mutually acceptable plan. Remarkably, Marion Weiss and Michael Manfredi were willing to consider potential design changes if the tunnel option was chosen. Months elapsed. On May 22, 2002, the *Seattle Post-Intelligencer*'s editorial board published an article titled "Get Going on Sculpture Park," applauding the design, noting high public enthusiasm, and pointing out that the biggest hang-ups of ambitious projects occur when private meets public in terms of transportation infrastructure. Their conclusion: "Build it now!"[36]

To ensure that SAM's interests were well represented in public planning, Chris Rogers hired an engineering and urban design consultant to gather information and independently evaluate the city's and state's viaduct replacement feasibility studies and the plan for a truck tunnel beneath the sculpture park. As a result of our consultant's evaluations, SAM informed the city and state planning team of the estimated costs of tunneling under the sculpture park site and the engineering requirements for the park's construction to enable tunnel excavation after the park opened. Finally, in September 2003, based on the price tag of hundreds of millions of dollars and the uncertain timeline, city and state engineers abandoned plans for a tunnel under the park, freeing SAM to move ahead with the Weiss/Manfredi design as originally conceived. We had, however, lost almost eighteen months while the tunnel was being debated.

A second major challenge that confronted us was the necessary replacement of the seawall and restoration of the shoreline, a prime example of turning a daunting problem into an opportunity to improve the water's edge for people and for sea life—especially salmon—in an urban

context.[37] When the city informed us it would cost an astronomical $50–80 million to repair the ten percent of the seawall we owned on tidelands in front of the future sculpture park, Chris Rogers, representing the museum, independently contracted with aquatic engineering consultant Anchor QEA, environmental consultant Aspect Consulting, and geotechnical engineering consultant Hart Crowser. We also expressed to them our interest in habitat restoration. This team of consultants came up with an ingenious, cost-effective solution: in-water buttresses and a large habitat bench that would stabilize the weakened seawall (see figs. 6.5–6). This environmental design, together with the excavation of a small pocket beach that softens the shoreline, cost only $5.5 million and was funded largely with federal dollars thanks to Washington Senator Maria Cantwell and Representative Norm Dicks.

Yet another challenge was the removal of the trolley barn on the park site, a maintenance facility for the vintage Waterfront Streetcar that was not operating at the time due to construction along the waterfront. The intense wave of negative publicity this process created caught the museum off guard. The Alaskan Way right-of-way, now an integral part of the sculpture park, was the northern terminus of the trolley service operated by King County, and County Executive Ron Sims had publicly promised to move the trolley barn, which obstructed views of the waterfront and was not compatible with the Olympic Sculpture Park's design. The Seattle Art Museum viewed the trolley line as an important public transportation link to the park, planned a trolley stop at Broad Street and Alaskan Way, and supported relocation of the maintenance facility; however, politicians disagreed about where to

FIG. 2.16
David Horsey,
"Olympic
Sculpture Park,
2007," *Seattle
Post-Intelligencer*,
March 16, 2005.

FIG. 2.17
Sellen Con-
struction team
members watch
as a mother duck
and her brood
cross the BNSF
Railroad to the
new beach,
May 5, 2005.

relocate it, and the costs of relocation proved
prohibitive. Without consulting the museum, the
county hired a design team to redesign the park
to accommodate the trolley barn in situ and
unveiled it to SAM, which soundly rejected the
proposal.[38] Subsequently, when the trolley barn
was demolished, passionate pro-trolley ire was
directed at the museum, which was unfairly
blamed for shutting down Waterfront Streetcar
service (fig. 2.16).[39]

On a more charming note, we faced another
unexpected delay in spring 2005 when, under
the cover of night, a mother duck used mixed
construction debris and twigs to make her nest
on the site. After contacting the National Audubon
Society for advice, Chris Rogers halted construc-
tion in the area of the nest for twenty-eight days
until the ducklings hatched and were old enough
to process to the new beach at water's edge.
Sellen Construction workers and Chris led
mother duck and her brood across the railroad
tracks, forcing a Burlington Northern train to
halt and make way for ducklings (fig. 2.17).[40]
Throughout construction of the Olympic Sculp-
ture Park, no matter how large—or tiny—the
challenge that confronted us, we maintained
our passion (and compassion), positivism,
and determination to see the project through
to completion.

## Downtown Museum Expansion, Transformation of SAM Campaign, and Cost of the Olympic Sculpture Park

The Olympic Sculpture Park would have been a
lighter lift if the Seattle Art Museum had not
undertaken multiple capital projects simultane-
ously—something museums rarely do. But in
2001, we seized an opportunity to expand the
downtown museum (and even aspired to renovate
the historic 1933 museum building in Volunteer
Park, a project completed almost two decades
later).[41] The 118,000-square-foot expansion of
the downtown Seattle Art Museum, designed by
architect Brad Cloepfil, was completed in June
2007.[42] Due to financial concerns, the museum's
Robert Venturi building, located in the heart of
downtown and opened in 1991, had been scaled
back from its original plan. Now, in the twenty-first
century, additional gallery space was essential if
Seattle collectors, whose numbers and activity
had increased dramatically in the last decades of
the twentieth century, were to gift major works art
to the museum. Other prominent national and
international art museums had already started to
cherry-pick private art collections in Seattle.
Therefore, in 2001, when Washington Mutual Bank
proposed a joint construction project on our
downtown block, the museum opted to build
boldly for the future.

Jon Shirley, chair of the Board of Trustees (2001–2008); Susan Brotman, president (2000–2007);[43] and I, SAM director (1994–2009), made a pact that we would remain in our leadership positions at the museum through completion of the sculpture park and downtown expansion. Once both were finished and open in 2007, we staggered our departures. Thus, we provided stability and continuity of leadership for the duration of the capital projects. In keeping with our slogan, "We are all in this together," the SAM staff was equally dedicated and worked well together and with board and community members to achieve these twin ambitious goals—most importantly, an art park free to all. Our motivated, intelligent team—museum staff (many of whom I had had the pleasure to hire) and board as well as community members like our docents—was unbeatable. For example, Robert Cundall, chief financial officer and later chief operating officer, is a smart, analytical thinker capable of managing complex financial and operational projects. Bob reflects the deep pool of talent on which we could draw to ensure our success.

To streamline fundraising, the Seattle Art Museum combined both capital projects into a single campaign, the Transformation of SAM, which garnered over 10,000 donors—many first-time museum supporters—and raised over $227 million by the time of its completion in 2007, a fundraising record for a cultural nonprofit institution in the Pacific Northwest. The mastermind of the museum's ambitious campaign was Maryann Jordan, assisted externally by Susan Brotman and internally by campaign director Jennifer Aydelott. Maryann was a dynamic force, creatively managing and motivating staff and inspiring trustees and the community with her intelligence, boundless energy, and positivism.

As board president, Susan Brotman devoted a staggering amount of time to fundraising from individuals and foundations, as well as encouraging staff and communicating with trustees, while Jon Shirley led public funding efforts and kept an eagle eye on capital projects, their budgets, and schedules. They complemented one another, and me, perfectly.

Our strategy for the Seattle Art Museum was two-pronged: to raise the significant funds needed to realize the two projects, and—equally important—to build broad-based community ownership of SAM: one museum, three sites. This message of One Museum, Three Sites, a museum that connects art to life, was featured on an inspirational short video titled *I AM SAM*, narrated by actor and Seattleite Tom Skerritt. We played the video at every opportunity, at every event, over and over, prior to the opening of both projects in the first half of 2007. In addition to direct-mail funding requests, a host of creative and fun entertaining events in Seattle (fig. 2.18) and beyond reached out to a broad, rapidly growing community base, producing campaign donations and building museum membership from the bottom up.[44] In 2004, the campaign goal supporting the expansion and the park increased from $150 million to $180 million, adding $30 million for special projects and restricted gifts, including funding for the seawall and the park's artistic program. Of the remarkable $227 million total raised, $85 million were earmarked for the Olympic Sculpture Park project: $20 million for land (Unocal site and 10 Broad Street), $5 million for environmental cleanup, and $40 million for construction/infrastructure, plus a $20 million endowment for park maintenance.

Missing from this breakdown are the costs associated with works of art and exhibitions in

the park. As Lisa Corrin notes in her essay, at the outset of the twenty-first century, the Seattle Art Museum possessed very few outdoor sculptures; however, Seattle collectors generously donated major works of art, asking Lisa to select those that she wished for the museum's waterfront sculpture park.[45] Because most of the sculpture was gifted to the museum, the initial art budget (approximately $12 million) was modest by comparison to that of many other sculpture parks. Most art costs were associated either with the purchase and installation of Richard Serra's monumental *Wake* (2002–3; see fig. 4.5) or with commissioned infrastructural artworks that are integral to the sculpture park.[46] Creating endowments for future art acquisitions, temporary exhibitions, and art conservation specifically for the park, where artworks are daily exposed to

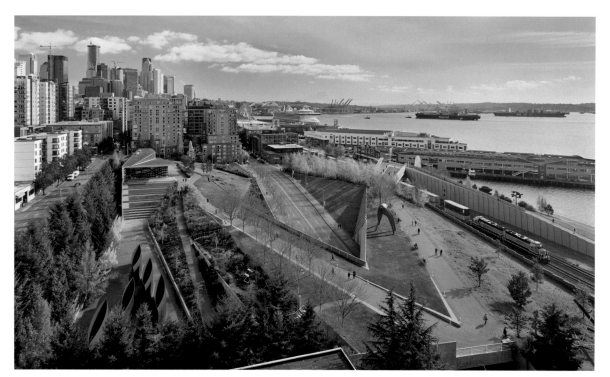

FIG. 2.19
Aerial view of
the Olympic
Sculpture Park,
fall 2020.

briny Seattle weather, remains an important goal
for the future.

## Conclusion

Raymond W. Gastil begins his 2002 book on
the New York City shoreline by observing, "The
waterfront calls for an open mind." It is a call that
Seattle's Olympic Sculpture Park both responds to
and extends, as Gastil notes: "From Barcelona to
Seattle, there is increasing evidence that spectac-
ularly creative talents can join with a city's com-
munities and leadership to redesign and renew its
public realm, from the scale of the sidewalk to the
scale of the region. Architecture and design, in
those cities, is seen as a valid cultural expression,
integral to a city's experience and growth."[47]
The synchronicity of propitious timing, visionary
leadership, powerful partnerships, broad-minded
civic philanthropy, strong civic will, and collective
openmindedness accounts for the creation of
the Olympic Sculpture Park. No doubt, the
innovative design by Marion Weiss and Michael
Manfredi was instrumental in galvanizing the
community and realizing our vision.

The ownership of the park by a major cultural
nonprofit, the Seattle Art Museum, a condition
of the Jon and Mary Shirley's landmark gift to
endow the park's operations, ensured that the
museum was and will remain the park's driving
force. Rising to the Shirleys' challenge, many
of the museum's trustees in the late 1990s and
first decade of the twenty-first century gave
generously of abundant financial resources.
Equally important, the museum's leadership, its
Board of Trustees, and staff were all strong, able,
and committed to realizing the promise of the
Olympic Sculpture Park.[48]

In addition, the museum's trustees, especially
the leadership, dedicated substantial time and
expertise to oversight of SAM's two simultaneous
capital projects and to fundraising, both private
and public. In SAM's record-setting capital
campaign, most financial support came from
private individuals; however, public funding
accounted for one tenth of the $227 million total,
an impressive sum. Public funds were instrumen-
tal in providing the resources needed for the
environmental cleanup, design, and construction

of the park, and for its salmon-friendly shoreline restoration. And think of the contributions of major works of art—outdoor sculpture donated by collectors, artists, and those passionate about the park and its collection.

Our lucky stars were aligned. The powerful partnership between the Seattle Art Museum and the Trust for Public Land, as well as with the City of Seattle under the leadership of Mayor Paul Schell, enabled the magical transformation of the last parcel of undeveloped downtown waterfront, a dreary brownfield, into an expansive, people-friendly green space where plants, wildlife, and creativity thrive (fig. 2.19). Unfenced and open, the Olympic Sculpture Park offers the surprise and joy of great art while capturing the youthful character and natural beauty of Seattle and the Pacific Northwest, encouraging everyone to slow down, breathe, and dip their toes in the water.

## Notes

Epigraph: Churchill's original statement, paraphrased above, reads: "We shape our buildings, and afterwards our buildings shape us." Winston Churchill, address to the House of Commons, October 28, 1943, cited in Fred R. Shapiro, *The Yale Book of Quotations* (New Haven, CT: Yale University Press, 2006), 154.

1. Jon Shirley was not yet on the Board of Trustees of the Seattle Art Museum. Subsequently, after joining the board in 1997, he became vice president in 2000 and was elected board chair 2001–8. During his tenure as chair, we simultaneously completed two capital projects: expanding the downtown museum and building the waterfront Olympic Sculpture Park.

2. See Sarah Clark-Langager, "The Outdoor Sculpture Collection: The Development of Public Art at Western," in *Perspectives on Excellence: A Century of Teaching and Learning at Western Washington University*, ed. Ronald L. De Lorme with Steven W. Inge (Bellingham, WA: Center for Pacific Northwest Studies, 2000), 99–147; and "Decades of Giving: Virginia Wright and Sculpture at Western," exhibition listing, 2000, Western Washington University website, http://westerngallery.wwu.edu/decades-giving-virginia-wright-and-sculpture-western.

3. Robert Warren, manager; Nnamdi Madakor, project manager; and other members of Ecology's Voluntary Cleanup Program team championed the project and expedited this complicated process.

4. News of the project first appeared in the *Puget Sound Business Journal*, February 1, 1999.

5. The Trust for Public Land had contracted an independent appraisal that valued the Unocal property at $25 million.

6. In addition to the $16.5 million to Unocal to cover the land purchase, purchase costs also included $500,000 for our transactional expenses, such as legal and environmental due-diligence fees, which the Trust for Public Land had generously paid up front.

7. Published in March 1999 following the public announcement, this first brochure, a four-fold color publication, was made possible by the support of Airborne Express.

8. Other essential partners at the Trust for Public Land included Will Rogers, president; Tom Tyner, attorney in the organization's Seattle office; Marty Rosen, former president; Craig Lee, Northwest director; and national board members Douglass Raff and Jerry Tone.

9. The Belltown neighborhood council, including Gretchen Apgar, president of the Denny Hill Association; Zander Batchelder, president of the Belltown Community Council; Mel Jackson, president of the Belltown Business Association; and Tom Graff, president of the Downtown District Association, enthusiastically supported the project.

10. The $3.56 million to purchase the 10 Broad Street property included a $2 million appropriation from the Seattle City Council, $1 million from the King County Council's Conservation Futures Fund, a $500,000 Federal Economic Development Grant, and $60,000 from private supporters.

11. Seattle City Council member Jan Drago, quoted in Linda Williams, "City Council Approves Acquisitions of Olympic Sculpture Park Property," Seattle Art Museum press release, March 27, 2002.

12. The George Benson Waterfront Streetcar Line maintenance facility served as the northern terminus for the streetcar operated by King County. The vintage streetcar traveled between tourist destinations along

the waterfront and served Pioneer Square and the Chinatown-International District.

13. Myrtle Edwards Park (formerly part of Elliott Bay Park; rededicated in 1976) occupies 4.8 acres; Centennial Park (formerly part of Elliott Bay Park; rededicated by the Port of Seattle in 2011 for the port's hundredth anniversary), 11 acres; and the Olympic Sculpture Park, 9 acres (excluding its .5-acre tidelands).

14. Seattle Hempfest, which advocates for the decriminalization of cannabis, is held annually at the city's Myrtle Edwards Park, adjacent to the northern edge of the Olympic Sculpture Park. (Seattle Hempfest 2020, the festival's twenty-ninth year, moved exclusively online due to the COVID-19 pandemic.)

15. The Project for Public Spaces worked on Bryant Park, behind the New York Public Library.

16. The orange-red chairs resonate with the orange-red of Alexander Calder's *Eagle*; however, we initially chose these chairs to echo the color of the industrial cranes in the Port of Seattle, visible to the south from the park, which load and unload cargo on ships and barges.

17. Jon and Mary Shirley generously donated the funds to purchase Calder's *The Eagle* for the Olympic Sculpture Park as a gift

to commemorate SAM's seventy-fifth anniversary. Seattle Art Museum press release, July 18, 2000.

18. Maria Barrientos and her staff, including John Schwartz, were particularly critical in project management, budgeting, and scheduling.

19. The Design Selection Committee, formed June 27, 2000, consisted of Mimi Gardner Gates (chair), SAM trustees and art collectors Jon Shirley (SAM board chair), Susan Brotman (SAM board president), Charles Wright, Virginia Wright, and Ann Wyckoff; Ken Bounds (City of Seattle superintendent of Department of Parks and Recreation); artist Gerry Tsutakawa; and two outside specialists, John Beardsley, noted author and professor of landscape architecture at Harvard University's Graduate School of Design, and Peter Reed, then curator of architecture and design, Museum of Modern Art, New York. Additional SAM staff members on the committee included Chiyo Ishikawa, curator of European painting and sculpture, and Chris Rogers, project manager. In March 2001, when Lisa Corrin was hired as deputy director of art and Shirley Curator of Contemporary Art, she joined the panel.

20. Bill Ivey, quoted in Linda Williams, Seattle Art Museum press release, August 31, 2000.

21. Mimi Gardner Gates, quoted in Linda Williams, Seattle Art Museum press release, August 31, 2000.

22. I had met Gail Dorn when, in 1999, Bill Gates Sr. was the speaker at The Minneapolis Meeting, a bipartisan speaker series sponsored by Minnesota Public Radio.

23. As Marion Weiss notes in this volume, "In many ways one of the most important aspects of the competition brief was that the museum acknowledged that they didn't know if the right design lead should be an architect, a landscape architect, or an artist; this was a pretty unprecedented approach." See "Design Vision for the Olympic Sculpture Park" in this volume, 86.

24. Design committee members Jon Shirley, Gerry Tsutakawa, Virginia Wright, Ann Wyckoff, Mimi Gardner Gates, and Chris Rogers took part in this trip. Jon's wife, Mary Shirley, also joined.

25. This total includes $3,859,360 in US Housing and Urban Development grants and $985,287 in United States Interior / Fish and Wildlife Services funding.

26. Public funding came from the City of Seattle ($6 million), King County ($1.7 million), the State of Washington ($8.1 million), and nearly $5 million in

support from the US federal government.

27. Jon Shirley, unpublished notes, 2001.

28. Lisa Corrin deserves credit for the artistic vision for the park. In 2005, she left Seattle to assume the directorship of the Williams College Museum of Art, Williamstown, Massachusetts. After Lisa's departure, Renée Devine, art program director, together with the museum's exhibition designer, Michael McCafferty, oversaw the realization of the commissioned infrastructure projects and the installation of sculpture throughout the park.

29. In 1997, the Architectural League of New York had selected Weiss/Manfredi Architecture/Landscape/Urbanism as one of "six critical emerging practices" in North America. The success of the Olympic Sculpture Park won them international acclaim.

30. Marion Weiss, in "Design Vision," 82.

31. Michael Manfredi, in "Design Vision," 76.

32. Owen Richards Architects acted as the Seattle-based architectural site representative, and Sellen Construction was the general contractor. See also Olympic Sculpture Park Project Credits, p. 187.

33. For more on artist collaborations on park

infrastructure elements, see Lisa Graziose Corrin's essay in this volume, "Art for 'a Park Like No Other.'"

34. The extensive list of Olympic Sculpture Park awards in this volume (see p. 177) testifies to their success.

35. The High Line, a different type of urban park, was under development in New York at the time.

36. Editorial Board, "Get Going on Sculpture Park," *Seattle Post-Intelligencer*, May 22, 2002.

37. For more on the park's relationship to the natural environment, see Lynda V. Mapes's essay in this volume, "Resurgence: Land and Water, Reimagined and Reborn."

38. This was only one of many outrageous ideas proposed during the project. One of the wildest was the idea of locating a new Seattle Aquarium building on the sculpture park site and placing "statues" on the roof.

39. Waterfront Streetcar service was ultimately suspended due to the costs of relocating the maintenance barn, as well as the closure of the line required during the Alaskan Way Viaduct removal and seawall replacement work for the Waterfront Seattle project in the coming decades.

40. "Milestones on the Rocky Road to a Waterfront Park," *Seattle Post Intelligencer*, January 18, 2007.

41. The renovation of the Volunteer Park building known as the Asian Art Museum, owned by the City of Seattle and leased by the Seattle Art Museum, was planned but would take place at a later date; it reopened February 7, 2020, just prior to the COVID-19 pandemic.

42. Seattle Art Museum, *Seattle Art Museum Downtown* (Seattle: Seattle Art Museum, 2007). The downtown museum reopened May 5, 2007, with a total of 268,000 square feet of museum space, including a 118,000-square-foot addition to the old Venturi building. Within the new 450,000-square-foot WAMU Tower building, SAM had 300,000 square feet.

43. Susan Brotman was the first of our group to proclaim, "We are all in this together," and the slogan stuck. Today, those words are painted on the entrance wall of the downtown Seattle Art Museum.

44. The Community Campaign was crucial to achieving SAM's financial and community support goals. Tasked with fundraising, and with cultivating community involvement, diversity, and visibility, cochairs Maggie Walker, José Gaitan, Assunta Ng, Constance Rice, and Brad Davis provided valuable input. Each cochair worked directly with SAM staff to assess and advise on the best combination of methods to reach and respond to a broad range of audiences. Donors to the campaign between $1,000 and $9,999 are eligible for permanent recognition on the Olympic Outlook, the etched steel railing along the waterfront of the Olympic Sculpture Park.

45. Although the local press was initially critical of the fact that the museum did not have a collection of outdoor sculpture at the outset of the project, we were confident that Seattle private collectors devoted to SAM would gift major works—which they did. Together, the Bagley and Virginia Wright Foundation and Jon and Mary Shirley donated or loaned eight works to the park, not including their contributions of funds toward the purchase of works by Calder and Serra. The park also attracted other significant works, such as Tony Smith's *Stinger* (1967–68/1999), along with funding to purchase Richard Serra's *Wake* (2002–3). A gift from Ernest Stuart Smailes's estate allowed SAM to commission the fountain by Louise Bourgeois (completed in 2005), who then gave a set of her *Eye Benches* (1996–97). Roy McMakin donated *Bench* (2004), a whimsical grouping of seating elements. We can hypothesize that the absence of a sculpture collection left the architects and curator free to exercise their expertise creatively, to respond to the site and to Seattle, in the choice of artwork and design of the Olympic Sculpture Park. Far from being a constraint, the absence of an established collection of sculpture was an opportunity.

46. The temporary installations in the pavilion, where a suite of works by a single artist is installed annually or biannually, are supported by separate funds.

47. Raymond W. Gastil, *Beyond the Edge: New York's Waterfront* (New York: Princeton Architectural Press, 2002), 19 and 27. See especially Gastil's chapter titled "Seattle Waterfront: Urban Art and Environmental Science in the Olympic Sculpture Park," 175–78.

48. The extraordinary SAM staff was critical to our success. Maryann Jordan, senior deputy director and head of external affairs; Robert Cundall, chief operating and financial officer; and Chiyo Ishikawa, deputy director for art, among many other talented staff, contributed to all aspects of the Olympic Sculpture Park project as well as the 2007 expansion of the downtown museum.

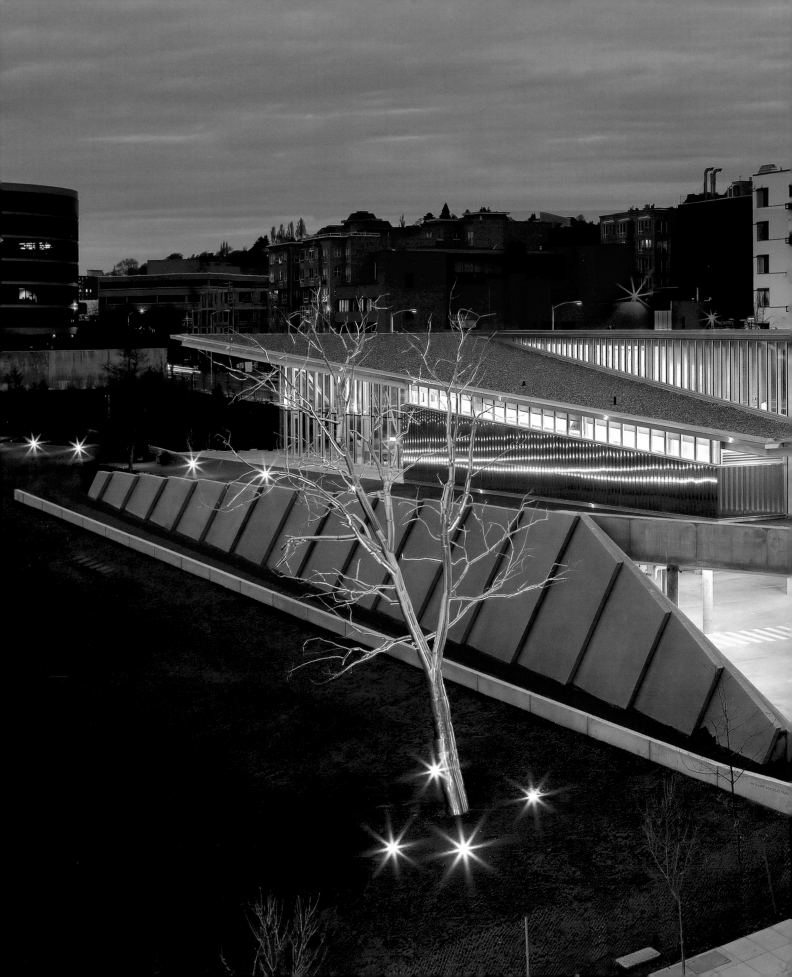

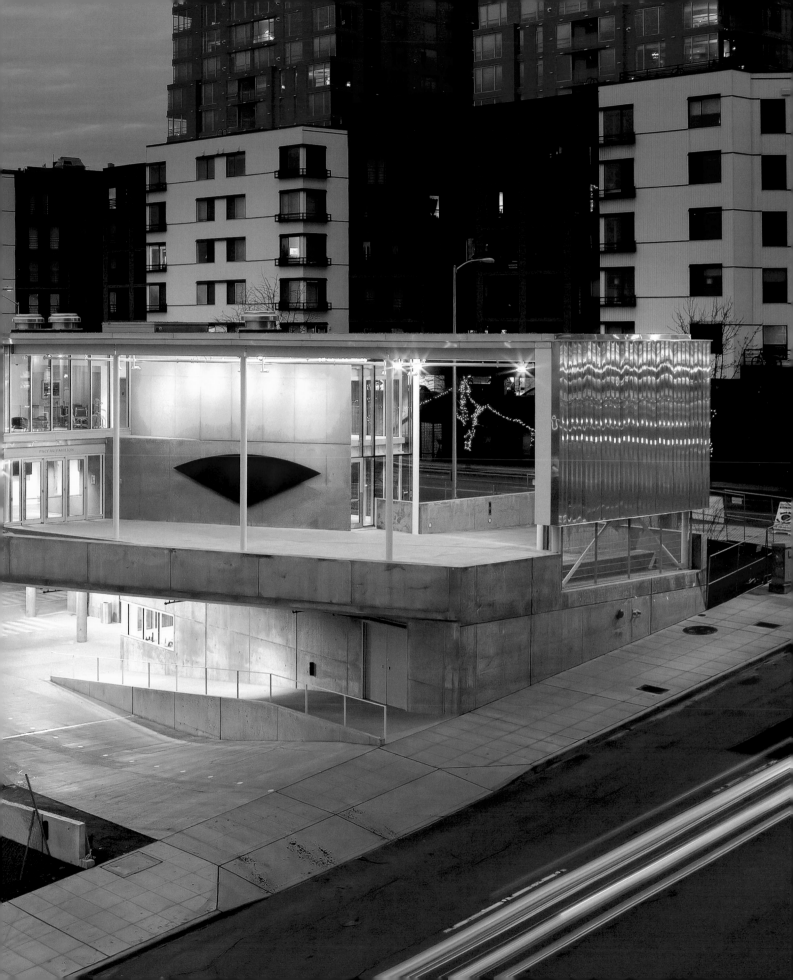

# Design Vision
for the Olympic
Sculpture Park

Marion Weiss and
Michael A. Manfredi
in conversation with
Peter Reed

*This is an edited transcript of interviews conducted at the studio of Weiss/Manfredi Architecture/Landscape/Urbanism in New York City on January 6 and 26 and July 28, 2019.*

**Peter Reed**   It has been a little more than a decade since the Olympic Sculpture Park opened and nearly two decades since Weiss/Manfredi was awarded the commission to design the park. The project has been critically acclaimed. I'm interested in the designers' perspective today. When you reflect on the park, what stands out for you?

**Marion Weiss**   Michael and I both teach graduate design studios, and what we never anticipated is how often the Olympic Sculpture Park has been used as a case study in universities all over the world. Our office has received requests for drawings from programs in Asia, Europe, South America, and Mexico.

**Michael A. Manfredi**   For the last five years, I've taught urban design at Harvard University, and the Olympic Sculpture Park has consistently been one of the thirty case studies that's assigned in both urban design and landscape studies—a canon that extends back to the fifteenth and sixteenth centuries and spans different continents. It has

emerged as a twenty-first century project that, by hybridizing architecture, landscape, and infrastructures, has become an essential touchstone when teaching urban design (figs. 3.1–2).

**REED**   What about the park makes it so relevant to the "canon" and the profession?

**MANFREDI**   Put simply, with the Olympic Sculpture Park, Seattle became a poster child for creating a hybrid urban project—a degraded, orphaned site that in its new life and remaking involved landscape, infrastructure, architecture, art, ecology, and the creation of a public realm. In fact, the park was the first North American project to receive the international Veronica Rudge Green Prize, an urban design award given to one project in the world every two years.

**WEISS**   We have PhD students from around the world who have shared their dissertations with us, and whose theories about the park are illuminating, often in distinct contrast to our initial ambitions for the project. For instance, one thesis submitted to the graduate school of National and Applied Science of the Middle East suggested that Weiss/Manfredi conceived of landscape as a structural idea rather than scenic invention. For us it is interesting to understand the terms

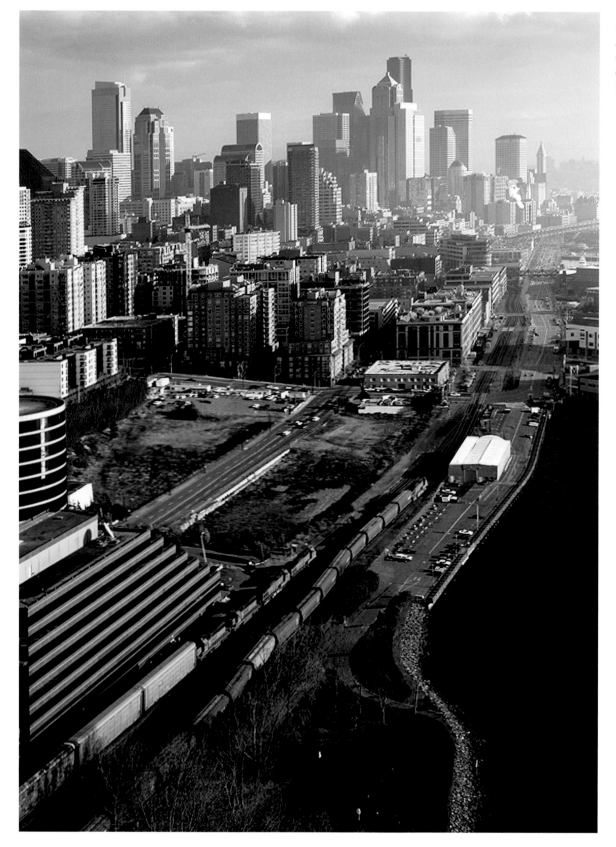

FIG. 3.1
Aerial view of site
conditions before
construction
in 1999.

FIG. 3.2
Aerial view of site
after completion
of construction
in 2007, with train
added for scale.

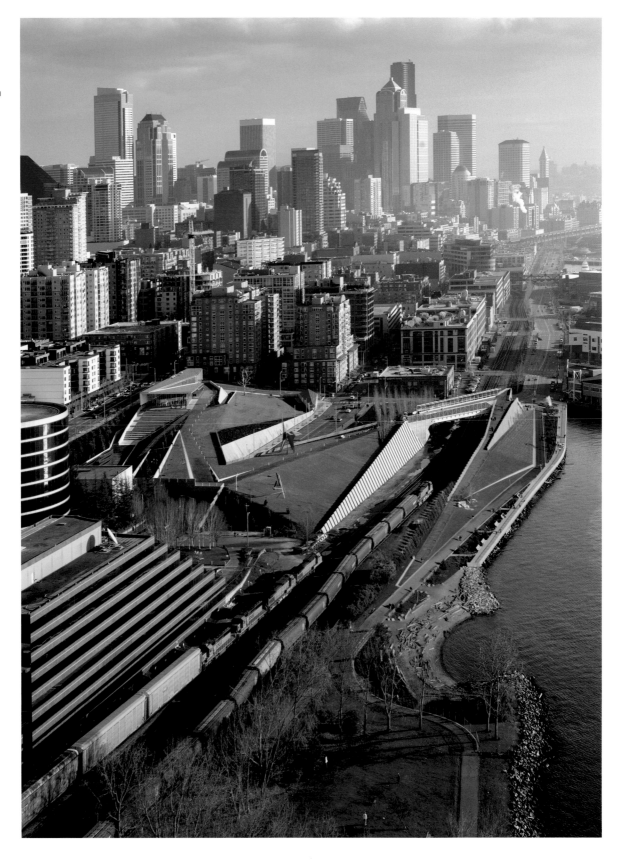

DESIGN VISION FOR THE OLYMPIC SCULPTURE PARK

and conditions utilized to describe our design approach.

REED     While the park has captured global attention and relevance, how did the site itself and the city of Seattle inform your design?

MANFREDI     Seattle itself was our muse during the competition. You could sense its ambition, as a young city in an incredible waterfront setting, to grow by building on its reputation as a center for emerging technologies and environmental concerns. And for the Seattle Art Museum (SAM) to site the park right in the city and on a brownfield, bisected by a highway and train tracks, was incredibly bold and unprecedented; it took courage, vision, and entailed a fair amount of risk on the part of the museum. That boldness was inspirational to us.

WEISS     The original brief reflected a lot of Seattle's preoccupations with ecology, with the identity of the Pacific Northwest, and it spoke to those values, suggesting that the water's edge was something central to their thinking. But it was the specificity of the site in the city that seemed so important. That's where we dug into the whole evolution of this site, which was, in fact, an invented site, a landfill site, created by the Denny Regrade nearly a century ago (see fig. 1.7).

REED     How did the site's history inform your thinking? As I recall, when you first presented your ideas in Seattle, you shared your research about the site, but you also had to present a vision for what the place could become.

MANFREDI     We spent a great deal of time investigating the geology and geography of the

region, the evolution of the city, and the opportunity of interweaving art and landscape. What inspired us also was Seattle's historic and innovative public art program. For us, our proposal was a love letter to Seattle. That's what resonated: the sense that the site's infrastructure was a rare opportunity, a gift, not something to be concealed, destroyed, or radically altered.

Our research included diagrams and notations about creating programs that were about the arts and how architecture and landscape should support art in multiple settings. For example, the paths through the park not only offer opportunities to go from one artwork to another but become works of art in themselves. The presence of the waterfront wasn't just a preconceived condition; we imagined that by creatively manipulating the shore of Elliott Bay, it could be put in play as an artwork. We also included a series of images that captured the haptic qualities of this site— the flicker of light on water, the shifting mist, the dynamics of moving trains (fig. 3.3), all the ephemeral qualities that distinguish this site. And our hope was to bring all these different conditions together—

WEISS     —including the fish in the water. We basically said that you can take measure of all these things, but what you cannot quite quantify is the immeasurable haptic qualities of being in nature, with the sight and smells of water, of the contrast of urban speed and the sound of birds, all the things that inform your experience there.

We came to realize that a site such as the Olympic Sculpture Park is not defined solely by its legal boundaries—there are aspects that are much more open ended. We were interested in the park's identity through revealing its vulnerabilities

FIG. 3.3
Pedestrian bridge, with Teresita Fernández's integrated *Seattle Cloud Cover* (2004–6), providing access to the waterfront over the Burlington Northern Santa Fe (BNSF) railroad tracks, 2007.

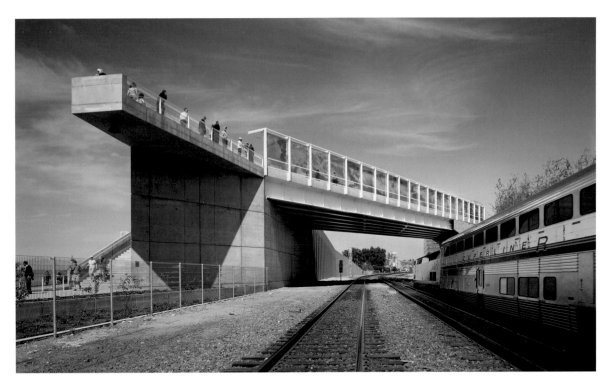

and histories. This illustrates an aspect of our practice that embraces multiple histories and experiences and builds on a site's inherent tensions.

**REED**   The haptic qualities you ascribe to the outdoor site become a particularly interesting dynamic in the park's role as a sculpture park, a place for art. As the design started to take shape, how did you think about the park as an outdoor gallery—as a setting for art? Did your research extend to speaking with artists or studying specific works of art that were likely to be shown at the Olympic Sculpture Park?

**WEISS**   We spoke with a lot of artists, and they all said they didn't want a perfect site, that it didn't need to be flat like a courtyard or the floor of a museum gallery. There was a hunger for a new commission that would be different than anything they had done before. In thinking of how to design for sculpture, our initial expectation was that artists need flat, open sites, but our research contradicted this.

**MANFREDI**   The artists didn't want to be type-cast based on previous work or to have their work defined and situated in predictable ways. There was no interest in us creating neutral plinths or plazas for their art. Instead, a consistent desire emerged to engage the context of the park and its broader location on Puget Sound.

**WEISS**   We were designing for two very different agendas: while there were a few works of art we knew would be in the park, there also needed to be opportunities for newly commissioned art. And the commissioned artworks would relate specifically to elements that might be infrastructural, like Teresita Fernández's transformation of the "throw" fence at the train crossing into a site for art. Each commissioned artist was given a range of opportunities within the site. In fact, it was through a dialogue with Mark Dion that the upturned wedge on our competition drawing inspired his idea for the *Neukom Vivarium* (2004–6, see figs. 4.7–4.8). Our conversation evolved into a collaboration where we developed the design of the wedge-shaped glass greenhouse that now

hosts the sixty-foot-long nurse log that Mark brought from a forest in the Pacific Northwest to support an evolving plant and insect community. The unlikely surprise of this nurse log inhabiting a highly trafficked urban intersection is central to what makes this living sculpture so remarkable.

**MANFREDI**　The museum was also generously supported by collectors who cautioned against placing too much sculpture in the park, to avoid the challenge of congestion typical of so many sculpture parks. I remember them saying that the worst thing we could do is fill this park up with sculpture and leave no space for the future.

**WEISS**　They were very conscious of avoiding the petting zoo paradigm for a sculpture park, with art evenly deployed like a miniature golf course. They were very aware that contemporary works needed room to breathe.

**REED**　What was your strategy to create spaces, or outdoor "rooms," on this empty site in which to situate different kinds of work?

**WEISS**　In a museum building, gallery walls can contain and create distinct experiences for one work and you're not distracted by the proximity of the other works of art. But in the park, the

FIG. 3.4
The valley precinct at night with view of the pavilion and detail of Richard Serra's *Wake* (2002–3), 2007.

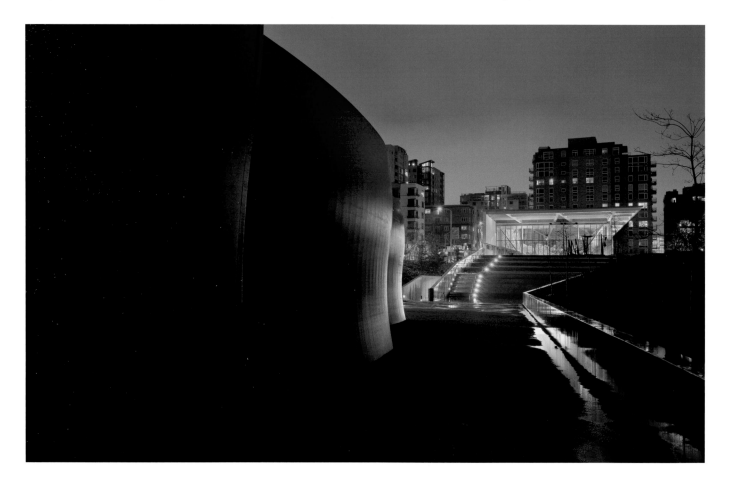

topography and walls became central formal strategies to make sure that one sculpture wouldn't overwhelm the park, but could be experienced independently within valley walls, groves, or hillsides (fig. 3.4).

REED   Was SAM prescriptive with respect to the kinds of spaces it needed in the park? What kind of direction did the client provide?

WEISS   SAM's brief for the project recognized the complexity the three distinct parcels created relative to their goal to create a seamless and connected park, and they were open to a breadth of ideas. While there was a recognition that Elliott Avenue and the railroad tracks needed to be crossed, we feared that the obvious solution of connecting the sites with distinct bridges might risk, no matter how beautifully designed, the creation of three separate parks.

MANFREDI   Exactly. We were convinced that in the end, that approach, at best, would yield three parks and two bridges, yet never produce the coherent and transformative experience that transcended these barriers.

REED   As I recall, there was also an alternative solution, which was to cover the entire site and conceal the tracks and road in order to unify the three parcels. But I think SAM realized that was simply not feasible, nor did they have the budget for that kind of construction.

WEISS   We were not interested in covering the site, which was off the table for economic reasons anyway. We explored the extremes of what it might mean to conceal the infrastructure or to construct three separate parks with the two

bridges. But then the idea of unfolding hybridity emerged for us, with a continuous, bridging landform ultimately emerging as the only solution that made sense. It was robust enough to be manipulated to deal with the forty-foot change of topography while creating a continuous journey from the city down to the water's edge. It was a fair amount of oscillating back and forth between the terror of all the factors that made the site so difficult and searching for something so singular that it could endure all the assaults of grade changes, site contamination, roadways and train tracks, and changing scale and section (figs. 3.5–6).

REED   The challenges of creating a sculpture park out of this unlikely, contaminated site were immense, and yet you found a solution to create a sense of the whole.

MANFREDI   In fact, there were skeptics in the art world who said you could never make a coherent sculpture park out of three separate sites—an observation that challenged us.

WEISS   We viewed the park as a continuum that could begin at Myrtle Edwards Park and wander up to the city or begin at the city and wander to the water's edge. As preoccupied as we were with the ethos of the site, both formally and environmentally, we wanted to take advantage of its urbanity, its vistas, its waterfront status, tactically seeing how we could leverage that grade change so the passage over infrastructure could be accomplished while sustaining the sense of the park as a whole.

What was striking to us, in designing the park, was to consider the inherited ideologies of what a sculpture setting should be. On one hand, you

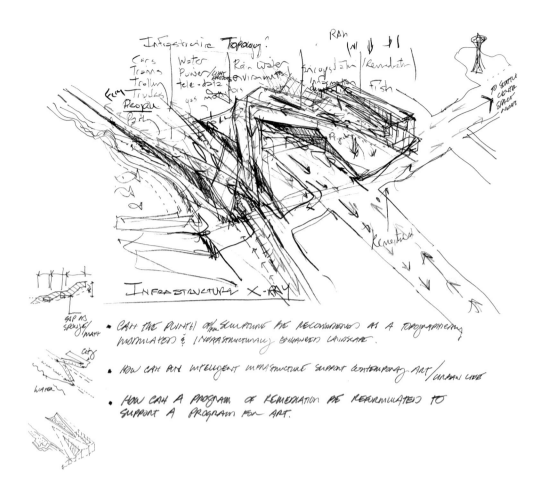

FIG. 3.5
Marion Weiss
and Michael A.
Manfredi, *Olympic
Sculpture Park,
Seattle*, 2001,
colored pencil
and ink on paper,
17 × 17 in. Museum
of Modern Art,
New York, Gift of
the architects,
1727.2012.9.

could think of something as expansive as the Louisiana Museum of Modern Art in Denmark (see fig. 1.9), which is a private home with shared vistas of the water, the horizon, and also sculpture. We were toggling between the kind of bounded definition of a piazza-like garden, such as MoMA's sculpture garden (see fig. 1.8), and preserving a sense of the infinite with the site's extraordinary views of the Olympic mountains.

So, the topographic opportunity of cresting hills and valleys allowed us to create boundaries rather than continuous walls, and yet intermittent walls allowed us to create more intimate settings for smaller works of art. In fact, this topographic strategy also informed the identity of the pavilion, which emerges from the landform to become a light-filled gallery with views of the mountains beyond.

FIG. 3.6
Weiss/Manfredi Architects, conceptual study of the Olympic Sculpture Park site design (hand model of Z-path concept), 2001.

**REED** Was the location of the pavilion predetermined, or were you free to locate it where you wanted?

**MANFREDI** We were free to locate it anywhere, and the southeast corner had advantages. As the most urban corner and at the park's highest elevation, it was a natural location to launch the Z-shaped path that initiates the journey from the city to the water's edge.

**REED** Can you expand on the design of the pavilion and how it relates to the topographic strategy you were developing for the landscape?

**MANFREDI** The topographic strategies that shape the landscape absolutely inform the identity of the pavilion. As part architecture and part landscape, its chameleon form functions as a boundary between these dual identities. As a continuum of the landform, the lower level is constructed with the same system of overlapping concrete walls that structure the topography of the park. The silhouette of the building mirrors the split topography of the park. The roof dips down to create an intimate arrival into the pavilion and then ascends to offer panoramic views of the Olympic Mountains.

**WEISS** The park pavilion is also woven into the urban itinerary, becoming both a portal to the park, a gallery of changing art, and an indoor destination with unparalleled vistas. It rescales the idea of unfolding the site into a more intimate setting, and the tapered forms and sloping elevations of the roofline utilize a strategy of converging perspective to compress or amplify the perception of the scale of the pavilion.

**REED** What informed your thinking about materials for the pavilion?

**WEISS** The folded, mirrored glass and steel reflect the movement and light of the urban surrounding, and together, the park and pavilion seduce visitors into slowing down and submitting to the sensations of the park, the city, and the art.

**REED** So, visitors are likely to enter the park and begin their journey through the pavilion. How did you develop the overall design to become more than a network of pathways?

**MANFREDI** The challenge at the Olympic Sculpture Park was to connect a series of places that were quiet, contained, where one could go "off course," where you could stop and pause and at the same time take in expansive views of the Olympic Mountains. In that sense, topography was the answer because it allowed us to carve discreet precincts for art, to create quiet places along a very public path. Topography, while initially a liability, turned out to be our greatest asset.

**REED** Were there historic precedents that informed your research for non-flat sites?

**MANFREDI** Though it may seem like an unlikely comparison, we did reflect on MoMA's sculpture garden (see fig. 1.8) because it creates a very singular, tranquil setting in the middle of the city. However, we were both predisposed by our own childhoods to appreciate topography. For example, there are several Italian gardens and villas like the Villa Giulia that I visited often as a child, and I never cared whether the garden was primary to the villa or the villa to the garden. In the best examples, Italian gardens and villas are

reciprocal, and together they negotiate topography beautifully. Likewise, the Spanish Steps in Rome, with its syncopated sequence of stairs and landings, is a great essay in how to manipulate topography, and it remains very influential. And Marion was also influenced by the topographic intensity of the hills in California where she grew up.

**WEISS** It's even more than the hills—it's the cultivated landscape and distinctly contoured topography that was influential.

**MANFREDI** This similarity, despite the very different landscapes we grew up with, is probably why we came to our professional relationship and practice together with shared passions.

**WEISS** Some of this was intuitive. My mother was getting her master's degree in geography while I was in high school, and we were surrounded by books, maps, and cultural narratives. What became second nature was an appreciation of how landscapes and sites are forever being made and remade.

**MANFREDI** That's why we were also both drawn to Land Art. Robert Smithson and Michael Heizer, for example, stand out. And, coincidentally, there is a fantastic early work by Michael Heizer on the waterfront adjacent to the sculpture park.

**WEISS** What's interesting to reflect on is that the identity of a site has been the enduring inflection point for our work. The more immense the challenge, the more inspired we feel. I think a lot of architects and landscape architects are looking for that perfect blank slate, a place where it's possible to control everything. Architects often

want to polish the top of the architectural pyramid with a camera-ready form. Instead, we often think that there's something so much larger to tune, to incorporate into design rather than sublimate the site to achieve the iconic architectural object.

And yet, each site is finite, and we wondered how to make one nine-acre site like Seattle's feel more infinite. That's where the strategy of converging perspective and topography together to alter one's perception of the scale determined the geometries of both the pavilion and the overall site design.

**REED** With respect to the evolution of your own thinking and projects that you have worked on, in what ways did the Olympic Sculpture Park represent a turning point for you?

**MANFREDI** The Olympic Sculpture Park provided a very significant and visible platform. Our earlier projects were foundations for our thinking, and the thread of a landscape and infrastructural inquiry that emerged in Seattle already existed. In our early academic work, we taught studios that connected architecture to landscape and to infrastructure. And our first built project was a park with significant infrastructural demands. But Seattle presented us with an opportunity unlike any other to bring all these disciplines together on an incredibly prominent site and with an ambitious art program.

**WEISS** It was a consolidation of all these preoccupations, because we had been fascinated and seduced by the overlooked opportunity intrinsic to infrastructure—that is, making infrastructure a seminal design opportunity. The convergence of all these sensibilities at the Olympic Sculpture Park achieved a newly

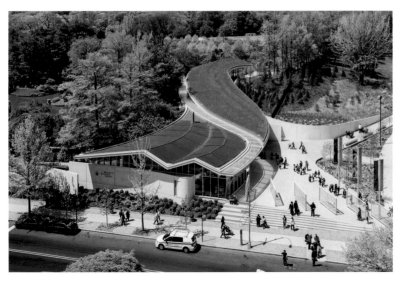

synthetic visibility. This insight informed our design for the Brooklyn Botanic Garden Visitor's Center, which is conceived as a wandering and inhabitable topography that mediates a twenty-foot grade change and the connections between the city and the garden (fig. 3.7).

**REED**  In fact, to reflect more accurately the changes in your work and profession, didn't you change the name of your firm around the time you were designing the Olympic Sculpture Park?

**WEISS**  Right, from Weiss/Manfredi Architects to WEISS/MANFREDI Architecture/Landscape/Urbanism.

**MANFREDI**  We changed the name while we were developing the Olympic Sculpture Park. It did redefine the firm, quite literally—and legally. The lineage of this decision goes back to when Marion and I started working together and won a competition, called the New American Green, to design a twenty-acre park in a small town, Olympia Fields, outside of Chicago in the early 1990s.

It was a competition open to architects, landscape architects, and artists, and there were no requirements in terms of specific disciplines, so we just jumped in. I think from that moment on we realized that our interest in the nexus of

architecture and landscape was broader than that of many of our peers. Because of the scale of the project, and because all the consultants were essentially under our aegis legally, we began to think about how our firm could be structured in a much more specific way to handle projects like this. Rather than just aspirational, the change became organizational.

This change was also validated for us in your MoMA exhibition, *Groundswell: Constructing the Contemporary Landscape* (2005). We had wandered into the work of landscape somewhat accidentally with our first built project, and when your show opened in 2005, we suddenly realized we weren't alone. Your exhibition was a seminal endorsement of the emergence of crossover terrains between design disciplines.

**REED**  Looking back to *Groundswell*, the exhibition focused on the "remaking" of cities and post-industrial sites (such as the Olympic Sculpture Park site). And while it was a "landscape" show, I aimed to be agnostic as to whether the designer was an architect or a landscape architect, which was a bit fraught politically. Moreover, there were architects who were realizing that if the twentieth century was about building buildings, the twenty-first century was about the open spaces in between. Which I think is a convenient way of describing the complexities of what you are facing with sites like the Olympic Sculpture Park: the infrastructure, the urban planning, the urban engineering in making new public spaces.

**WEISS**  I think one of the things that the park brought into focus for us was the possibility of crafting a multitasking site. Our teaching has been always parallel to our practice, and the research studios that I lead at the University

of Pennsylvania, that Michael has done at Harvard and Cornell Universities, all focus on the questions that no single discipline can answer alone.

Right when the Olympic Sculpture Park was happening, Laurie Olin and I were teaching joint studios at Penn. We taught for three years together, with half landscape students and half architecture students. We wanted the landscape architecture students and architecture students to influence their colleagues' thinking and approach to design. Our goal was to try to dissolve those distinctions while amplifying both sensibilities. It succeeded rarely, but when it did succeed, the projects were exponentially better than those without this disciplinary transcendence.

**MANFREDI**  It was 1+1=3.

**WEISS**  Michael was doing similar things with students at Cornell, and we were consistently struck by potentially distinct architectural approaches to shape the land. That translates to the specifics of the material, the palette, what's tactile, what's not, what's rough, what's refined, and all these sensibilities start to unpack themselves at scales far broader than a strictly architectural project.

The Olympic Sculpture Park certainly influenced our subsequent work, such as Hunter's Point South Waterfront Park (2013–18; fig. 3.8), a linear waterfront park along New York's East River, informing our approach to the choreography of movement, legibility of form, and the wildness of the water's edge. In Seattle, our experience with two marine engineers foregrounded the nitty-gritty technical demands that must be addressed precisely in order to succeed. We found ourselves

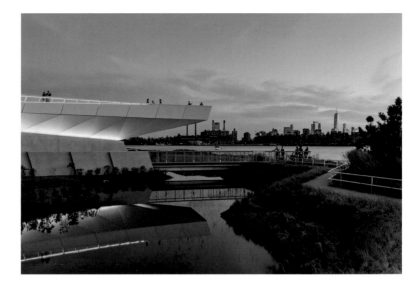

incorporating the values of adjacent disciplines as we were working on these kinds of projects to integrate all the systemic constraints and demands from the beginning, so that the ultimate design expression could be both smart and seemingly effortless.

**MANFREDI**  One significant imperative that emerged since we designed the sculpture park is the magnitude of environmental challenges that cities are facing, which has made Seattle even more relevant. We reshaped the water's edge to create a salmon habitat and capped a brownfield site. The environmental priorities were more embryonic and less part of the public debate when you presented *Groundswell*. Today, in this environmentally precarious time, these priorities are increasingly urgent.

**REED**  We hadn't yet experienced the disasters and devastating impacts of events such as Hurricane Sandy in New York and Hurricane Katrina in New Orleans.

**MANFREDI**  And they hadn't occurred with such frequency. This urgency is making projects like the Olympic Sculpture Park more relevant, less in terms of finished form and more in terms of performative intention.

FIG. 3.8 Hunter's Point South Waterfront Park, with views of the Manhattan skyline, designed by Weiss/Manfredi, 2013–18.

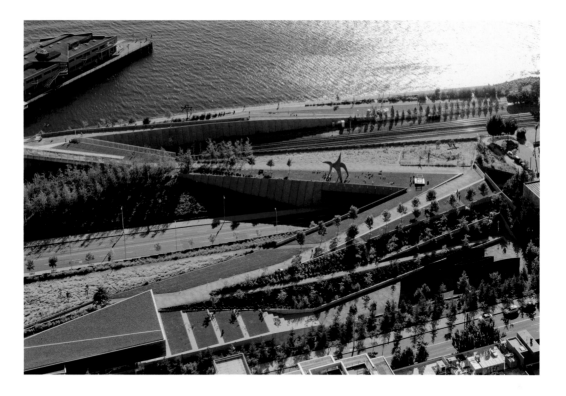

FIG. 3.9
Aerial view of
the Olympic
Sculpture Park
with Z-shaped
path, 2011.

**WEISS**   The fact is that our social and environmental worlds are overlapping in interesting ways. Just like our environment, our social settings are increasingly fragile. The degradation of both starts to inflect the way we think about the public realm. We're always trying to amplify the public dimension of our projects, even if, in fact, they're privatized.

The Seattle Art Museum is a private institution that elected to participate more generously in the public realm than many of its peers. It was keen on making the park open and free, with all the vulnerabilities that that creates. The embrace of these vulnerabilities impressed us and has informed the choice of projects that we've pursued. Hunter's Point South Waterfront Park is open to a large, diverse community, but it is also subject to flooding. The dual challenges are opportunities for invention, and we're excited by projects without obvious formal precedents. And that's where the wandering, fortified perimeter that protects the new wetland of Hunter's Point South, under the thrust of the cantilever that overlooks the city, leverages the intimacy of being at the water's edge and the spectacle of looking out at the city. This dialectic of simultaneity is very interesting for us.

**REED**   You brought up two things I want us to discuss further. One is the notion of a site and its boundaries; the other is about the public realm. When you confront a new project, it sounds like you have a way of looking beyond the brief and beyond the "boundaries" of the site and program. Can you describe your process along these lines?

**WEISS**   One of the most important discoveries we made from Seattle that has really framed the way we think about our projects is that sites are not the boundaries that are given by the client. And that whenever anybody puts a dotted line around what they control, that dotted line is the beginning of our inquiry, not the limit of it. The site for the Olympic Sculpture Park is extraordinary because of the adjacencies: the highways, train tracks, contaminated subsurface, and grade changes are all continuous and interconnected elements that transcend the boundaries of the site (fig. 3.9).

In many ways one of the most important aspects of the competition brief was that the museum acknowledged that they didn't know if the right design lead should be an architect, a landscape architect, or an artist; this was a pretty unprecedented approach. For us, we also delayed conclusions and created a series of conceptual models, looking deeply at the history of the site's geology, the dynamic regrade, the legacy of art in landscape, the city's percent-for-art program, and the identity of infrastructure, landform, and city making. All were threads that we wanted to materialize and reveal to ourselves.

It was a crossfire of thinking, drawing, making, and postponing to the very last minute the creation of one formally simple design that could simultaneously address an unlikely collection of aspirations and challenges. So that approach has informed our work, even now. If you can simultaneously construct sites and delay architecture, something distinct and unexpected has an opportunity to be created.

**MANFREDI** Frank Lloyd Wright said something like "great architecture requires great clients." It's a cliché, but it really does come down to having a great client. This project was uncharted territory for all of us, and we benefited from a client with a dream of creating a new paradigm for what a sculpture park could be. They were open to a range of approaches, did not have preconceived ideas of how this project should evolve, what it should look like, and they recognized, most importantly, the ambition of their dream.

**REED** Another reason the park has become a success is that it has become a new anchor in the city. The physical transformation of the derelict site has been accompanied by a renewed sense of urban vitality. You mentioned that SAM wanted to make a contribution to the public realm. How did this inform your design?

**MANFREDI** Twenty years ago, the site wasn't part of the perceived "downtown"; it was a centrally located site but socially, economically, and culturally disconnected. Despite this, SAM wanted a park that was open and free to the public, which was an incredibly generous ambition that dovetailed with our interest in dissolving the boundaries between park and waterfront, park and city.

**REED** Moreover, the site was out of bounds, fenced off; it looked abandoned.

**WEISS** The museum was gambling on something that museums rarely do. Rather than control entry by ticketing, they were invested in exposing the park's identity to all the vagaries of urban life. In some ways, it is a civic idea of a sculpture park. We're effectively emulating the generosity of the city with the intimacy of a sculpture garden. And

FIG. 3.10
Precast concrete panels with reflections of Teresita Fernández's *Seattle Cloud Cover* (2004–6) and the aspen grove, 2006.

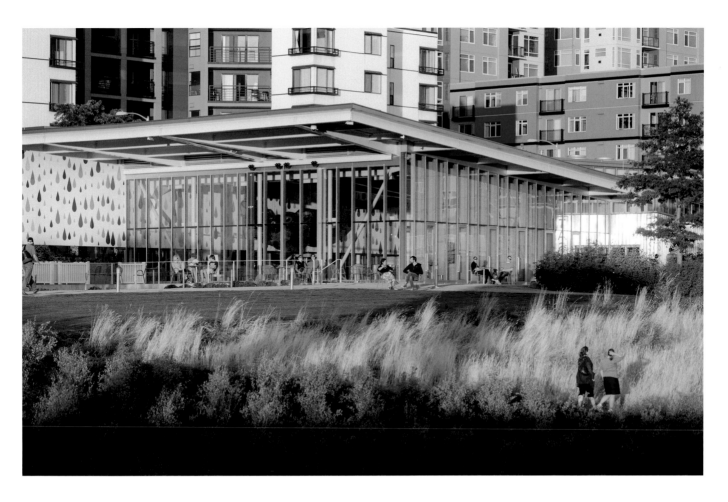

FIG. 3.11
The pavilion,
viewed from
the Olympic
Sculpture Park's
east meadow,
with glimpse of
Trenton Doyle
Hancock's
site-specific
installation *A
Better Promise*,
(2011).

the mediating word is *park*, not *garden*, and a park is a space open to the public.

A lot was at stake. Once the park was completed, the museum had an artifact that required constant cultivation. There's significant risk in taking on these larger territorial projects that require enduring curatorial care. Architecture can generally take care of itself as long as it's cleaned. Landscapes and larger territories take enormous commitment, because they're more vulnerable; more can go awry without that level of care, and in that way, it's very different from architecture.

**REED**   I think people certainly under-appreciate what a landscape demands (figs. 3.10–11).

**MANFREDI**   Completely. The assumption is "just plant it and it will grow." And there is also a great

misconception regarding resilient landscapes and the assumption that by being native they require no maintenance. Cultivation, both as a cultural and ecological construct, was central to our design thinking. We love that culture and cultivation share the same root, and as curation can occur across disciplines, museums need to carefully curate their open spaces just as they need to curate their art.

**WEISS**   These responsibilities were new, in fact, for Seattle, and very new to the museum.

**REED**   You were designing not only for SAM, but also with the public in mind. How did this sort of public-private duality influence your thinking?

**WEISS**   The museum had a public ambition. While they had works of art in mind, they didn't

have a setting that was immediately optimal for all their aspirations. And they weren't looking for an icon per se, which might raise questions about the idea of how central art in the landscape could be. They were very preoccupied with creating both a setting for art and a public space.

MANFREDI    Yes, you would think they might have asked for an iconic form, but they never did. The discussion was as much about the environment as it was about the art, and the ecological ambitions—such as the restored salmon habitat (fig. 3.12)—were as important as the cultural ones. The museum also recognized the importance of creating a public setting: a gift to the city that would be open and free. In retrospect, one of the great contributions the Seattle Art Museum has made is exposing art to a larger constituency. A group of people who might not recognize a Richard Serra or an Alexander Calder can now see art in an open and public setting.

WEISS    Right, making it accessible to a broader community of people who might feel shy about putting themselves in a place dedicated to art. For instance, the Storm King Art Center, over fifty miles from Manhattan, is a generous landscape for art, but it is also a destination for those informed about art. We were inspired by the museum's commitment to removing walls, both literal and conceptual, from the broader community's idea of art.

REED    Your embrace of the public and community came across in your initial presentations. It felt genuine.

MANFREDI    The notion of community was embedded in the pro bono projects that Marion

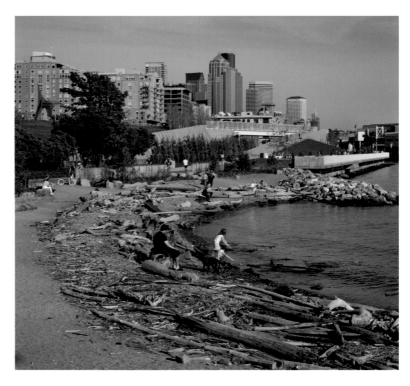

FIG. 3.12
Olympic Sculpture Park pocket beach with restored seawall and salmon habitat bench, 2007.

and I started our practice with through the Architectural League of New York. Architecture has a social dimension that, for us, is very central to our work. You can't rely on the community to make a design, but you rely on the community to help spark a design that has the potential for new social or cultural connections. We could not have asked for a project that was more enmeshed in the community and in the making of a public setting than the Olympic Sculpture Park.

REED    How people will use and occupy a new site isn't exactly predictable. How did you endeavor to make the Olympic Sculpture Park not only environmentally sustainable but also socially sustainable?

MANFREDI    Marion and I are very conscious of making a variety of settings that the public can appropriate and make their own. Choreographing varied settings that are more open ended and that leave something to chance, that encourage both prescribed and spontaneous events, is one of the ambitions of our work.

**WEISS**  Relative to this question of movement, we realize that we aren't chasing down the one view that sums it up all at once, but rather the discovery of what movement and topography together can yield within a landscape. The zigzag path sets up distinct vistas. In some cases, pathways divide two views; Richard Serra's *Wake* (2002–3), for instance, is defined by both an elevated walk and carved-out earth, yielding two unique perspectives (see figs. 2.8 and 4.5). Our interest lies in creating these infinitely intimate worlds, which are bounded in some cases by trees, walls, and topography. Our design for Hunter's Point South Waterfront Park similarly splits elevations and creates very different experiences in the same space, separated by a thirty-foot change of grade.

**MANFREDI**  The topographic agenda at Hunter's Point South, as at the Olympic Sculpture Park, privileges how one moves through space. At Hunter's Point South, changes in topography create shifting vantage points. For example, the uphill arc of the elevated public overlook offers expansive views of Manhattan, while the lower arc on the water's edge follows the contours of the newly created wetland.

**WEISS**  We were so intrigued with Seattle because of this idea of slowness within the park and movement and speed below. Cars can be whizzing though Elliott Avenue and you can stand at a point directly above the center of the road (fig. 3.13). We like optimizing the tension between the things that are different about a site, some that are in your control and some that are not.

**REED**  To what extent did you have to construct the topography? My recollection is that other than the railroad tracks and the highway, there really was no *there* there.

**WEISS**  The topography is a complete invention, although the forty-foot grade change across the site existed. In fact, 200,000 cubic yards of earth created this switchback and elevated landform, a serendipitous gift from the downtown museum excavation.

FIG. 3.13
Night view of Elliott Avenue bridge with Alexander Calder's *The Eagle* (1971), 2007.

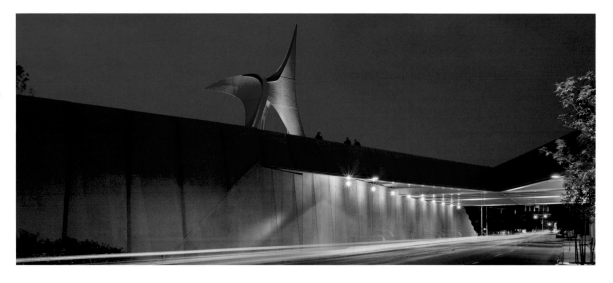

MANFREDI In effect, we reconstructed the topography to shape it. By shaping it, we created a promenade to choreograph movement. At the Olympic Sculpture Park, paths widen and narrow to collaborate with the invented topography.

WEISS In terms of scale, the Seattle site was only nine acres, so it's relatively small. To create a place that is both infinite and intimate, we looked for opportunities to modulate the scale of the site through borrowed views, calibrated topography, and perspectival convergence (fig. 3.14).

MANFREDI We should mention the rediscovery of the public realm through digital media. People taking selfies in a public setting like the Olympic Sculpture Park was certainly something we never thought of when designing the project—the technology was barely there.

WEISS Public space is more important than ever as our reality becomes more virtual. Whereas there was a fear twenty years ago that the emergence of the digital landscape would diminish the public realm, it has amplified the urgency to experience these settings.

MANFREDI Now there's a renewed possibility of situating yourself in relation to memorable public spaces, saying, in effect: "I am here." The ability to be digitally interconnected has validated the importance of physical space.

REED What you're describing is that, fundamentally, the Olympic Sculpture Park is a public space; that people feel a sense of belonging and that the social life of this urban space is thriving.

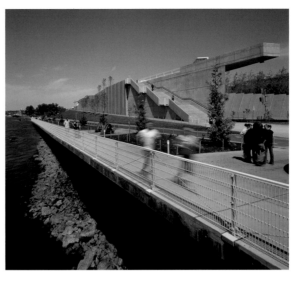

FIG. 3.14
The Olympic Sculpture Park waterfront promenade with pedestrian and bike pathways, 2007.

MANFREDI People have claimed specific places in the Olympic Sculpture Park that we never expected would become destinations. For example, everybody thought building near the tracks was dangerous. Now the tracks have become an extremely popular setting. Train spotting has become a consistent pastime, and couples are photographed on the tracks adjacent to the Louise Bourgeois sculpture and framed by the bridge; that setting is both improbable and surprisingly photogenic (see pp. 92–93).

REED One might argue that the ease and proliferation of taking pictures on cell phones makes the world smaller and more visible, but it also compromises the experience of art and landscape. How well can you know a site from photos?

MANFREDI Reducing the environment to a set of images is so antithetical to what great landscapes or great architecture can do—which is to engage all the senses. There is an aural aspect, a tactile aspect, and your senses of smell and touch are sharpened by being in a place.

WEISS You could argue that that's true of any good architecture or landscape. Photographs of a city, garden, or building can inspire our trip

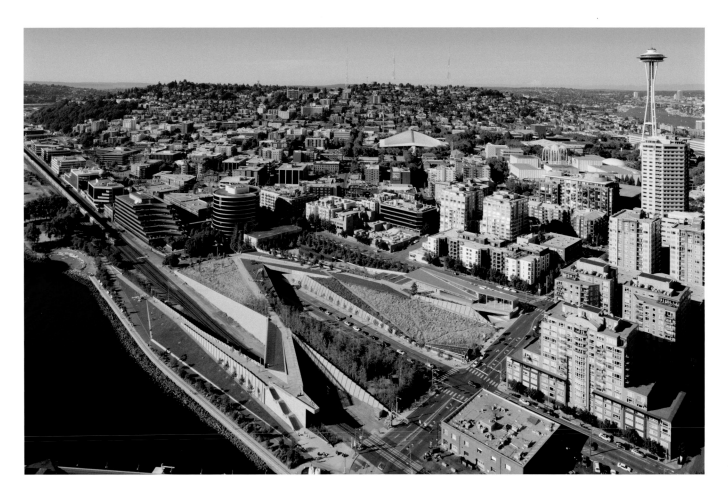

FIG. 3.15
Aerial view
the Olympic
Sculpture Park,
2011.

itineraries, but the experience of landscapes is impossible to capture through the camera lens.

**MANFREDI**   We believe that one of architecture's great attributes is how it invites our bodies to negotiate the environment. The choreography of how we move through space, the promenade, is even more important to us now. It was central at the Olympic Sculpture Park, where clearly defined zones are linked through a very carefully calibrated sequence of routes (fig. 3.15).

**REED**   How does this play into the idea of seduction that you mentioned before?

**MANFREDI**   The idea of seduction is important in place making, and this relates to the question of why the Olympic Sculpture Park continues to be a

compelling place for both first-time and return visitors. We think there is a hunger for settings that invite tactile engagement and open-ended experiences.

**WEISS**   To achieve this authenticity, we try to bring into focus things that are unseen, bringing an innocence to the design of each site. We're continually hoping to reveal the visceral experience of a place and to communicate what is authentic and enduring.

**MANFREDI**   Today, the stakes for preserving our environments and supporting our public space have never been higher. We hope the Olympic Sculpture Park will continue to resonate for future generations and offer ever-changing moments of delight and discovery.

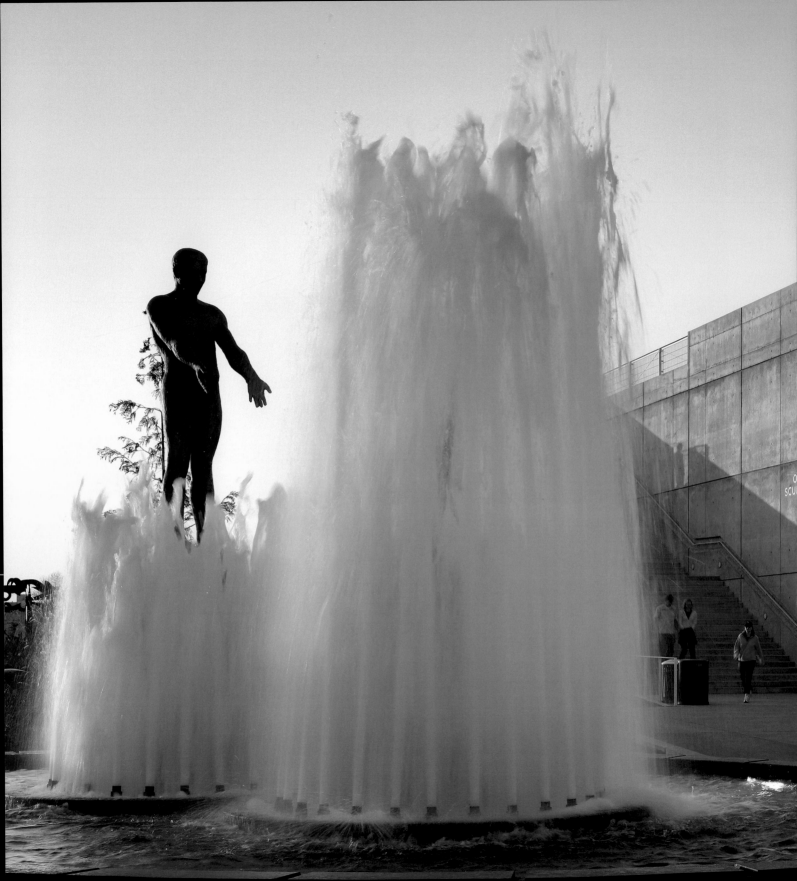

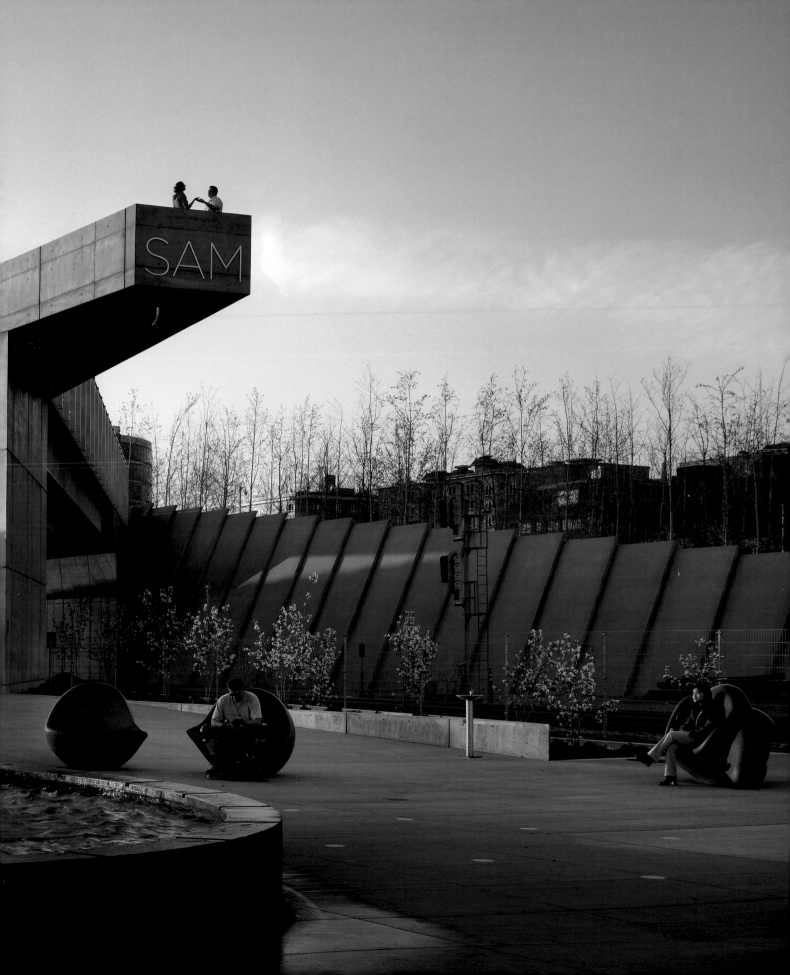

# Art for "a Park
Like No Other"

Lisa Graziose Corrin

The City of Seattle has long viewed its streets and squares as potential-filled places for public art to be integrated into urban life. The democratic design of the Olympic Sculpture Park, striking for its openness to the city, reflected Seattle and its artists' shared vision for urban context and works of art to commingle, evident since the city enacted its One Percent for Art initiative in 1973.[1] It was clear that the approach to the initial artistic program of the Olympic Sculpture Park should be similarly open, integrated, integral. With only eight and a half acres to occupy, the artistic program must also, by necessity, be intentional.

In 2001, when the Seattle Art Museum (SAM) Design Selection Committee interviewed architects for the project, the museum's collection of outdoor sculpture numbered just four works, one of which was a recently acquired stabile, *The Eagle* (1971, see fig. 2.13), by Alexander Calder, intended specifically for the park.[2] In envisioning the park's artistic program, SAM saw potential for gifts from the community's many civic-minded collectors. Indeed, the idea for the park itself came from two such collectors, Jon and Mary Shirley, in 1995, with enthusiastic support from Virginia Wright, who would join them in giving major works for the park (fig. 4.1). Other Seattle collectors close to the museum had important outdoor sculpture collections as well. The museum hoped that, in creating

the Olympic Sculpture Park, it would provide a home for anticipated gifts of art, ensuring these works would remain in Seattle to be shared with the public. These local collections were of similar vintage, each with many distinguished examples by modern American and European artists whose work eventually became ubiquitous in sculpture parks in the United States and Europe.[3] The museum's aspiration was to "create a park like no other," to quote Mimi Gates when, in 2001, she invited me to join the SAM team and jumpstart the park's artistic program. Thus, the challenge was to build upon an anticipated foundation of gifted works through strategic purchases and commissioning works by a new generation of artists, to demonstrate the flexibility and expansiveness of the sculpture medium.

With finite real estate, the museum took a less-is-more approach to the artistic program. All sculptures, but especially monumental outdoor works, need room to breathe, to allow for an unfolding experience in space and in time. Providing ample space to approach, to engage, and to reflect upon the physical experience of a work—its form, mass, and materiality—allows for an intimate connection to the work of art, empowering viewers to make meaning through their bodies. It was also important to leave space in the park for future acquisitions, artist interventions, intermedia, and

performance works, as well as for recreational enjoyment of this rare downtown greenspace.

While the museum's director championed independent curatorial vision, we engaged many stakeholders in discussing how to shape the artistic program: collectors, dealers, critics, historians, environmentalists, residents and, of course, artists. Building consensus among members of three different committees—the Olympic Sculpture Park Building and Artistic Program Committees and the museum's Committee on the Collection, composed variously of staff, trustees, and community members, with some overlap—was critical. Discussions around artist proposals were not always easy, but they demonstrated the level of passion and commitment of the stakeholders and their deep sense of responsibility to the park and to the people of Seattle. Our collective decisions would leave an indelible mark on the city.

As the curatorial vision for the park's artistic program coalesced, we identified opportunities for specially commissioned works to be built into the park's infrastructure and invited proposals from several artists. These proposals were also the subject of spirited discussion among committee members. The committees requested that some artists make alterations to their original proposals or to submit entirely new ones. Not all of them succeeded. An exciting idea might be too expensive to build or to maintain or might require significant site modifications. Some proposals were challenged on aesthetic grounds, provoking feisty debate, and were voted into the program by a slim margin. Not everyone was comfortable with risk. Some committee members expressed wariness that the results of commissioned works would be unpredictable. One member encouraged the museum to consider consolidating the

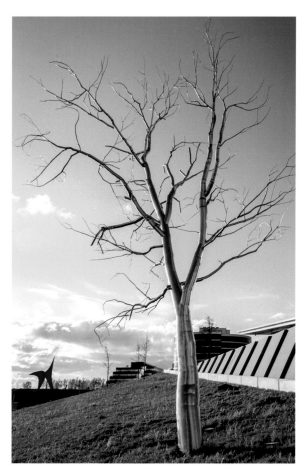

art budget allocation for commissioned works, which was modest relative to the scale of the park project, and to purchase a single major work by a recognized figure. Another even suggested that we build the park without any commissioned artworks at all, because the process of producing new art while also constructing a massive civic project appeared too difficult. It was important to trust in the process of dialogue and to play it for length. Our mantra, "We are building a park like no other," reminded the group of what we had set out to do and prevented self-censoring at especially challenging moments.

Starting with very few works in the collection was both a challenge and an opportunity. An artistic program needs an organizing principle with an inner logic to shape decision making and to give shape to visitor experience. Curating is storytelling. What story did we want the park to

tell that would be a capacious, generous, and flexible organizing principle for the present and not feel outmoded in the future? Developed in tandem with the artistic program, the site design by Weiss/Manfredi Architecture/Landscape/Urbanism offered an evolving, mutable model capable of incorporating—and also inspiring—a constantly shifting definition of sculpture and accommodating a wide range of artistic approaches and programming strategies. As they moved through this constructed landscape, visitors would encounter some works that looked and behaved in familiar ways, as well as other approaches to the sculpture medium in which their own interactions in social space are the work of art itself.

What these varied approaches to the medium within the park have in common is a dialectical relationship to the plinth—arguably the defining issue within the recent history of art, one that continues to this day. Both Marcel Duchamp's Readymade *Fountain* (1917) and Constantin Brancusi's *Bird in Space* series (1920s–40s) topple, from his seemingly impregnable stone plinth, the white male hero on horseback cast in bronze, elevating both the common urinal and sleek arc, respectively, in the hero's place. Once artists knocked sculpture off its pedestal—literally and metaphorically—it entered the space of the viewer and gained its meaning from an active self-questioning of its essential nature as well as from the behavior it precipitated.

The relationship between the object and its context is also central to this dialectic. As Calder's colossal *Eagle* lifts its red steel "head" against the wind toward the watery horizon, echoing the forms of the red and orange cranes in the Port of Seattle in Puget Sound and Elliott Bay, it erases the distinction between art and its surroundings,

using air, light, the texture and even the hue of groundcover as part of the work. Indeed, no longer distant, precious, or elevated, much sculpture today is participatory, alert to its site, and in every way "down to earth."

When Marion Weiss and Michael A. Manfredi were shortlisted for the sculpture park project, we discussed extensively this dialectical relationship with the plinth within the history of modernism and its continuation in contemporary art. This, in turn, inspired them to make "the plinth" similarly the central organizing principle of their design. Taken as a metaphor, it enabled them to resolve the major challenge of the park's site conditions—how to unify more than eight acres of vacant brownfields composed of three distinct parcels of land segmented by a major traffic artery, Elliott Avenue, and the Burlington Northern Santa Fe Railroad tracks. Their innovative solution was to create a reinvented topography in the shape of a great Z, a 2,200-foot-long central path of crushed stone and mowed turf descending the site in a continuous zigzag while connecting a glass-and-steel pavilion to a new shoreline pocket beach, using land bridges as lids over Elliott Avenue and the railroad (see fig. 3.9). The bold angles of the path rise up over the city's infrastructure like a grand green platform. Within that platform are a series of precincts, each with an individual landscape identity, suggesting a series of variable plinths readymade for a diverse range of sculptural investigations (see map, pp. 14–15). The distinct character of these precincts also provides varying contexts within the meticulously carved landscape for site-specific artists to respond to or react against.

For example, contiguous with the pavilion, the valley precinct, more than any other in the park, recalls the traditional sculpture garden. A series of

terraced walkways, backed by gently ascending and descending retaining walls, provides an intimate setting, inviting introspection when engaging with more modest-sized sculptures, including Beverly Pepper's *Perre's Ventaglio III* (1967, fig. 4.2) and two works on loan at the time the park opened and later gifted to SAM, Louise Nevelson's brooding, collage-like sculpture *Sky Landscape I* (1976–83, fig. 4.3) and Pepper's *Persephone Unbound* (1999, fig. 4.4) standing guard like a neolithic sentinel.

The centrifugal force around which these artworks gather is Richard Serra's *Wake* (2002–3), five pairs of locked toroid forms measuring fourteen feet high, forty-eight feet long, and six feet wide, with acid-washed surfaces (see fig. 2.8).[4] Serra described these complex forms: "Each module is identical and comprised of two S-sections, which are inverted in relationship to each other. As the S-sections locked together, the concavity and convexity of one side lock to the convexity and concavity of the other side."[5] A remarkable feat, harnessing sculptural imagination to technology, *Wake*'s composition of hot-rolled steel was created through computer imaging and with machines designed to make ship hulls—in this case, a demilitarized machine formerly used in manufacturing French nuclear submarines. Suggesting a series of massive tidal waves or the profiles of battleships reflected on the surface of the open sea, the strong industrial appearance of *Wake* harmonizes with the character of the Seattle waterfront, with its distant views of container ships plying the bay.

When Serra met with Weiss/Manfredi to discuss the siting of *Wake*, they used a miniature scale model to review potential placement in each precinct. Serra was impressed by the park design, stating later, "There is nothing else like this in the country" for outdoor art.[6] He was particularly fascinated by how the architects' design incorporated the movement of trains as a key element of the park experience. The unfolding of time in space is important to his work, but the speeding trains, he said in the meeting, added a new component to his thinking: velocity. Ultimately, Serra chose the contemplative and contained space of the valley for *Wake*. He suggested modifications in order for *Wake* to work within the site. He also wanted to ensure that the smaller works surrounding it would be experienced individually and respectfully. In response, Weiss/Manfredi added retaining walls to create linear galleries parallel to the valley on its western edge. Serra liked the contrast of the straight, low walls against the curvilinearity of his sculpture. He also asked the designers to omit a marsh on the valley floor hosting "ancient" plants and grasses, part of the original concept proposed by landscape architect Charles Anderson. Serra set the five elements of his work in what instead became an open field. The viewer understands the configuration of *Wake* through the movement of their

FIG. 4.2
Beverly Pepper, *Perre's Ventaglio III*, 1967, stainless steel and enamel, 7 ft. 10 in. × 6 ft. 8 in. × 8 ft. Gift of Jon and Mary Shirley, in honor of the 75th Anniversary of the Seattle Art Museum, 2005.200.

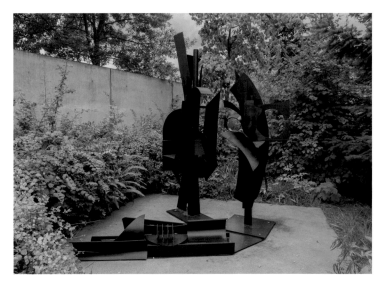

body in relation to the surfaces and as they pass fluidly between the heaving forms (fig. 4.5).[7] For Serra, space is as tangible a material as steel; *Wake*, and the context he helped shape for it, transforms our consciousness of our relationship to space, altering our perception of the world and our place within it. Visible from the start of the sculpture park's path, *Wake* introduces visitors to this ethos of self-reflexivity—that sculpture and viewer are self-questioning entities—which lies at the center of the park's artistic program, as soon as they pass through the pavilion.

Smooth transitions in Weiss/Manfredi's design create the perception that the park flows uninterruptedly into the city and the city into the park. With the exception of the valley, with its retaining walls creating a sense of enclosure, there are no walls in the Olympic Sculpture Park to keep art in or people out. Instead, "art thresholds" demarcate the boundaries of the park—works of art signaling to visitors that they are entering a space that is both of daily life and intended to elevate one's experience of it. These begin at the pavilion and mark the park's entry points along Broad Street all the way to the water's edge. The works of art along these thresholds function as a kind of group exhibition in which artists across generations explore "the tree" as a motif, a fitting theme given that Seattle's first wealth was built,

in part, on the logging industry. Ellsworth Kelly's *Curve XXIV* (1981, fig. 4.6), like a rust-hued autumn ginkgo leaf, greets visitors on a sweep of exterior pavilion wall. Denoting a transition to the upper meadow is Roxy Paine's fifty-foot stainless steel *Split* (2003, see fig. 4.1), a "specimen" meticulously executed by the artist through a painstaking analysis of the composition of a real tree, reconstructed from heavy industrial plates supporting approximately five thousand pounds of cantilevered branches, with more than twenty different diameters of steel pipes. Beckoning from a distance and viewed just as one crosses into the park, the work is sited within a backdrop of natural greenery, its gleaming surface reflecting the very surroundings that its presence so dramatically alters and calls into question. Another "tree," the centerpiece of Mark Dion's *Neukom Vivarium*, with its sixty-foot-long nurse log, marks the junction of Elliott Avenue and Broad Street (2004–6, fig. 4.7). A marriage between conceptual art and a botanical field station, Dion's first permanent, monumental public art work in the United States, like many of his installations, critically considers the culture of nature—"nature" as a man-made construction that simultaneously reflects and circumscribes our capacity for wonder. Mark di Suvero's *Bunyon's Chess* (1965, see fig. 2.4) is sited at a subtle entry portal to the

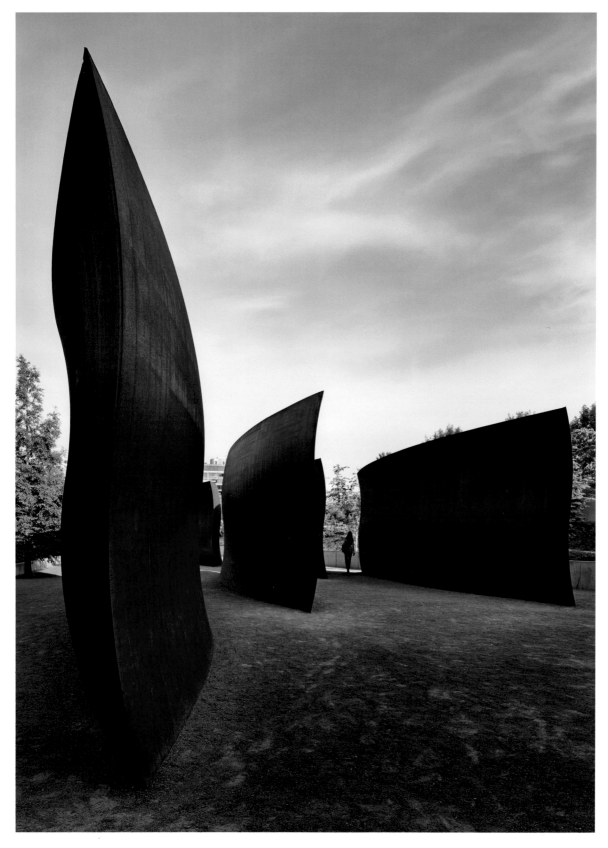

**FIG. 4.5**
Richard Serra,
*Wake*, 2002–3
(detail), 10 plates,
5 sets of locked
toroid forms,
weatherproof
steel, each set,
overall: 14 ft.
1¼ in. ×
48 ft. 4 in. ×
6 ft. 4⅜ in.;
overall installa-
tion: 14 ft. 1¼ in. ×
125 ft. × 46 ft.;
plate thickness
2 in.; weight:
30 tons (each
plate). Purchased
with funds from
Jeffrey and
Susan Brotman,
Virginia and
Bagley Wright,
Ann Wyckoff, and
the Modern Art
Acquisition Fund,
in honor of the
75th Anniversary
of the Seattle
Art Museum,
2004.94.

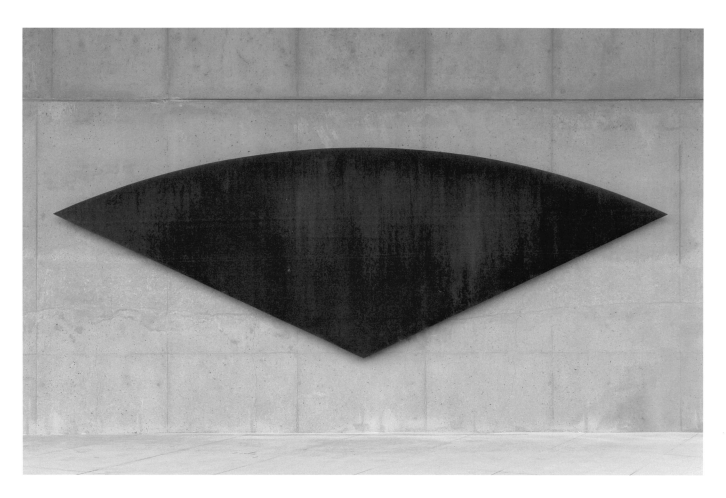

FIG. 4.6
Ellsworth Kelly,
*Curve XXIV*, 1981,
⅜-inch weath-
ering steel, 6 ft.
4 in. × 19 ft. × ⅜ in.
Gift of the Virginia
and Bagley Wright
Collection, in
honor of the
75th Anniversary
of the Seattle
Art Museum,
2016.17.2.

park from Bay Street, its suspended, giant cedar logs an allusion to the equally gigantic lumberjack Paul Bunyan, a folk hero famed for his superhuman strength. The massive, dense logs, suspended by cables to form diagonals that intersect with a triangle of steel support beams, seem to defy gravity. Along the water's edge, Roy McMakin also chose a live tree to form the letter V in "LOVE" for his installation *Love & Loss* (2005–6, see figs. 5.7–8).

In addition to thematic resonances like the tree motif, works marking the park's boundaries also embrace humor and sentimentality. Claes Oldenburg and Coosje van Bruggen's *Typewriter Eraser, Scale X* (1999, see fig. 1.16), on temporary loan 2007–17, appeared to be careening down the hill abutting Elliott Avenue. Visitors who used typewriters prior to the advent of the personal computer would have recognized this oversized,

once-commonplace desk accessory. For young Microsoft professionals in their Teslas whizzing by in the traffic below, it might read merely as a brightly colored abstraction. Placing this Pop icon within the context of Seattle, a city renowned as an innovative tech capital, gave the obsolescence of the monumentalized low-tech object a poetic poignancy.

One of the most imposing art thresholds defines the park's edge along Broad Street: Tony Smith's inscrutable *Stinger* (1967–68/1999, fig. 4.8; see fig. 2.10). Resting on a single diamond point, the sculpture seems to float over the ground, a configuration vacillating at the intersection of sculpture and architecture. This position is used to unsettling effect in the contradiction between the work's simple plan and complex elevation, which the viewer is challenged to resolve. Originally (and aptly) titled *One Gate*, *Stinger* suggests this

ancient architectural form, and its resonance with an archetypal structure enabled Smith to emphasize the importance of the spectator's physical movement from the work's exterior to its empty interior space, a transition he identified with spiritual passage. A preliminary drawing for the artwork reads, "Even those who enter by the wrong gate, who take the wrong path, will find their way. It shall be the right way, the correct way."[8]

Finally, four works by Louise Bourgeois greet visitors entering or leaving the park at the waterfront entrance: three pairs of black granite participatory sculpture-seats, *Eye Benches I, II,* and *III* (1996–97), and *Father and Son* (2005), a fountain situated underneath the park's cantilevered bridge (see figs. 5.11–13). The tolling of a bronze bell suspended beneath the bridge comingles with the rush of water, passing trains, and the ring of bicycle bells, a reminder that the park is in Seattle and Seattle is, quite literally, in the park.

In order to respect the fishing rights of the Coast Salish peoples who first occupied this land, the sculpture park's artistic program does not extend into the most dramatic of the park's thresholds, Puget Sound. The environment at the water's edge is very fragile, and one of the distinctive features of the park's design is its underwater tidal garden at this junction of city and sea. Young salmon return to the shoreline and seawall, providing scientists an opportunity to observe ecological changes at the site.

As the park's landscaping matured, as the needs and resources of SAM changed, and as visitor behavior was better understood, the museum re-sited or removed some works.[9] Anthony Caro's *Riviera* (1971–74, see fig. 1.17) no

FIG. 4.7
Exterior view of Mark Dion's *Neukom Vivarium* (2004–6) across Elliott Avenue, with the Olympic Sculpture Park pavilion in the background, 2007.

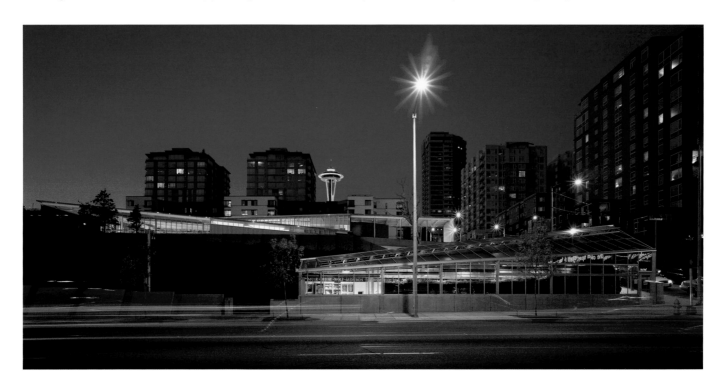

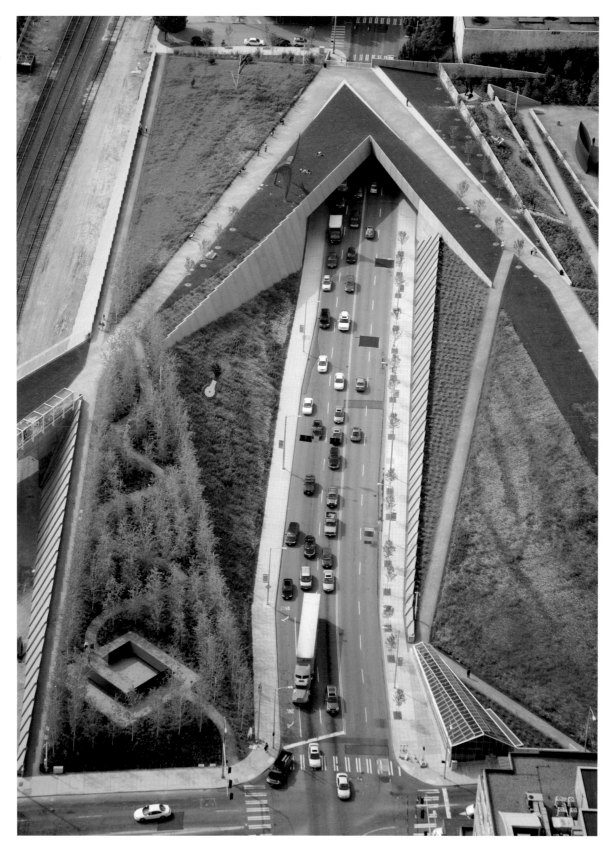

FIG. 4.8
Tony Smith,
*Stinger*, 1967–68/
1999 (lower left),
steel, painted
black, 6 ft. 6 in. ×
33 ft. 4¼ in. ×
33 ft. 4¼ in. Gift
of Jane Smith,
2004.117.
Mark Dion's
*Neukom Vivarium*
(2004–6)
is visible at
lower right.

ART FOR "A PARK LIKE NO OTHER"

longer marks the pavilion's terrace, removed to better accommodate revenue-generating events and, more importantly, for conservation reasons. Children were inclined to play among its fragile "legs," and visitors even chained their bicycles to the sculpture. Tony Smith's *Wandering Rocks* (1967–74) was originally located in the grove, which Charles Anderson designed to evoke the "civilized wild," selecting quaking aspens that grow quickly and thrive in an urban environment.[10] Anderson planted the trees in a grid, and new saplings rapidly defied that imposed organization, springing up between their parents just as new growth in a city defies a fixed urban grid.[11] The grove's gathering of trees initially formed a natural alcove and intimate enclosure for *Wandering Rocks*, ideal for experiencing its signature geometry and strong organic quality derived from the forms of molecules, crystals, and other naturally occurring structures. When the trees matured, the enclosure became dense, sheltering Smith's black forms. This new, hidden environment encouraged defacement of the artwork, so SAM moved *Wandering Rocks* to a highly visible, open space (fig. 4.9). Penned in and without context to give it scale, Smith's *Wandering Rocks* sadly wander no more. Balancing sensitive siting of artworks against the practical realities of a park without barriers will always be a challenge for the museum.

The realities of budget and staff capacity also impacted some of the original artistic plans for the park. Video projects in the parking garage and provision for projections on an exterior wall of the pavilion were early casualties. Ideas for sound works that would benefit from the buffering qualities of the grove's plantings were all put on hold, while maintaining the technological capability to commission these works in the future. It became clear early in our planning that easing tension between artistic innovation and ambition and available resources for a museum managing three distinct sites—SAM, the Olympic Sculpture Park, and the Seattle Asian Art Museum—would require pacing and farsighted planning.

For the opening of the park, the museum decided to focus resources on commissioned works by Mark Dion, Teresita Fernández, Roy McMakin, and Louise Bourgeois, each built into the fabric of the site. Once these projects got underway, it was clear that the museum needed a full-time art program director to manage the needs of all artworks being installed, in concert with the design and construction teams. Renée Devine served in this essential role, which became crucial in the final period leading up to the sculpture park's opening in 2007, six years after SAM revealed the winning architects' names to the public.[12]

Devine played an especially significant role in the very complex production of Dion's *Neukom Vivarium*, a work that, while integrated into the park infrastructure, defines "permanence" as a relative state. Dion's project provides an instructive case study of the commitment demanded by an interdisciplinary, highly participatory permanent public artwork whose meaning is activated through audience engagement requiring ongoing facilitation by the host institution.

FIG. 4.9
Tony Smith's *Wandering Rocks* (1967–74) sited adjacent to Teresita Fernández's *Seattle Cloud Cover* (2004–6) on the pedestrian pathway over the BNSF railroad tracks, 2016.

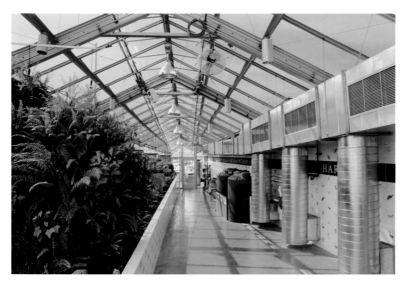

FIG. 4.10
Mark Dion, *Neukom Vivarium*, design approved 2004; fabrication completed 2006, mixed-media installation, greenhouse structure length: 80 ft. Gift of Sally and William Neukom, American Express Company, Seattle Garden Club, Mark Torrance Foundation, and Committee of 33, in honor of the 75th Anniversary of the Seattle Art Museum, 2007.1.

The centerpiece of *Neukom Vivarium* is a 55,000-pound, 60-foot-long nurse log, a western hemlock—the state tree of Washington—enclosed in a custom-designed 80-foot-long greenhouse that represents nature as a complex system of cycles and processes, of death and rebirth (see figs. 5.1–3). Its green glass roof simulates forest canopy light in Pacific Northwest rainforest conditions, creating a welcoming environment for fungi and lichens, moss, plants, and insects (fig. 4.10). The witty design of the greenhouse connects it closely to that of Weiss/Manfredi's pavilion, echoing its shapes and materiality (see fig. 4.7). Visitors can catch sight of the greenhouse's angular form from the pavilion, looking across the upper meadow. A diminutive door leads unexpectedly into a grand space where the mammoth log awaits.

The *Vivarium* is more than a public art installation. It is a deeply collaborative project that began with the production of the work and will continue throughout the life of the installation. With Renée Devine's support, Dion consulted with a terrestrial ecologist to identify a nurse log of appropriate scale that could be moved from its site at the Green-Duwamish River watershed to the park with the aid of a 550-ton crane. Devine also helped the artist connect to and partner with dozens of scientists from the region, from spider specialists

and nurse log experts to scientific illustrators commissioned to make drawings of bacteria, fungi, lichen, plants, and insects transferred to blue-and-white tiles installed throughout the greenhouse as a "field guide." Available to help visitors observe the teeming lifeforms that make the log their home are carts with microscopes and magnifying glasses, along with reference books in a custom-made cabinet designed by the artist. Dion intended for docent-educators to facilitate these activities. Their role is also to answer one of visitors' most common questions about the work: "Why is this art?"

A trained docent can point to how the artist designed every element of the greenhouse and its interior in accordance with his aesthetic logic (fig. 4.11). This corrects the mistaken impression that the greenhouse is a standard-issue plant-growing unit. A detail as simple as the location of a down-spout required considerable discussion between Dion and the project architect.[13] In short, the *Neukom Vivarium* is a meticulously conceived and multifaceted work of conceptual art and not an amateur science experiment. Hooked up to a complex mechanical life-support system entirely visible to the viewer, this hybrid work of sculpture, architecture, environmental education, and horticulture inspires awe for the unceasing and unexpected processes of nature as it transforms itself and our environment every day. A docent might add that the presentation of the nurse log, set upon a slab under the glass greenhouse roof, is an ironic nod to the conventional display of sculpture on a pedestal enclosed in a glass case. By removing the nurse log from the forest ecosystem and placing it within the art ecosystem—that is, in the context of a sculpture park—Dion's *Neukom Vivarium* asks us to perceive the log differently than we might if we encountered it on a

FIG. 4.11
Olympic
Sculpture Park
docent leading a
tour of Mark Dion's
*Neukom Vivarium*
(2004–6), 2007.

mountain hike, and to consider it critically in light of the installation he has created around it.

Dion's installation offers two distinct teaching moments: the opportunity to explore in microcosm the ecosystems of the Pacific Northwest and the opportunity to engage with contemporary conceptual art practice and to make meaning through participation. Performance, by himself or others, is an important dimension of Dion's practice. Slipping seamlessly into the role of naturalist or educator, he asks the same of the docents. This is crucial for Dion's work to fulfill its potential, to perform the intent of the work of art. The *Neukom Vivarium* is currently open only for limited hours when the museum is able to provide volunteers. Park visitors are, therefore, left peering into the greenhouse windows much the way museumgoers look longingly at a sculpture on a pedestal encased in a transparent vitrine. Keeping the decaying log at a distance amplifies its status as a precious object, and denying regular access to the log itself turns this "living sculpture" into a static form.

Teresita Fernández also proposed harnessing the multisensory experience of the park's urban context in her 212-foot-long site-specific installation, *Seattle Cloud Cover* (2004–6, fig. 4.12), a work of art that blurs the boundaries between sculpture and functional structure. It was commissioned as a creative response to the need for a barrier to keep objects from falling or being thrown from the land bridge to the railroad tracks below. By day, *Seattle Cloud Cover* is a fully integrated element of park infrastructure that creates a dramatic sense of occasion for visitors traversing the great expanse of path and provides shelter beneath to pedestrians who seek cover from Seattle's unpredictable weather. By night, seen from boat or car, the luminous enclosure appears

as a dynamic slash of color, creating a distant point of reference within the parkscape.

Like Dion's *Neukom Vivarium*, Fernández's installation explores "nature" as fundamentally a human construction emanating from representation. *Seattle Cloud Cover* consists of a continuous glass canopy along one side of the bridge. The glass is imbued with vivid images of the Miami sky in intensely saturated colors based on digital photographs of the Florida city's changing skies, with hues ranging from pale violets to intense pinks (see fig. 5.5). Beneath the canopy, the viewer feels suspended in the painterly artifice of the digital cloud cover. The artist punctuated these images with a Ben-Day dot pattern, like regularly spaced clear portholes through which views of Seattle's actual skyline are visible. As sunlight penetrates the glass, the cast shadows of the "cloud formations" create a vibrant pattern of distortions spanning the entire length of the bridge. Turning toward the spectacular view of Elliott Bay, the viewer experiences the inescapable contradiction between this represented landscape and Seattle's panorama of water, mountains, and ever-changing skies. The movement of the viewer, combined with the perceived and actual movement of the sky and water and the way the city pops in and out of focus through the transparent spaces of the translucent glass, gives this animated work a cinematic effect, dazzling from every perspective.

These two infrastructure projects, along with Roy McMakin's *Love & Loss* (see fig. 5.8), refresh conventions associated with traditional park

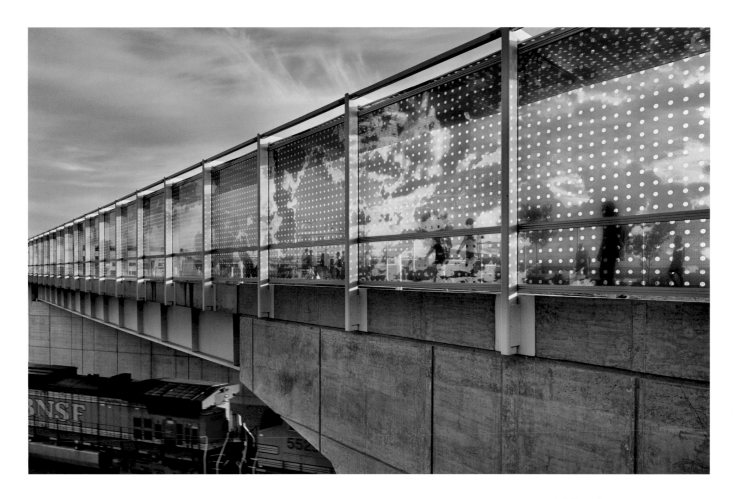

FIG. 4.12
Teresita
Fernández,
*Seattle Cloud
Cover*, design
approved 2004;
fabrication
completed 2006,
laminated glass
with photographic
design interlayer,
approx. 9 ft.
6 in. × 200 ft. ×
6 ft. 3 in. Olympic
Sculpture Park Art
Acquisition Fund,
in honor of the
75th Anniversary
of the Seattle
Art Museum,
2006.140.

settings such as the tropical greenhouse, the arched bridge, a romantic secret garden, and the ubiquitous park bench. Yet another park cliché is the bubbling allegorical fountain. Inspired by early drawings of her sons in the bathtub and their relationship to their father, artist Louise Bourgeois has reimagined the fountain to portray the unusual theme of father and son.

*Father and Son* became part of the artistic program through serendipity and an unusual legal arrangement. Seizing that opportunity enabled SAM to realize an additional ambitious infrastructure project by an artist of great distinction. In 2002, the Seattle Art Museum learned from Barbara Goldstein, the public art coordinator for the Mayor's Office of Arts and Cultural Affairs for the City of Seattle, that a Seattle resident, Ernest Stuart Smailes, had bequeathed his estate of approximately $1 million to the city to finance the

creation of a "fountain(s) [that] shall include one or more un-clothed, life-size male figure(s) designed in the classical style, i.e. realistic."[14] The City of Seattle, the beneficiary named in Smailes's will, declined the bequest and agreed to assign all of its right, title, and interest in the bequest to the Seattle Art Museum for the Olympic Sculpture Park as the entity most capable of realizing Smailes's intention. In a "Memorandum of Agreement between the Estate and the Museum," contingent on approval by the King County Superior Court, which it ultimately received, the estate's three-person oversight committee agreed to this arrangement. The memorandum outlined provisions including the advance approval of the oversight committee throughout the process of design, construction, and completion of the fountain. In 2003, SAM presented a shortlist of artists to the committee and, with its

members' approval, the museum invited proposals from Louise Bourgeois, Eric Fischl, Robert Gober, Antony Gormley, Zhang Huan, Glenn Ligon, and Kiki Smith.[15]

The bold proposals ranged from Zhang's monumental pagoda fountain, in which a figure was held aloft on the back of a turtle, to Smith's foreboding installation of life-size endangered species figures, including man and woman, set against cascading fountains, pools, and a geyser. The committee was especially drawn to the subtle beauty of Ligon's proposal inspired by the myth of Narcissus from Ovid's *Metamorphoses*. Ligon's design called for a twenty-foot circular basin made of reflective black granite with a sloping floor, surrounded by a polished concrete wall and ringed by texts from Ovid's poem inscribed on contrasting paving stones. Two bronze figures of African American men, one above and one below the water, would gaze at one another, although their differing poses would complicate their relationship. The estate's committee considered the quietude of Ligon's work in connection with the site's cacophony of activity and ambient urban sound and discussed whether it might be equally lost when viewed either from the height of the overhanging bridge or on axis with the bike path or Broad Street corner. The strong verticality of Bourgeois's proposal, *Father and Son*, with its potential to take physical command of so many intersecting spaces, ultimately won the approval of the Smaile's estate oversight committee.

*Father and Son* features two classically sculpted nudes, a father and son, atop high poles within a broad, elliptical catch basin. Just over life size, their proportions are slightly exaggerated to compensate for the foreshortened perspective of the viewer standing below. The artist selected stainless steel so that the figures would seem to

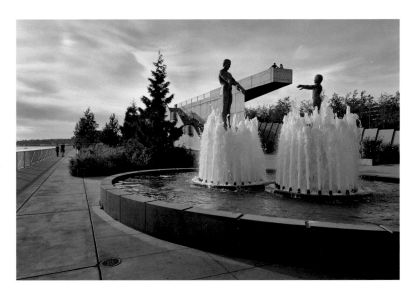

disappear within the flowing fountain. A concealed timer marks the twenty-four hours of the day. On the hour, a bronze bell tolls, pitched to a perfect F sharp.[16] As the bell strikes, the timer triggers the water to rise on one figure and descend on the other. The following hour, the pattern alternates so that the father and son never appear simultaneously. The stainless-steel figures, when revealed, seem suspended like ciphers in the air above the water. The brushed satin finish and softly modeled surfaces catch the light and shimmer with watery reflections. The water suggests both an insurmountable chasm and a life-giving force; the figures stand vulnerable before each other in their physical and emotional nakedness.

It was the artist's intent that the figures be separated by two distinct, cascading water "curtains," always keeping one figure hidden. Hydraulic engineers specially designed jets capable of thrusting great quantities of water up into the air and over the figures and rigorously tested full-scale mock-ups in Toronto. The volume of water needed to create the aesthetic effects that Bourgeois specified—disabling the father and the son from making contact or ever seeing eye to eye—was immense and ultimately drove the size and depth of the fountain's basin. Innovation does come at a cost. The fountain is

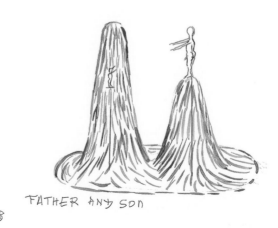

FIGS. 4.14, 4.15
Louise Bourgeois,
*Father and Son*,
2004, watercolor,
graphite, and
ink on paper,
8 × 9½ in. each.
Seattle Art
Museum: Gift
of the artist,
2005.30-31.

expensive to run and maintain, and the fountain's required use of potable drinking water and its energy demands may become unsustainable in the future. Due to climate change, Seattle is experiencing colder winters than it did at the time the fountain was commissioned. Wind at the water's edge is ever more changeable. At times, both figures are exposed as water levels drop, barely covering their bases (fig. 4.13). This alters the artist's intent and, therefore, the work's meaning.

The "meaning" of *Father and Son* also shifted with the winds of public opinion. The Seattle Art Museum released the artist's proposal and drawings to the local media in fall 2005 (figs. 4.14–15). Upon selecting Bourgeois' proposal, the Smailes oversight committee felt its subject, the relationship between fathers and sons, was timely and relevant, with more fathers than ever before playing expanded roles in their children's lives. However, when the drawings were published, conservative media outlets looking for a "splash" turned some opposition to the figures' nudity into sensational headlines. Thus began the "nude dude" controversy. On September 29, 2005, Ken Schram of KOMO television in Seattle titled his commentary "Putting Pedophilia on a Pedestal?" "It's not about the penis," he argued, it was the work's "aura of pedophilia. . . . The sculpture might

as well be called the priest and the altar boy."[17] Adding fuel to the fire, a Seattle-area pastor, Joseph Fuiten of Cedar Park Church in Bothell, Washington, and chairman of the Faith and Freedom Network, an evangelical Christian lobbying group, was quoted in the *Los Angeles Times*: "When we have children, we teach them that if a child is approached by a naked man, it's simply not appropriate."[18] This scaremongering narrative resulted in a racist and homophobic mischaracterization of the artist's identity; one critic alleged that Louise Bourgeois was "a gay, male, Latino named Luis."[19] The museum rallied to the defense of the artist and her fountain. Today, *Father and Son*, like another public art collaboration between SAM and the city, Jonathan Borofsky's landmark *Hammering Man* sculpture in front of the museum's downtown Robert Venturi building (see fig. 1.13), is both a beloved icon and a central meeting place for families visiting Seattle's park for art.

Some planned projects could not be realized. For example, after seeing a successful water feature on the Arthur Ross Terrace, the roof adjacent to the Rose Center for Earth and Space at New York's American Museum of Natural History, SAM's director Mimi Gardner Gates expressed enthusiasm for the Olympic Sculpture Park to have something comparable to engage children. She did not want the park to become too

precious or feel unwelcoming to families; "Do Not Touch" signs send mixed messages in a park that was built without walls to convey a sense of being "free, open, and accessible." The museum invited Olafur Eliasson, Cai Guo Qiang, Buster Simpson, and Trimpin to propose interactive water features for the area adjacent to the pavilion.

Cai Guo Qiang's concept, *Flowing Water Charmed Encounters*, was favored as a symbolic means for connecting the park with the Seattle Asian Art Museum and its commitment to both historical and contemporary Chinese art. His proposal was inspired by landscape elements in his native China. It featured an artificial stream animated by a series of oversized deer scares and a waterwheel that would pull rain runoff from the pavilion roof through the inside of the building, across the terrace, down the slope and into the valley precinct, providing nourishment for the plantings and creating its own ecosystem. The meandering indoor stream would have chairs scattered beside it and rocks that served as tables, with underground pipes taking surplus water out to Puget Sound.

Members of the Artistic Program Committee raised concerns, however. How would the water stay clean enough for children to touch? What if there was inadequate rain? How would the indoor stream impact pavilion use? The artist generously revised his proposal several times. However, it became increasingly clear that any water feature would create permanent limitations on site usage and entail significant maintenance and running costs that the museum would need to negotiate in perpetuity.[20]

The berm, with its steep slope, also posed challenges. The museum identified this site as ideal for an ambitious seating project with the view over the water, making for a spectacular communal gathering space. Vito Acconci proposed *Re-Making Nature: A Park of Highways*, an extravagant, extensive redevelopment of the precinct. Roy McMakin proposed *Shoreline*, in which the berm became an artificial "beach" with sculptures imitating sea detritus for seating. Pedro Reyes proposed *Rock Skeletons: Benchscape*, dynamic sculptural forms as topographic seating areas. After SAM selected Reyes's proposal, technical review of the artist's components for the site revealed that Weiss/Manfredi's elevated topography, while dramatic, was not sympathetic to commissioning or installing art. This "plinth" would need modification. The museum pushed pause on the proposals and altered the berm to a grade of 1:3, adding a flat area for Roy McMakin's *Love & Loss*, which was commissioned later as an alternative to his original *Shoreline* proposal. Reyes instead created new work for the pavilion—his inhabitable *Capula XVI (obolo a)* and *Capula XVII (obolo b)* (both 2006) (fig. 4.16, see fig. 5.9) and a temporary wall frieze (see fig. 5.10). Ironically, both of Reyes's works draw on the history of unrealizable utopian architecture and avant-garde constructions.[21]

McMakin's *Love & Loss* introduced into the park's artistic program works that blur the line between practical objects and sculpture (see pp. 116–17). The artist, who at the time lived in Seattle, was already renowned for exploiting the tensions between the usually separate creative activities of sculpture, architecture, and design. Some of his objects retain only vestiges of their usual functions, confounding our expectations of their purpose and meaning. Double entendre—sometimes visual, sometimes verbal—is a recurring motif in his work. Dramatic and sudden shifts in scale and perspective also call into question the

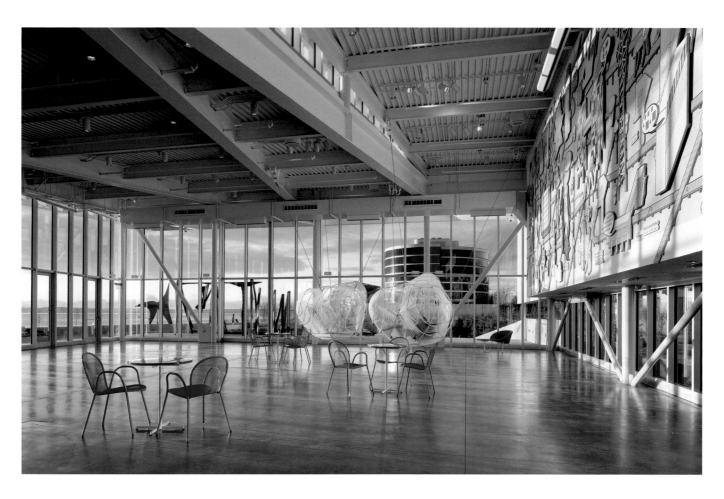

purpose of his forms, signaling in *Love & Loss*, for example, that these are no ordinary, utilitarian benches, even when we are invited to sit upon them. These are benches with "content." *Love & Loss* consists of *L*, two curved benches, one with the dimensions of a loveseat for two, another a mischievous loveseat for three; *O*, a reflecting pool; two *S* forms denoted by a path and swirl of seating; *V*, a pruned, partly painted tree; and *E*, a curvy picnic table surrounded by stools. A red, illuminated ampersand perched high on a pole connects *L*, *O*, *V*, and *E* to *L*, *O*, *S*, and *S*, just as the work's title connects the dualistic nature of these most human of sentiments to the cycles of nature—the *V* tree blossoms in the spring and loses its leaves in the winter. For McMakin, the "love" and "loss" also refers to the city of Seattle itself. Its lonely neon ampersand mourns the disappearance of the quirky signs that shape a

city's individuality, like the iconic 1950s pink neon elephant advertising Seattle's first touchless carwash, recently demolished. These are the unique visual textures that gave Seattle its character and attitude before the city was radically altered by decades of unchecked growth and increasing wealth.

This erasure also extends to the displacement of populations due to the rise in Seattle's real estate values and the high cost of living in a city dominated by richly compensated tech workers—a modern-day echo of the displacement of the region's Indigenous peoples who once camped on these shores (see figs. 6.2 and 7.3). Until recently, the Olympic Sculpture Park site was inhabited by multiple communities who lived in the margins of the city during the period of rapid change sparked by the late twentieth-century tech boom. Artist Glenn Rudolph began photographing occupants of

this and other disused sites around Seattle and the West in the late 1980s, and SAM featured some of these images in an exhibition in the park's pavilion when it opened. Rudolph's work provides an unflinching snapshot of the daily lives of individuals and groups pushed to the margins of Seattle beginning in the 1990s, casualties of the city's sudden, unequal economic growth. Rudolph captured his subjects—Coast Salish peoples from across the Pacific Northwest, frequenters of the ironically named Millionaire Club (a charity serving the homeless on nearby Western Avenue), migrant workers, and hobos—in the interstitial space that would soon become the sculpture park. Some were old-time rail riders like *Barry the Trainman/Walkman* (1986, fig. 4.17). Hiding in the bushes along the tracks, they would hop on and off freight trains waiting for a green light to move through a tunnel exiting Seattle, hitching rides to more hospitable rural towns across the West. In *Boat* (2006, fig. 4.18), a woman suffering from mental illness, a resident of a local halfway house, peers over a fence at the same spot she visited day after day to chain smoke overlooking Puget

Sound. *Joey* (2005, fig. 4.19) portrays a temporary worker from Ketchikan, Alaska, who slept on cardboard boxes and performed hauling work on the Microsoft campus. Using extreme contrast and backlighting, Rudolph photographed individuals crouched in the tents of homeless camps and hobo jungles, their existence pushed emphatically into the foreground, the ghostly specter of rising Seattle skylines hovering ever closer to their precarious existence. Rudolph's portraits of these itinerant residents are a stark reminder of those left out of the romantic myth of Seattle as a progressive utopia, including those who were displaced by the development of the Olympic Sculpture Park.

Rudolph's images throw down the gauntlet for the Seattle Art Museum and its future approach to both the artistic program of the Olympic Sculpture Park and its relationship to its city. SAM has a responsibility to offer experiences that make visible what might be more conveniently left concealed—experiences that do not suppress the complexity of Seattle's history or its present but, rather, excavate and amplify them. When the park

FIGS. 4.17, 4.18, 4.19
Glenn Rudolph, *Barry the Train-man/Walkman*, 1986, gelatin silver print, 41 × 31 in.; *Boat*, 2006, gelatin silver print, 31 × 41 in.; and *Joey*, 2005, archival digital print, 31 × 41 in. PONCHO and the Mark Tobey Estate Fund, in honor of the 75th Anniversary of the Seattle Art Museum, 2006.50, 2006.43, 2006.52.

FIG. 4.20
Au Collective
dance company
performs in
the Olympic
Sculpture Park's
valley precinct
with Richard
Serra's *Wake*
(2002–3), 2017.

opened, new works by artists introduced to Seattle for the first time complemented public artworks by artists from the region already located within close proximity. SAM's curators continued this balance through imaginative temporary projects and performances.[22] For example, the museum's 2020 winter Artist in Residence Program at the park featured Kimberly Deriana (Mandan/Hidatsa), an architect and artist specializing in sustainable, environmental Indigenous architecture, housing, and planning. Deriana took up residence at the Olympic Sculpture Park to research, workshop, and realize a site-specific project. There remains much untapped creative potential to catalyze critical reflection of where Seattle has been and where it is going at a particularly urgent moment of reckoning in the region and in our nation. SAM can specifically seek opportunities for artists and programs to engage with the park's site itself—land as contested terrain and as home to Indigenous peoples and settlers, to immigrants from across the world and innovators from across the country; land as a natural resource to be exploited, to be commodified, and to be healed. It is time for SAM to respond

to calls for a long-overdue permanent work to be commissioned from an Indigenous artist, since the park is located on the ancestral lands of the Coast Salish peoples.[23] SAM should also expand its presentation of works by artists living beyond the borders of the United States; Seattle is now, and has been for over a century, a global city with strong ties to China, India, Japan, Korea, and Mexico. The grassy steps leading to Richard Serra's *Wake* were conceived as a gathering place, the valley floor an event platform (fig. 4.20), and the pavilion a space for convenings. Activating these spaces as plinths spotlighting public discourse, dialogue, and debate would amplify the museum's commitment to playing a meaningful role in the civic life of Seattle and complement the yoga classes, dance performances, and social events that take place at the park. The genius of the Weiss/Manfredi design is its malleability, its extraordinary capacity to respond to its context. By rooting the park's program in what makes Seattle a city like no other—its history and the ideas, issues, and dreams of all its citizenry—SAM can leverage their design to better meet its promise to give

Seattle "a park like no other." Many museums have adjacent sculpture gardens, but the Olympic Sculpture Park, created in a generous, civic-minded spirit, is particularly distinct for being some distance from SAM's front door at the opposite end of town. For the diverse visitors who meander the length of its zigzag path each day, the park has become the new front door to the museum and a great, green welcome mat. A park without walls flowing seamlessly into the city is an apt embodiment of SAM's vision, "to connect art to life." This is an auspicious moment for SAM and its sculpture park to even more fully embrace this aspiration.

## Notes

This text is an excerpted and updated version of my essay "Creating Place in Seattle," which appeared in *Olympic Sculpture Park* (Seattle: Seattle Art Museum, 2007), 24–61.

1. In January 1973, the Seattle Arts Commission successfully proposed two of the country's earliest percent-for-art programs, to both the City of Seattle and King County councils, recommending that "all requests for appropriations for construction projects from eligible funds shall include an amount equal to one (1) percent of the estimated cost of such project" to support the "selection, acquisition, and/or installation of works of art to be placed in, on, or about public facilities" (*Seattle Times*, January 24, 1973). See Alan J. Stein, "Seattle's 1 Percent for Art Program," HistoryLink.org, essay 10645 (October 18, 2013), http://www.historylink.org/File/10645#:~:text=In%201973%2C%20Seattle%20passed%20a,%26%20Culture%2C%20advocated%20the%20program. Upon its installation in 1975, Tony Smith's *Moses* (1968), located at the Broad Street Green at the Seattle Center, became the first major public art acquisition under Seattle's percent-for-art program.

2. The three other works were a reclining figure by Henry Moore, *Three Piece Sculpture #3: Vertebrae* (1968, cast 1969), installed across from the Seattle Public Library, which the museum declined to move amid concerns over public disappointment; Mark di Suvero's *Schubert Sonata* (1992), a kinetic sculpture installed on the roof of Benaroya Hall, home to the city's orchestra, which was later relocated to the sculpture park (see pp. 158–59); and a work by David Smith, deemed by conservators at risk from the elements and unsafe to exhibit outdoors.

3. These collections favored artists including Anthony Caro, Louise Nevelson, Beverly Pepper, David Smith, Tony Smith, and Mark di Suvero. Virginia and Bagley Wright generously offered SAM a number of outdoor works then situated on their property, from which the museum chose five as gifts for the Olympic Sculpture Park.

4. According to the artist, the title, *Wake*, was a tribute to his friend and lifelong supporter Kirk Varnedoe, a curator at the Museum of Modern Art (MoMA) who died prematurely of cancer in 2003. Varnedoe had been planning a retrospective exhibition of Serra's work when he died. Lisa Corrin and Richard Serra, interview transcript, press event held at Weiss/Manfredi Architecture/Landscape/Urbanism, New York, September 2004, p. 3, Seattle Art Museum archives. *Wake* also refers to water; the steel forms suggest the water streaming behind a moving ship and the looming sides of the ship itself. Sheila Farr, "'There's Nothing Else Like This in the Country' for Outdoor Art Says Artist," *Seattle Times*, July 25, 2006.

5. Richard Serra, quoted from an interview with Hal Foster, in *Richard Serra: The Matter of Time*, ed. Carmen Giménez (Bilbao: Guggenheim Museum Bilbao and Steidl, 2005), 36.

6. Richard Serra, quoted in Farr, "There's Nothing Else."

7. See Serra and Foster interview, in Giménez, *Richard Serra*, 36.

8. Smith conceived *Stinger* in a 1967 maquette for the exhibition *Art of the Real* (1968), where it was installed in MoMA's sculpture garden. The Olympic Sculpture Park work was posthumously cast in 1999. Smith named the sculpture for a popular cocktail, whose sweetness masks its intoxicating effects. *Stinger* resembles an impenetrable fortress, but then, with a twist similar to the effect of its namesake, one partially open side invites viewers to enter, gently enclosing them like a familiar embrace.

9. Michael McCafferty, former director of exhibition design, and SAM's registrars and art handlers collaborated on the original siting of the works, most of which remain in place.

10. The description of the landscape plan in my text is indebted to several conversations with Anderson in fall 2005.

11. Charles Anderson hoped that the rustling of quaking aspens in the breeze, as they matured, would increasingly buffer the heavy traffic sounds, turning it into ambient white noise. I hoped that this would become an ideal precinct for installations involving sound.

12. I had accepted my first director's position, at the Williams College Museum of Art, in 2005, so a team of artists, architects, fabricators, and installers executed the artistic program I developed under Renée Devine's supervision. I remained involved electronically from a distance, coming to Seattle for key moments during the installation.

13. In a fax dated May 25, 2004, Dion emphasized the importance of remaining "vigilant that . . . none of us want a building," but that the greenhouse "must embody some rather contradictory conception—monumental but ephemeral, totally invisible from the park yet spectacular from the street . . . a purpose-built structure." In an email dated October 27, 2005, Renée Devine wrote to the *Vivarium* project architect, Owen Richards, "Mark is adamant that this solution is unacceptable to the Artwork. Mark feels that it is very disrupting to the sight lines within the greenhouse to introduce a diagonal against the very strong grid pattern that is created by the tiles and the frieze. . . . The down-spout would create too much interference" with a number of components Dion had planned. The artist specifically asked for the down-spout to be located along the east exterior wall, near the rainwater storage tanks. For this correspondence, see Seattle Art Museum archives.

14. Quoted from the "Last Will and Testament of Ernest Stuart Smailes," prepared by the Law Office of Timothy Bradbury, Seattle Washington, and signed on December 18, 1996.

15. Smailes's lawyer, Timothy Bradbury, elaborated on the donor's intention for the fountain in a letter dated December 3, 2003, to the author and Erik Pihl, then SAM director of development. "The [committee] members realized that one design element is the quantity of water used in the fountain. The committee is of the opinion that Mr. Smailes preferred a fountain where the amount of water is not subtle." This was another reason why they questioned whether the Ligon proposal met Mr. Smailes's intentions. In addition, Bradbury pointed out, "It is important for the artists to remember that Mr. Smailes intended the sculpture to be realistic and an intact male. . . . Mr. Smailes intended that the sculpture celebrate the male nude in his entirety." Upon hearing this, Robert Gober politely declined to submit a proposal. See correspondence from the Law Office of Tim Bradbury to Lisa Corrin and Erik Pihl, December 3, 2003, 3, Seattle Art Museum archives.

16. The bronze bell was cast in Amsterdam.

17. "Ken Schram Commentary: Putting Pedophilia on a Pedestal," transcript from KOMOTV.com, September 29, 2005.

18. Sam Howe Verhovek, "Plan for Statue of Nudes Exposes Seattle's Modesty," *Los Angeles Times*, October 2, 2005, http://www.latimes.com/archives/la-xpm-2005-oct-02-na-statue2-story.html.

19. Robert L. Jamieson Jr., "Right Wing Having an Art Attack over Nude Sculpture," *Seattle Post-Intelligencer*, October 1, 2005.

20. In recognition of its commitment to Cai's work, the museum would later temporarily install his *Inopportune: Stage One* (2004), suspended over the lobby in its newly expanded downtown location.

21. Today, the *Capulas* are in storage at the museum awaiting conservation.

22. The Seattle Art Museum published *Seattle Art Museum Olympic Sculpture Park 2007–2017* to commemorate the ten-year anniversary of the park and highlight the curated temporary installations and programming in the pavilion and throughout the park during its first ten years.

23. See Sue Peters, "Broken Promises?," in *Seattle Weekly*, February 12, 2007, http://www.seattleweekly.com/arts/broken-promises/. The park has labels for plants of medicinal value written in Lushootseed, the native language of the local Coast Salish peoples (see pp. 136–37), but as yet no permanent works of art by Indigenous artists.

# On Commissioned Works
# for the Olympic
# Sculpture Park

Artist Interviews with
Lisa Graziose Corrin
in association with
Renée Devine

## Mark Dion
### *Neukom Vivarium*

**Lisa Graziose Corrin**   When shaping your proposal for the *Neukom Vivarium* (2004–6, see figs. 4.7, 4.10–11), how did you define "site"?

**Mark Dion**   My work always starts from an encounter with the site, but as an expanded idea; the site is not merely the place, but the social history, the culture, the ecological history, people, and the zeitgeist. What struck me about Seattle was the impressive environmental literacy of its population. Years of environmental education had produced the benefit of a well-informed citizenry concerned about the natural world.

This also extended to how people in Seattle spend their leisure time. When working in the offices of the Seattle Art Museum, I noticed that the staff, coming back from their weekends off, did not talk about the cocktail and dinner parties they attended or the exhibitions and seminars they visited over the break, as they might in New York. Instead, they spoke about the hikes and kayak trips they took or the mountains they climbed. Seattle-ites have a deep and joyful connection with nature. When I first visited the city, locals would not ask me if I had seen Alexander Calder's *The Eagle* (1971) or the museums, but rather had I visited the salmon ladder at the Ballard Locks. From that, I understood how the notion of nature as a process was important to the people of the city.

Seattle in a sense of the European settlement is a young city. Not so long ago, a forest inhabited by Coast Salish peoples was in the very spot where the city's center, a mega transnational capital, now stands. I wanted the tree, this vast nurse log, to be an ambassador from the banished forest to the city (fig. 5.1).

**CORRIN**   The commission for the Olympic Sculpture Park was not your first *Vivarium*.

**DION**   I had already made two much smaller versions. One of these was indoors and one outdoors. They both highlighted the productivity of a dead tree as the host of hundreds of other organisms. In the case of the *Vivarium* in Düssel-dorf (2002), the work was also intended as a critique of the particularly hygienic forestry policies that privilege tree farms over forests.

FIG. 5.1
Artist Mark Dion watches the installation of the nurse log for *Neukom Vivarium*, June 2006.

119

It was not until I visited the forests of the Pacific Northwest that I fully understood the potential and depth such a work could have.

FIG. 5.2
Mark Dion, concept drawing for *Seattle Vivarium*, 2005 (scientist in white lab coat [Mark] with young girl and nurse log installation), watercolor on paper, 5¼ × 7¾ in. Gift of Sally and William Neukom, American Express Company, Seattle Garden Club, Mark Torrance Foundation, and Committee of 33, in honor of the 75th Anniversary of the Seattle Art Museum, 2007.1.5.

**CORRIN**  How did your experience of the Pacific Northwest forests transform the ambition of your thinking and the scale of what you proposed?

**DION**  I had spent my young life in the woods, exploring and playing. However, the scrappy forests I encountered had been cut to a nub at least twice. They were examples of resilient succession but they did not prepare me for the Pacific Northwest's primary forests, woods with all the parts of the ecological puzzle still intact. That was where I encountered the idea of the nurse log—the dead tree that *releases* its bound energy for the next generation of forest to exploit (fig. 5.2). In temperate rainforests, the valuable nutrients in the environment are washed out to sea, however they were once captured and used in the trees. In the Pacific Northwest, when one of the forest giants dies or falls, the bound energy is quickly exploited by organisms including sprouting trees. There is something marvelously affirmative and incontrovertible in this process. If ever there was a way to understand nature as a process, this was it.

**CORRIN**  Collaboration across many disciplines is central to your artistic practice.

**DION**  Often my work takes the form of team building. This piece necessitated a broad scope of expertise. In addition to strong contributions from you, Lisa; from Marion Weiss and Michael Manfredi and Owen Richards, the project architects; and from Renée Devine, the project manager, the *Vivarium* was shaped by dozens of discussions with a team of experts in forestry, ecology, environmental education, hydrology, lighting engineering, nature illustration, etc.

**CORRIN**  The result is a work that enlivens all the senses and raises profound questions about the nature of art.

**DION**  At the core of the project was my own melancholic approach to the culture of nature, but it also expanded my vocabulary beyond the use of sight. The work's success is dependent on how it motivates all the senses; on how it is immersive. When one enters the *Vivarium*, the smell immediately transports you to the forest. The quality of the air and humidity are different. Being in the building can feel like being in the belly of a whale. The sounds of the structure maintaining itself—the vents opening, the shade coming down, the sprinkler and fans turning on—can be quite uncanny. I think I learned from this project, more than any other, the power of full immersion.

**CORRIN**  What is your intention in "exhibiting" a tree on the plinth, like a Duchampian readymade?

**DION**  I could not be less interested in the notion of the readymade. The idea of recontextualizing something within the realm of art has to be richer than mere relocation of an object.

I am interested in the nurse log because it is so much more than a thing. It is a habitat, a process, a life-generating dead organism. The art work is not merely the tree, or the tiles, or even the building—it is the entire complex of all the parts.

**FIG. 5.3**
Mark Dion, concept drawing for *Seattle Vivarium* (plan view), colored pencil on paper, 11 × 14 in. Gift of Sally and William Neukom, American Express Company, Seattle Garden Club, Mark Torrance Foundation, and Committee of 33, in honor of the 75th Anniversary of the Seattle Art Museum, 2007.1.6.

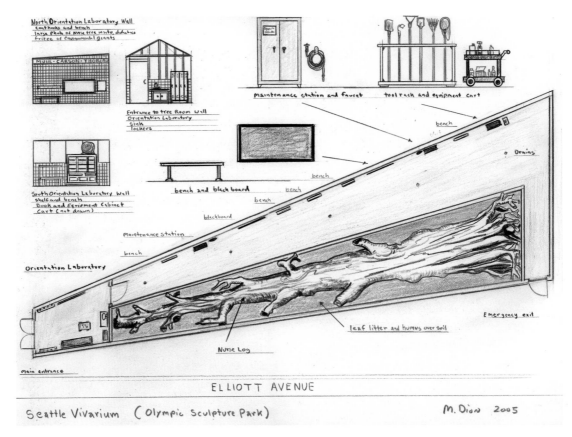

**CORRIN**   What about the element of time?

**DION**   The Seattle *Vivarium* is an artwork that will evolve and change. The tree is not a thing like one might find in a natural history museum, it is process. Visitors can come and see the *Vivarium* and it will never be quite the same experience. I have visited the work some dozen times and always find it a very different dynamic experience.

**CORRIN**   Why go to the trouble of moving a tree from a forest to a greenhouse in a city and then keeping it alive artificially with so much effort and investment?

**DION**   You are right there is a lot of apparatus and energy needed to maintain the nurse log's decay and forest's rebirth. This equipment and infrastructure are flagrant, extremely visible, and foregrounded rather than hidden. I wanted to reveal how many invisible systems the forest itself provides—respiration, hydrology, nutrient recycling, temperature regulation, etc. The intent is to foreground integrated ecological systems to give a sense of how much energy it takes to replicate what the forest floor does for free.

The Seattle *Vivarium* is a kind of garden and, like all gardens, it is an example of philosophy made concrete. It is built to express the idea that in nature, even death has a productive and rejuvenating function. It is a work about the interconnectedness of things, more than it is some kind of *science* experiment. All the other elements in the work—the antechamber, the tile frieze, the apparatus, architecture, the morgue-like interior—are designed to express the process of nature's cycles, while at the same time emphasizing the contradiction that the *Vivarium* itself is an artificial and theatrical structure (fig. 5.3). Without this contradiction, the work would be merely an illustration.

# Teresita Fernández
## *Seattle Cloud Cover*

**Lisa Graziose Corrin** What shaped your vision for *Seattle Cloud Cover* (2004–6), the specially commissioned artwork that takes the form of a walkway and bridge? How did the location and the unique qualities of the site influence the way you approached the commission?

**Teresita Fernández** The site was just two brownfields. I had to imagine the elevated landscape designed by Weiss/Manfredi. On a practical level, the challenge was to connect these two areas over the railroad tracks. It had to be both bridge and walkway, a passage to shape the experience moving from point A to point B (fig. 5.4).

I was interested in the surrounding landscape, and how the work could become a viewing mechanism for everything that was around it—Puget Sound, the distant Olympic Mountains, the city and the skyline of Seattle. I wanted to

create a canopy as a lens over the city where you would see everything through a constantly changing glass screen. Viewers themselves are moving as they are simultaneously seeing everything around the work changing. The most important thing to me was that the piece would be experienced on the move.

**CORRIN** Where do the sky images come from? They certainly do not look like Seattle skies.

**FERNÁNDEZ** The work comprises thousands of images taken in Miami, my hometown, which has incredibly dramatic sunsets (fig. 5.5). The title, *Seattle Cloud Cover*, contradicts these images since Seattle is stereotypically described as gray and gloomy. The jolt of saturated color enables you to see what you expect differently. I was also thinking about and questioning the history of

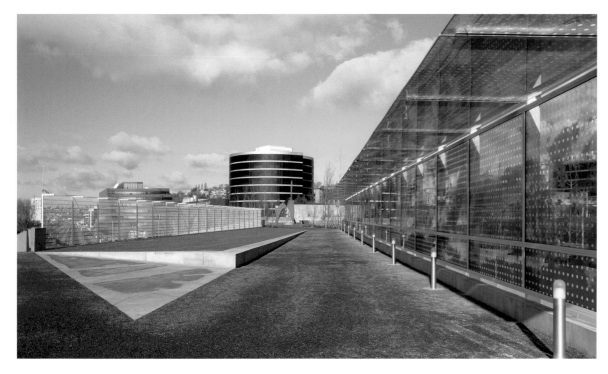

FIG. 5.4
Teresita Fernández, *Seattle Cloud Cover*, design approved 2004; fabrication completed 2006, laminated glass with photographic design interlayer, approx. 9 ft. 6 in. × 200 ft. × 6 ft. 3 in. Olympic Sculpture Park Art Acquisition Fund, in honor of the 75th Anniversary of the Seattle Art Museum, 2006.140.

landscape painting—the grandiose views of French Romantic and Hudson River School landscapes; abstract color-field painting such as that of Rothko; and less art historical references such as Japanese anime.

CORRIN    When I lived in Seattle, the weather would begin one way in the morning and be very different by the afternoon. People walking over the bridge are in motion, and so are the skies. Trains below are in motion as well. Depending on the weather, the work comes to life in a completely different way. The light goes through the portals and you see those intensely colored images reflected on the concrete fences running alongside the railroad tracks (see fig. 3.10; pp. 16–17). If you were on a train moving past them, you would see this extraordinary panorama of color. It just appears and suddenly, as you whiz by, it is gone.

FERNÁNDEZ    I imagined the site of the bridge as being this place that was constantly being animated by the train activity directly underneath. There's an awareness of a subterranean area below the piece, as if you are on the third floor of a building but you know that something is happening on the second and first floors—an awareness of experiencing different planes simultaneously.

CORRIN    What about the role of time in the work?

FERNÁNDEZ    I'm interested in slow sculptures, like a bonsai tree or a melting glacier. *Seattle Cloud Cover* is like a barometer of the ever-shifting city and its atmospheric conditions. There are times, depending on the angle of the light, the seasons, and the presence of the quivering aspen trees, when the whole piece just lights up and becomes very rich and dramatic. And then there are other times when it looks like not much at all. I think of viewers as each being their own individual version of "the public."

CORRIN    How did the creation of *Seattle Cloud Cover* affect your work afterward?

FERNÁNDEZ    *Seattle Cloud Cover* was an enormous opportunity for me to be able—at that early stage in my career—to work large scale, and to actually create something that lives in the landscape. It taught me about how—in ways that still inform my work—there's a kind of intimacy that prevails working on a monumental scale, a deeper understanding connecting intimacy with individual experience, seeing viewers as both spectators and performers. Since then, I have continued to explore this notion of "stacked landscapes"—the idea of being in more than one place at once.

CORRIN   It literally becomes a stacked landscape between the landscape of Miami captured in the panoramic images, the landscape of the park itself, and then the landscape of the city.

FERNÁNDEZ   Yes, many of our conventions for seeing are based on the cinematic. When you're watching a film, one frame is projected, then the shutter closes, then the next frame is projected, then the shutter closes, and that happens at an accelerated speed. But what really happens when that shutter closes is that the first image that you saw still exists on the back of your retina as a ghost image, an after-image, so that when the new frame appears, it looks like it is seamlessly connected to what came before. It appears seamless precisely because of how your eyes work. *Seattle Cloud Cover* is a lens showing downtown Seattle appearing in and out of those clear, round openings. When you speed that up by walking faster, it creates this flickering effect, like an early cinematic zoetrope device.

CORRIN   It is both an appearing and a disappearing landscape.

FERNÁNDEZ   Exactly. And conceptually, that idea is key—the landscape is often more about what you don't see than what you do see. In *Seattle Cloud Cover*, the landscape is transformed by these shifting, color-saturated clouds. And the piece is really about locating yourself within that experience (fig. 5.6).

CORRIN   It is about the viewer. The technique that you used to create the glass panorama is also a sandwich.

FERNÁNDEZ   It is. The photographic montage interlayer was sandwiched between layers of thick glass. While we don't typically think of glass as being related to the landscape, glass is made out of sand. It literally is the landscape, as are most materials.

CORRIN   Much of your work is about the hidden meaning of the material itself.

FERNÁNDEZ   Yes, I am interested in this kind of material intelligence—how the material is a physical manifestation of the concept informing the work. In *Seattle Cloud Cover*, the specificity of glass is important. We think of glass as solid, but it's really a suspension—something that is liquid that has solidified, but which is very slowly shifting.

CORRIN   A bridge is a construction suspended over two spaces.

FERNÁNDEZ   My work is about how we construct ideas about what landscape is. Landscape is not just land. It is also our preconceived notions, our own biases. The way places are named, for example, is about who has control over them. Who has agency over the story that is told about the same exact landscape is part of its expanded meaning.

CORRIN   When the Hudson River School painters created their work, the landscape they represented did not exist anymore—it was far from a pristine wilderness.

**FERNÁNDEZ**   It was, in fact, a thoroughly human-ized landscape, managed and kept sustainable by Indigenous peoples for hundreds of years. Our ideas about Hudson River School painting are a fabrication, a romanticized notion of the American landscape depicted as an untouched paradise before European contact—that's a construct. My work is about breaking down and questioning built-in biases.

**CORRIN**   It is about the complexity of seeing, the eye as an engaged organ connected to a bigger context. What differentiates a merely functional bridge that keeps visitors from tossing things onto the railroad tracks is that it is a bridge that creates meaning. When curating the park, I wanted these kinds of works built into the infrastructure of the park to provide critical moments of reflection.

FIG. 5.6
Detail of Teresita Fernández's *Seattle Cloud Cover* (2004–6).

**FERNÁNDEZ**   When art does do that, there's this quality of self-reflection that's really valuable because you see yourself in the work. When we are engaged and moved by artworks, it is because we have seen ourselves in them somehow.

What I am doing now still has everything to do with place. Understanding where you are is crucial when we think about social justice. If you under-stand where you are as a kind of active, social location, you can start to understand who you are, which means you can, then, figure out who you are in relation to other people.

These ideas may seem unrelated to *Seattle Cloud Cover*, but it is actually the most important element that I learned from this work. The work functions as a cue that asks you to slow down, to be disoriented, so that you might see in a new way. You literally and metaphorically find yourself through that mediated landscape.

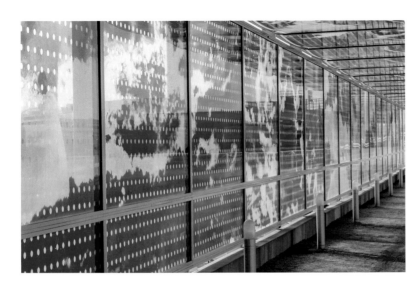

# Roy McMakin
## *Love & Loss*

**Lisa Graziose Corrin**  What shaped your vision for the Olympic Sculpture Park commission?

**Roy McMakin**  Prior to *Love & Loss* (2005–6, fig. 5.7; see pp. 116–17), I developed several other proposals. Originally, I competed with other artists for a staircase/seating project on the berm.

**CORRIN**  It was a very steep site, and the design was altered at a later point because placing art there would have been difficult.

**MCMAKIN**  My original proposal required a stairway and a substantial footprint. You also had budget constraints. Eventually I was chosen as an artist but not for realizing any of these proposals.

**CORRIN**  We chose *Love & Loss* from among several ideas that you had already been thinking about. I thought it was the perfect match between conceptual complexity and accessibility for a broad audience.

**MCMAKIN**  One of the criteria we discussed was the capacity of the piece to be understandable to people who don't come to the park with a strong experience in how to read contemporary art, but also at the same time, when people do have that experience, they are able to also get a lot from it.

**CORRIN**  How did the context of the park, the site, its history, the city of Seattle matter as you developed your proposal?

**MCMAKIN**  I had lived in Seattle for quite a while. It was my home. I felt a big sense of responsibility as an artist living there. I was being given this very fancy piece of real estate and I wanted to leave something that was meaningful and a legacy for my work.

There were some significant losses in my life at the time, from my mother's death to my father's death, to estrangements from my siblings, which triggered an upheaval in my life and my husband Mike's life. This led to us ultimately changing our lives and leaving Seattle.

**CORRIN**  The work can be experienced sitting in it, walking by it and looking up at it, or from the water, where it is like a message in a bottle. What message did you want to send?

**MCMAKIN**  I had a strong relationship to Puget Sound and my husband did, too, having grown up literally on the beach on Vashon Island. Riding ferries and being out on the water was a huge part of my life at that time.

I made *Love & Loss* just as Seattle started changing really fast. The spinning neon ampersand refers specifically to other kinds of charming neon signage, a sense of nostalgia for the built environment that was being lost. This subject is a

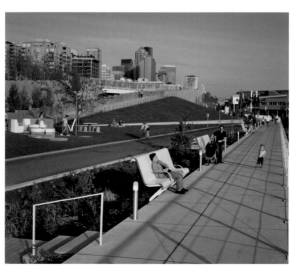

FIG. 5.7
The Olympic Sculpture Park waterfront promenade with Roy McMakin's *Love & Loss* (2005–6).

driving force within my life and in my work. The piece refers to a Seattle that was beginning to disappear. Its modesty and charm is the opposite of what Seattle now has become. The loss of loved ones and the loss of a city we care about are both important aspects of one's emotional life.

Mike grew up and lived much of his adult life in Seattle. People in Los Angeles where we live now ask him, "Do you miss Seattle?" He says, "Yeah, I miss Seattle, but the Seattle I miss is not there anymore." The one that he knew and he loved, right?

Before I came to Seattle, I was living in Southern California and Los Angeles, and I lived in a historic house by Irving Gill, the modernist architect who was so influential. Southern California was changing fast. A city evolves quickly. I had this overriding sense of loss for the hopes and dreams embodied in early twentieth-century architecture there. I just had to get away from what it was becoming.

In choosing Seattle, I felt there was potential for the city to evolve, but I thought maybe because the built environment wasn't as impressive or significant as that of early Southern California, that it would be less painful for me to see it evolve and get torn down. Later, when the crappy, modest, funky, blue-collar Seattle was being torn down, I discovered that I actually loved that, too. I became nostalgic for its vernacular signage, for example. The ampersand sign evokes signage like the famous elephant neon of the car wash near the Seattle Center and other old neon signs that were around at the time. Not to diminish the personal and human side of *Love & Loss*, which many people see in that piece; it just as strongly connects to my anguish at the destruction of the built environment that is beyond my control.

CORRIN  The work is conceptual, but its individual elements are also formally beautiful. When you see images of your sculpture online, they tend to focus on the bright red ampersand lit up against the sky. It becomes an abstract sculptural presence that echoes the color of Alexander Calder's *The Eagle* (1971) and the vermillion cranes in Puget Sound. It's both an ampersand that has a very specific meaning and a sinuous form that connects and completes the composition. *Love & Loss* is eloquent and elegant, and it is also utilitarian.

MCMAKIN  Utility and functionally are at the core of my work. I also design furniture and have created architecture. *Love & Loss* would not work if the visitors were not permitted to be in it. Yet, it is not the most efficient way to create park seating.

CORRIN  The functional dimension of *Love & Loss* is a delightful way of pulling someone into the conceptual rigor of your thinking.

Lightheartedness coexists in the work alongside this gravitas. You adore charm. *Love & Loss* plays with many of the conventions we find in parks, such as pocket garden spaces with delightful seating and small, delightful fountains. The *O* in your sculpture is, unexpectedly, a pleasant little birdbath.

MCMAKIN  It is funny to do that when you have the entire Puget Sound a few feet away from it (fig. 5.8). It's charming and poignant. Puget Sound can churn away sometimes and can seem unfriendly, even if it is beautiful. After all, you cannot just wade into it. I wanted to juxtapose alongside that immense body of water a very accessible, sweet little water feature that would be in contrast to the big, foreboding water out

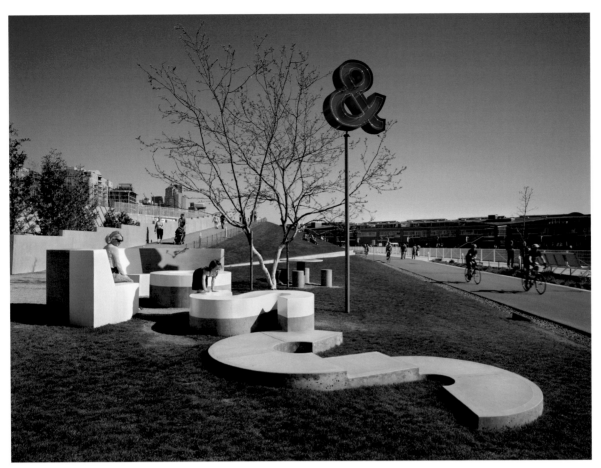

FIG. 5.8
Roy McMakin,
*Love & Loss*,
2005–6, mixed-
media installation
with benches,
tables, live tree,
pathways, and
illuminated
rotating element,
overall: 24 ×
40 ft. Olympic
Sculpture Park Art
Acquisition Fund
and gift of Paul G.
Allen Family
Foundation, in
honor of the 75th
Anniversary of
the Seattle Art
Museum, 2007.2.

there. People started putting coins in it. That was unintended. Whatever the reason, expressing wishfulness and the desire for good luck—that's a positive thing. There are a lot of contradictions in the work, or let's just say it's one thing and it's another.

CORRIN    There is also a lot of visual play in your piece. You identified the perfect tree to express the *V*. The white paint is always there, but the V-shape is only pronounced when the tree loses its leaves. It then disappears and shifts the focus from "love" to "loss." How did you choose the tree?

MCMAKIN    The criterion for the tree was obviously always the V-shape. I wanted a tree that was very ordinary, not something fancy. I wanted it to stay small and I wanted it to be charming.

It needed to be deciduous so that it went through leaf cycles and flowering. The interesting thing about the tree, and which is part of my intention, is that it obviously is going to die. This inherent mortality is embedded in the piece.

CORRIN    The artwork will also suffer a loss and, perhaps, so will the park. The Olympic Sculpture Park was intended as a place for connecting with art and with nature. However, fifty years from now, it may look and be experienced very differently because of global warming. Who knows what kind of tree will be able to thrive there fifty years from now?

MCMAKIN    A palm tree.

# Pedro Reyes
## *Capulas XVI* and *XVII* and *Evolving City Wall Mural*

FIG. 5.9
Pedro Reyes,
*Capula XVI (obolo a)* and *Capula XVII (obolo b)*,
2006, stainless steel and woven vinyl, each approximately 8 ft. 2 in. × 8 ft. 2 in. × 6 ft. 6 in. Olympic Sculpture Park Art Acquisition Fund and the Modern Art Acquisition Fund, in honor of the 75th Anniversary of the Seattle Art Museum; Commissioned from the artist by the Seattle Art Museum, 2007.3-4. On view 2007–8.

**Lisa Graziose Corrin**   You were originally asked to submit a proposal for an outdoor work to be located on a steep berm leading down to the bicycle and pedestrian paths along the water's edge.

**Pedro Reyes**   My proposal was titled *Rock Skeletons: Benchscape*. It proposed an artificial topography, with sculptures that had steps. These steps created a natural place for people to sit, both inside and outside the work, and to climb the sculptures. Inside, they were like little amphitheaters.

**CORRIN**   We realized that the berm was a challenging site for locating works of art, and the berm's design was later modified. We asked you to take your thinking indoors by commissioning several of your *Capulas* (fig. 5.9).

**REYES**   In addition to the site constraints, the weather in Seattle is rainy, so the outdoor seating would have been wet most of the year. I am happy with having shifted to working inside for the

activity that I wanted to foster in visitors, offering comfort to them and a place to chill (see fig. 4.16).

**CORRIN**   Your work emphasizes participation and individual agency in making meaning by challenging the privileging of individual creative authorship, as in Joseph Beuys's social sculpture. It stands in strong contrast to thinking about public sculpture as a static object in space. We wanted this practice represented in the range of definitions of sculpture encountered in the park.

**REYES**   For the pavilion, my idea was to create a place for people to hang out, which is something that you do quite literally in my inhabitable hanging pieces. You can enter the *Capulas*. They are functional sculptures, almost like furniture. You can occupy these spaces alone or in small groups. Their social dynamic is quite relaxing; people can spend as much time as they want in these spaces. Coming to the site and slowing down was an important part of my thinking. In a city that is so dynamic, I wanted to offer people an opportunity to stop and be comforted by the sculpture. The *Capulas* are a like a hammock or a rocking chair. There is a notion that doesn't exist so much anymore in the contemporary world—the role the rocking chair had on a porch, or lying in a hammock, which is to be there without doing anything. I was interested in that very basic experience within this acceleration of urban development in Seattle.

**CORRIN**   How has your background as an architect contributed to your approach?

**REYES**   Architects address needs that must be met and have problems to solve. It is curious that people think artists break rules, but I think that

what happens is quite the opposite—artists impose extra rules upon themselves. I often impose upon myself an extra rule—that work should also perform a function. Sometimes that function is political. Sometimes that function is architectural, environmental, educational, etc. When you expand yourself into the social space of art, you don't know exactly what the outcome will be. That's what is interesting. You have to set the limits of the game, but you don't know what the outcome of the game will be.

CORRIN    Rules result in play. What are the rules for the *Capulas*?

REYES    If a room is made of rectangles, the *Capula* shall be round.

If a room has rigid walls, the *Capula* shall be elastic.

If a room has an inside and an outside, the *Capula* shall be permeable.

If a room is grounded, the *Capula* shall hover.

If a room is steady, the *Capula* shall swing.

If a room has walls that block light, the *Capula* shall radiate light.

If a room creates a fixed field of vision, the *Capula* shall be kinetic.

If a room needs furniture, the *Capula* will turn itself into furniture.

If a room hides from view, the *Capula* allows a glimpse.

If a room is an ensemble of parts, the *Capula* shall be a continuum.

CORRIN    Given these rules, the *Capulas* are intended to be fundamentally nomadic art works. They can move from site to site, changing their character depending upon the environment. Remixing the meaning of the work was also at play

in a second work commissioned for the interior of the pavilion, *Evolving City Wall Mural* (2006, fig. 5.10). This is a monumental wall piece with hundreds of elements that can be reconfigured each time the work is installed. The elements were inspired by the changing nature of the City of Seattle.

REYES    The mural took advantage of another feature in the building, an expansive wall ideal for a mural or a wall drawing. My large drawings were mounted on thick board and cut along their silhouettes to emulate pieces from a giant puzzle. These drawings of characters, buildings, and events composed an urban landscape depicted in an axonometric grid, which visually implied movement. Upon my arrival at the museum, I arranged the pieces on the wall, and the mural was completed.

The wall piece also reflects my architecture background. The forms are imaginary elements in a fictional city created from layers of three-dimensional drawings but within a flat perspective. In a city, there are a number of things happening simultaneously.

I am interested in the different historical systems that organize space in drawing—the Japanese approach and the approach in the Italian Renaissance are very different from one another, and my mural allows a combination of the two.

CORRIN    Consistent in all of your work is the continual transformation of the work's meaning. This is particularly significant in *Evolving City Wall Mural*.

REYES    Murals often present visions of history. They show us how the historic moment

FIG. 5.10
Pedro Reyes,
Mexican, born
1972, *Evolving
City Wall Mural*,
2006, mixed-
media installation,
approximately
14 ft. 11 in. ×
54 ft. 7½ in. Olym-
pic Sculpture Park
Art Acquisition
Fund and the
Modern Art
Acquisition Fund,
in honor of the
75th Anniversary
of the Seattle
Art Museum;
Commissioned
from the artist by
the Seattle Art
Museum, 2007.5.
On view 2007–8

represented was seen or interpreted at a specific point in time. As time passes, our perception of the past changes.

**CORRIN**   The composition of the wall mural is open to constant change to reflect new percep- tions of the city and its history.

**REYES**   History is frequently modified according to the contemporary interests of the present historical moment.

**CORRIN**   How did the pavilion projects further thinking about your work?

**REYES**   A sculpture park is more of a public space than a museum, because in a museum, you have a policy of not touching the art, of experiencing it quietly. In a park, it's about leisure, it's about communality. Responding to that in new work was extremely exciting for me. That is why both of my works are interactive. To me, the works are only complete when they start being used by the public.

**CORRIN**   Your work is always very generous and open.

**REYES**   The compositions of both the *Capulas* and the mural are open to constant change depending upon who is installing them wherever they go. In fact, the mural was later recomposed and installed at the Seattle Art Museum's down- town space. A local designer did the second installation in a very clever way, arranging the pieces so that they were each casting a shadow, giving it an even more the sculptural quality.

For me, the work is only completed once someone else takes your work to a place you would not have foreseen yourself. Museums are too concerned about authorship and definitive states of an artwork.

# Jerry Gorovoy on Louise Bourgeois *Father and Son*

*Jerry Gorovoy was studio assistant to Louise Bourgeois from the 1980s to 2010 and is now head of the Easton Foundation, a charitable organization Bourgeois established in the 1980s.*

**Lisa Graziose Corrin**   You worked closely with Louise Bourgeois as she shaped her vision for the Olympic Sculpture Park fountain commission. This was her second fountain commission, after the work she created for the Pittsburgh Cultural Trust. What informed the work for Seattle?

**Jerry Gorovoy**   Louise's art usually came from her direct experiences in real life. There is always a strong autobiographical thread. *Father and Son* (2005, fig. 5.11) is a reference to Louise's son, Jean-Louis Bourgeois, and his father, Robert Goldwater. Around the time of the commission, Louise was taking part in Jean-Louis's psychotherapy sessions, which focused in particular on his fraught relationship to his father. Having been involved in a few of the sessions, I felt that Louise orchestrated the conversation away from herself and toward Robert as a way of deflecting Jean-Louis's anger. In the sculpture, Louise wanted to express the sad fact that Jean-Louis never felt the love that his father had for him.

The piece shows father and son, their hands extended, trying to reach each other. The hopelessness of this attempt is expressed by the water, which alternately hides one figure from the other. The sculpture symbolizes the universal difficulty of communicating what we feel, and of making oneself be understood. It also represents the inability to express and accept love. This is a pessimistic view of human relationships and gives the work a somewhat tragic quality.

**CORRIN**   The figures are stainless steel, and their surfaces express modelling in clay so that the water and the changing light catch within the little indentations. It makes the sculptures even less visible when they are covered but also more alive when they are revealed. Louise seems to have had a real affinity for water as a material.

**GOROVOY**   Louise always lived near rivers. Her family, which did tapestry restoration, located their atelier near the Bièvre River, as its tannin-rich water helped set the dye during the reweaving process. For her, flowing water brought back memories of her childhood in France. It symbolized innocence, the passing of time, healing, and reparation, but also had darker connotations. In her work, flooding water can be seen as murderous, and her imagery of drowning reflects suicidal impulses. She often spoke of depression as a state of being at the bottom of a dark well.

With Louise, every symbol, form, or material has multiple sources and multiple associations, which can often be contradictory. The fountain she created for the Pittsburgh Cultural Trust is conceptually the opposite of *Father and Son*. It's about joining and inseparability. At the top of the piece, two rivulets of water flow up out of separate peaks and then join together, streaming continuously down a spiral to the bottom. Psychologically, this merging of the two streams of water expresses Louise's lifelong fear of separation and abandonment.

**CORRIN**   The work in Seattle is both a fountain and a clock. The water over each figure shifts when a cast bronze bell rings in each hour.

**GOROVOY**   While the ringing of the bell is meant to draw you close in order to witness the

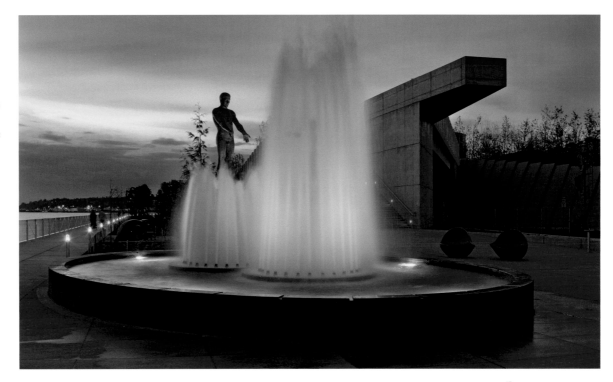

FIG. 5.11
Louise Bourgeois, *Father and Son*, 2005, stainless steel, aluminum, water, and bronze bell, overall fountain basin: 36 ft. × 26 ft.; father figure height: 77 in.; son figure height: 57 in. Gift of the Estate of Stu Smailes, 2006.141.

oscillation of the water from one figure to the other, it also signifies the eternal divide between the father and son. Though time passes, nothing will ever change.

CORRIN    Every day the fountain repeats the same lack of interaction between the figures. They never reconcile (see figs. 4.14–15).

GOROVOY    In the same way, Louise was forever trying to reconcile her relationship with her own father in her work. Both her father and her husband died prematurely. How does one come to terms with someone who died long ago but still haunts your mind and actions? The impossibility of resolution creates obsession, which is represented by the perpetual ringing of the bell and the undulating water.

 This piece also expresses the timelessness of the unconscious. In psychoanalysis, which Louise underwent for many years, the patient goes back to the past as a way of understanding the present. Different temporalities—past, present, and future—coexist in the realm of

emotions. In a relationship, there are things that are said, and then other things that are never spoken about. The early emotions between the child and his parents is the foundation for all future relationships. Louise certainly was interested in the Oedipus complex and the way this played out through generations.

CORRIN    The water has a strong material and expressive presence that is central to the meaning of the work. It was technically challenging to develop the custom jets necessary to achieve the force required for the water to cover the figures at the right height. The shape of the water adds to their self-containment. Was this the artist's intention?

GOROVOY    Yes. The water represents isolation, but also refuge—a way of hiding, retreating, and taking cover. There were a lot of technical issues in getting the water to behave the way that Louise wanted it to, but ultimately she was happy with how it conveyed these polarities of being revealed and being hidden.

The figures are very classical in their modelling. They are archetypes. Louise chose stainless steel so that the figures would blend in with the water as it goes up and down. Most importantly, however, the sculpture represents the gulf between people.

CORRIN   The sound of the rushing water is both enervating and soothing. There is also the sound and material presence of the wind. It was important to Louise's concept that only one figure can be seen at a time, but when the wind kicks up on Puget Sound, the two figures are sometimes visible simultaneously (see fig. 4.13).

GOROVOY   Many of Louise's pieces are conceived with all of the senses in mind. She was definitely interested in the sounds surrounding this sculpture. The water's movements, the wind, and the rain almost become the voices of the figures. Their sounds—which can change with the weather—add to the emotional intensity of the drama conveyed.

Louise was aware that at some point—because of the elements—the piece might not function in exactly the way that she had intended. I remember her saying, "If the wind comes, so be it." Regardless, you still see the two figures trying to reach out to each other despite their eternal separation.

CORRIN   The introspective feeling of the work is always present no matter the direction of the wind. When the wind blows and they are both revealed, the figures physically see eye to eye, but it is almost as though they are still not seeing one another. They are aware of each other's presence, but they are still not really connecting.

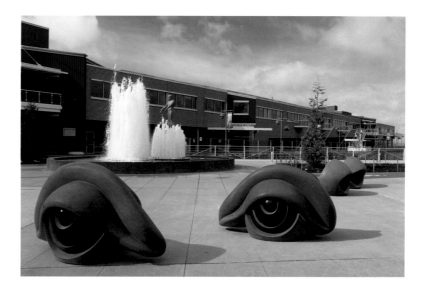

GOROVOY   Louise was very consistent in her ideas about relationships, how difficult it is for people to really understand each other, or to make oneself loved.

CORRIN   Love is strongly communicated through the eyes, and sight is one of the senses she has explored in her work. What informed her decision to give the *Eye Benches* (1996–97, fig. 5.12) to Seattle to surround the fountain?

GOROVOY   In her public works, Louise wanted to bring people together (fig. 5.13). In contrast to the fountain, in which the two figures are never really able to see one another, the *Eye Benches* are for being with someone, looking at someone, and being watched by someone. For Louise, eyes represent seduction and communication.

CORRIN   And, like all of Louise's work, looking inward.

FIG. 5.12
Louise Bourgeois, *Eye Benches II* (foreground), 1996–97, black Zimbabwe granite, each 48 × 76 15/16 × 46 in. Gift of the artist, in honor of the 75th Anniversary of the Seattle Art Museum, 2005.114.1-2.

FIG. 5.13
Park visitors seated on Louise Bourgeois's *Eye Benches II* (1996–97) with Teresita Fernández's *Seattle Cloud Cover* (2004–6) in the background, 2007.

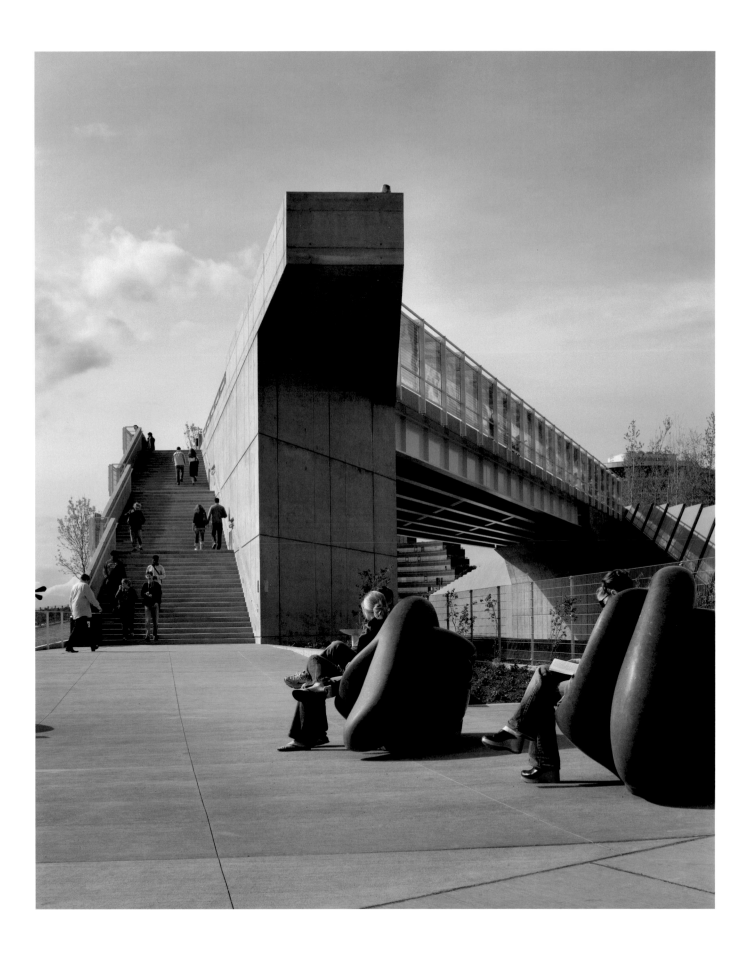

# Olympic Sculpture Park Map
## *Plants and Precincts*

**VALLEY**
čəbidac
Douglas fir
(*Pseudotsuga menziesii*)

x̌əpayac
Western red cedar
(*Thuja plicata*)

ťəq́ədiʔac
Western hemlock
(*Tsuga heterophylla*)

sx̌əx̌ulčac
Western sword fern (*Polystichum munitum*)

**MEADOW**
x̌čaʔadᶻac
Garry oak
(*Cuercus garryana*)

ċabidac
camas
(*Camassia quamash*)

čqaysəb
("wildflower")
blue wildrye
(*Elymus glaucus*)

**GROVE**
ċəḱapaʔac
nootka rose
(*Rosa nutkana*)

stəgʷədac
salmonberry
(*Rubus spectabilis*)

ťaqaʔac
salal
(*Gaulthoria shallon*)

q́ʷq́ʷəlac
evergreen huckleberry
(*Vaccinium ovatum*)

**SHORE**
ťatnixlo
shore pine
(*Pinus contorta*)

ťiləqʷac
beach strawberry
(*Fragaria chiloensis*)

 x̌ʼəlx̌ulčac
high bush cranberry
(*Viburnum trilobum*)

**HABITAT BENCH**
ɫabac / green algae, multiple species, including sea lettuce (ḱʷlva fənəstrata)

q́waʔəb / brown algae, multiple species, including bull kelp (*Nereocystis luetkeana*)

ɫabac / red algae, multiple species, including *Chondracanthus exasperatus* and *Mazzaella splendens*

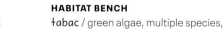

Streets

Bicycle path

Z path and waterfront promenade

Walkways

Lushootseed language and plant experts Vi taqʷšəblu Hilbert, Zalmai ʔəswəli Zahir, and Tracy Rector identified Indigenous names for many native plants at the Olympic Sculpture Park. Where possible, this map uses Southern Lushootseed words to reflect the local dialect, though some examples represent Northern Lushootseed terms or other variants.

WESTERN AVENUE

VALLEY

BROAD STREET

EAST MEADOW

ELLIOTT AVENUE

BAY STREET

NORTH MEADOW

WEST MEADOW

GROVE

MYRTLE EDWARDS PARK

SHORE

ALASKAN WAY

ELLIOTT BAY TRAIL

PUGET SOUND

HABITAT BENCH

PIER 70

# Resurgence

*Land and Water, Reimagined and Reborn*

Lynda V. Mapes

## A Setting Like No Other

From a bird's-eye view (fig. 6.1), the Z-shaped path that structures Seattle's Olympic Sculpture Park resembles a river meandering through a swath of green, amid the city's gray. It is the path of an animal on walkabout, a shape from nature. An invitation to linger, and to explore. To see what more is here.

Swoop in closer: here is a softness amid so much that is hard. A beach where the sea once again meets the land, for the first time in more than a century. Right in the heart of downtown, in one of the country's fastest-growing cities, the underwater ballet of tiny salmon fingerlings and herring, shimmering silver in the shallows, has resumed. The mother seals perhaps remember this place, from generations long back. They were among the first to arrive at Seattle's newest beach, bringing their pups to bask.

The plants have resumed their songs in this place: tall grasses sighing, aspen murmuring in the fresh breeze off Puget Sound. In the long summer evenings, birds and dragonflies hawk over meadows for bugs. Summer asters bloom, and the tangled understory burgeons with snowberry, salmonberry, and thimbleberry, all native to this land and feeding a community of small lives on wings and feet. For here, once again, is a wholeness where for so long there was separation.

A renewal where there was loss. And a setting for contemplation of all that this place has been—and that it can be.

Dismembered and poisoned, this nearly nine-acre site was literally degraded: sluiced down with water cannons and carted away, dumped offshore from barges as Seattle's hills were scalped to a flat grade for development from 1898 to 1930 (see fig. 1.7). It became a place hard used, a fuel depot and tank farm for more than sixty years.

But with the building of the Olympic Sculpture Park has come a natural recovery for this landscape, as much as an aesthetic and spiritual one. The park is a fresh start in a central downtown waterfront with new purposes for people in a changing city. A proof of concept not only for a design, but for an emerging identity. Imagined was generosity and spaciousness to remediate not only a contaminated brownfield site, but unrelenting urban density. Plantings to cleanse and filter the rainwater, feed wildlife once again, and rejuvenate some of the abundance the First People knew in this place. Revived, graced with art, and gifted to a grateful city, this would become a place for everyone to enjoy for free what is usually only the private pleasure of a fortunate few. Unobstructed spectacular waterfront views. Waves. Meadows. Light. Sky. Original

artworks. Inspiration. It is a tribute to a belief in possibility, and renewal. That things actually can get better.

The sculpture park today also is a place to learn and experience the natural history of Puget Sound country, rendered in miniature: the Pacific Northwest, in haiku. An environmental learning center, an urban nature center, a public sculpture garden: the Olympic Sculpture Park is all of these things. It is a place of journeys grand and small. Layers of experience are gradually revealed. Like the art, the *here* in being here is not placed baldly, on a plinth. It is uncovered, discovered with each visit. Explored, it is ever new.

A place used up and cast off has been repurposed and reimagined. Benzene, toluene, xylene, ethybenzene, and more have given way to graceful cinquefoil, showy fleabane, camas, Oregon sunshine, blue wild rye, and all their flowering relations. Soft paths muffle footsteps. *Seattle Cloud Cover* (2004–6, see figs. 5.4–6), a glass bridge adornment by Teresita Fernández in pastels, pinks and yellows, refracts light and color to the eye. Shifts of light and cloud, paths both grand and intimate intuit desire lines, inviting broad ambits of imagination through generous, open space.

Here are some of the best views in the city, even the region. But also nurturing, peaceful redoubts, sheltered by trees. Places to be quiet. Such a luxury, this space, in a fast-densifying city.

Remarkably, people are as free to come and go as the birds, the insects, the animals, and the seasons. No ticket is needed. No fence. No gates. No requirement to buy something, in order to remain, by the hour. There is freedom to picnic, to nap, to walk a dog, to bring a friend, or to be deliciously alone. To gaze upon heroic open views of sea and sky, or to savor inward contemplation in a sheltered valley, watched over by conifers. Mentors in the art of taking the long view, they guide and inform. A procession of dawn redwoods and gingkoes, too, evoke the region's ancient songlines of deep time.

The Zen master of the site reposes under glass. A nurse log, brought here from the Green-Duwamish River watershed (see fig. 5.1). This damp, fern-clad log is a living time capsule which, like this park, tells the history of what came before. It, too, testifies to the promise of regeneration. The log lies within an eighty-foot-long greenhouse, custom built for its repose (see fig. 4.7). The log silently teaches a lesson both ominous and reassuring. Of impermanence, that we too will pass. But also that what we were becomes part of all that comes after us and will continue long after our own brief visit to this life. It is a teacher in the nature of change, in a place born in flux. So while the Olympic Sculpture Park is a destination art museum, it also is a park unlike any other in the city. It all began with a very special setting.

Geologically young, Puget Sound is the second-largest estuary in the country, a sparkling jewel alive at the feet of the park. Orca whales come here in the long, slanting light of winter dancing on cold waves, to hunt native runs of chum. Among the last fresh salmon on tables from

FIG. 6.1
Cooper's hawk flying above Richard Serra's *Wake* (2002–3), n.d.

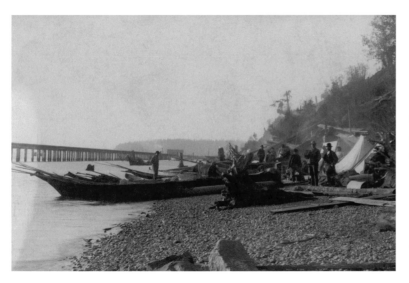

FIG. 6.2
A waterfront
Coast Salish
camp with canoes
at the foot of
Broad Street,
Seattle, looking
north, ca. 1885.
Photo by H. E.
Levy. Museum
of History and
Industry, Seattle
(MOHAI), Seattle
Historical Society
Collection,
SHS2714.

Thanksgiving to New Year's, chum are precious winter food for orca—and for the Nisqually people whose name graces both a river and a glacier on Mount Rainier, which reigns supreme in the south-facing views from the sculpture park. Glaciers like those that gleam on its flanks carved the fjords and bays of Puget Sound about thirteen thousand years ago, at the end of the last ice age. An ice dam across the Strait of Juan de Fuca broke loose, and the marine waters of the Pacific Ocean poured in. The result: Puget Sound, a coldwater inland sea reaching nearly one thousand feet in depth, yet also shallowing to bays and coves where young salmon travel, rest, and feed. Here is the place of silver shoals of forage fish, herring and sand lance that feed the salmon that feed the whales.

Pull back from the beach to the bluffs that calved sediment, feeding the soft drift cells of fine material nourishing the nearshore. Great battlements of logs that coasted to salt water on winter's storm-swollen rivers protected the shoreline from erosion. Overhanging trees dropped leaf litter and duff into the water where grazers shredded and devoured it. Primal recyclers, they stoked the base of the food chain.

This is how it was in this spot as, for thousands of years, the Native people of this place lived along the shore, in seasonal camps (fig. 6.2) until,

starting in about 1850, settlers and the beginnings of industrial development disrupted, displaced, and destroyed so much of the self-sustaining natural economy and Indigenous ways of life here. Building railroads, filling tidelands, constructing roads, cutting forests. The history of this place is a barroom brawl with nature, a roundhouse punch that went on for a century.

In all, at least eight large-scale transformations since the 1800s have been imposed on this place, the site of the Olympic Sculpture Park, with many more reverberations uncounted, unseen to the human eye, in the living shore buried under fill, and in the soil, paved and polluted. But here is what we know:

First came the building of roads and railroad tracks, supported above the tidelands on wooden trestles, built on planks and timber pilings. Made in the mills that devoured the forests that had cloaked the shore.

Then the site was smothered under fill from the violent regrade that demolished the city's hills.

Beginning in 1905, fill was deposited behind the trestles, using soil and demolition materials from the regrade to create new flat land, rail and shipping access to the shore. Fill was heaped ever waterward, obliterating what had been the ancient beach. Later, a seawall constructed along the Seattle waterfront severed the last of the connections between the shore and Puget Sound. The seawall created two more acres of prime waterfront real estate at the future park site.

In 1910 came the most lasting mark: the development, by Union Oil Company of California (Unocal), of a fuel storage tank farm and fuel transfer facility on the site with the opening of its Seattle Marketing Terminal (fig. 6.3). By the 1950s, the facility had grown to a six-acre fuel-storage complex. The bulk fuel distribution facility

handled leaded and unleaded gasoline, diesel, motor oils, and petroleum-based solvents, all stored at the site.

There was more: a barrel factory, an asphalt plant, manufacturing, storage and distribution facilities, automotive services, parking and warehousing. Unocal phased out its use of the terminal in 1975 and undertook a cleanup with state agency oversight. Contamination of the land and groundwater with fuel residue was the source of the pungent stink of petroleum that clung to the area. Some sixty years of fuel handling had left the soils and groundwater severely contaminated. Even after the cleanup was largely completed, the landscape remained a scar on the Seattle waterfront, a brownfield castaway.

Train tracks and a major arterial road cut the property into pieces. The property was a disheartening jumble that hid in plain sight the very special place that it was: the last best slice of land near Puget Sound, facing the Olympic Mountains, right in the heart of downtown.

Developers had already taken an interest. One project would have created a 125-foot-high mixed-use development with more than 800 new condos, 250,000 square feet of office space, and a small marina. But visionaries saw a possibility for beginning a new relationship, both human and natural, with the site. A forever gift to the future, in the creation of an outdoor sculpture park that also would seek to bring back natural ecological function to both the land and the water. But first, they had to finish the cleanup.

### Healing the Land, Cleaning the Water

Chemicals still contaminated the site when the Seattle Art Museum (SAM) acquired it for an outdoor sculpture park. Unocal, in partnership with the Washington State Department of

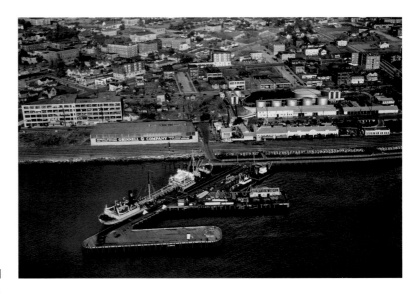

Ecology, had already done a lot of work, removing tons of petroleum-contaminated soil and cleaning up the groundwater. Gone forever and now hard to imagine were the numerous aboveground storage tanks, the underground heating oil tank, the storage sheds and pipelines, drums, and cans, the tanker loading dock. In all, they removed more than 76 million gallons of contaminated groundwater; 4,600 gallons of petroleum products, and 127,000 tons of petroleum-contaminated soil from the site.

The museum negotiated a final cleanup agreement with the Department of Ecology that reflected its use not for human habitation, but for permanent open space. Under the agreement, the site was capped to prevent direct contact with the remaining polluted soil and to reduce surface-water infiltration. Air monitoring ensured the site was no longer affected by vapors that haunted the site, volatizing from petrochemicals polluting the soil.

It took an engineered layer cake of fabric, rock, and clean soil, packed within retaining walls with a sloped, concrete surface, to provide the new shape and fresh start for the land, restoring some of the original contours, habitat, and microclimate diversity of the site. Sourcing half the fill just blocks away, from another Seattle Art Museum project then underway, saved both

FIG. 6.3
Aerial view of Unocal fuel dock and plant, Seattle, ca. 1932. Photo by Charles Laidlaw. Museum of History and Industry, Seattle (MOHAI), PEMCO Webster & Stevens Collection, 1983.10.17561.1.

FIG. 6.4
A bald eagle
watches over the
pocket beach
at the Olympic
Sculpture Park,
n.d.

cost and carbon emissions by reducing the
need to truck in soil from (or away to) more
distant locations.

Rebuilding the site's topography restored lost
views for people and for wildlife. It brought back
sun angles to nourish plants. Building up the site
also made possible the ingenious Z-shaped path
that solved the disjunction of the site while also
creating pedestrian access all the way to the
water (see fig. 3.15). Located in one of the fastest-
growing areas of the city, with one of lowest ratios
of park area to population within Seattle, the
sculpture park provided needed open space and
added to the existing amenities, including the
Seattle Aquarium, cruise-ship terminal, and
Myrtle Edwards and Centennial Parks, on the
downtown waterfront.

Together, these make Seattle not just another
city, but a place where anyone can, from the

center of downtown, revel in Mount Rainier, the
Olympic Mountains, and the inland sea of
Puget Sound.

## Rediscovering Puget Sound

With the site cleaned up and preserved, the
next step was reestablishing a connection to its
beating heart: the waters of Puget Sound, a
communion long severed by industrial develop-
ment of the site. Envisioned was a reenlivening of
twelve hundred linear feet along the park, both at
the shoreline and even underwater.

Always at the heart of the original vision
for the park was restoration of at least part of
the shoreline to a more natural state, with a
350-foot-long pocket beach (fig. 6.4). But that
work led to other benefits. Tearing out the old rock
riprap to create the beach revealed that the sea
wall was compromised, a concern heightened

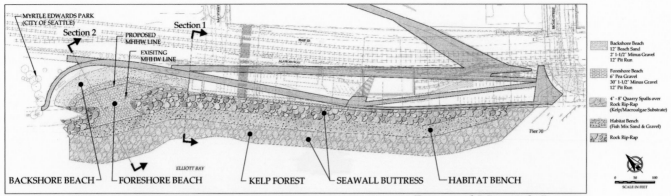

BACKSHORE BEACH — FORESHORE BEACH — KELP FOREST — SEAWALL BUTTRESS — HABITAT BENCH

Backshore Beach
12" Beach Sand
2' 1-1/2" Minus Gravel
12" Pit Run

Foreshore Beach
6" Pea Gravel
30" 1-1/2" Minus Gravel
12" Pit Run

4" - 8" Quarry Spalls over
Rock Rip-Rap
(Kelp/Macroalgae Substrate)

Habitat Bench
(Fish Mix Sand & Gravel)

Rock Rip-Rap

**Proposed Materials Layout**

**Existing Conditions Plan**

with the Nisqually earthquake in 2001. But rather than rebuild a conventional seawall, the architects created a far cheaper—and better—alternative: a rock buttress to support the wall and a habitat bench to create a shallow, intertidal habitat along park's entire shoreline (figs. 6.5–6). A place where salmon and other animals could rest and feed and travel.

In addition to saving tens of millions of dollars in fixing the seawall, the rock buttress and fifteen- to twenty-foot-wide habitat bench also created a way station on an otherwise hardened, inhospita- ble, urbanized shore. A bit of their ancient inter- tidal home, once again, for plants and animals to recolonize.

The half-acre embayment on the eastern shore of Elliott Bay also is wildly popular with humans, who visit the sculpture park in every season and weather, eager for a first piece of waterfront in the middle of downtown where they can actually dip their toes in salt water. Or build a

fort out of the driftwood and stack cairns from beach stones—the human art-making impulse evinced here, just as surely as in the masterworks all over the park.

This also is a place to hear the reprise of the tide's ancient music, the fall of waves on the beach a soothing cadence. Water seems to have a magical effect on people. Even adults recover their ancient mammalian selves, bathing in the cold water, happy, up to their necks in the clear goodness of Puget Sound. The clarity of the water is a surprise, maybe even a shock in so urban an area. Look over the edge to the habitat bench and the water sparkles with green-blue. There is no trash, not a bit. No muck, no goo, no oil sheen. Barnacles shimmer on the rocks below. And yes, there are fish. Lots and lots of fish.

Peter Hummel is a landscape architect at Anchor QEA in Seattle who helped design the habitat bench and pocket beach. This was the first big move on the waterfront to bring back a bit of

FIG. 6.5
Anchor
Environmental,
LLC, Olympic
Sculpture Park
pre-construction
conditions plan
and proposed
materials layout,
2006.

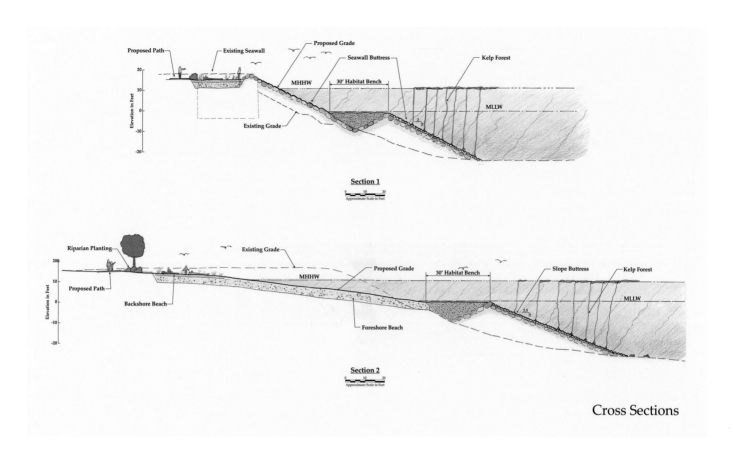

Cross Sections

FIG. 6.6
Anchor
Environmental
LLC, cross sec-
tions schematic
of existing seawall
rock buttress with
shore habitat
bench and pocket
beach, 2006.

nature and to link downtown to a natural beach. "It was such a success it really changed people's perception both ecologically, and as a use of public space, about what is possible. It was a foundation for a lot of other things that now are also happening, at a bigger scale," Hummel said.[1]

What the museum and its collaborators created at the park was, to him, part of a long progression in the environmental movement:

At first it was about stopping pollution and destruction, it wasn't until later where we really looked at it differently, where we are really trying to bring something back, take something that was degraded significantly in the urban environment, and make it work for people, but make it work for wildlife and fish, too. Have it function ecologically.

I don't think anyone appreciated the resilience of nature until we started trying these little steps. This to me is just part of that

thinking, but applied to downtown. It's a great message, people get really discouraged these days about seeing the environment deterio-rating, but we are doing things we never believed we would do that are making things better. We made things worse for a long time, but now we are learning we can make things better, if we make the commitment and the investment.[2]

Jason Toft, a research scientist at the School of Aquatic and Fishery Sciences at the University of Washington, began monitoring the site offshore in 2005, before construction of the park began.[3] Recording the presence of underwater plant and animal life, Toft and his team continued their work to learn the effect of recreating even just a bit of natural beach and habitat on this urban shore. They didn't merely model likely effects with a computer. Toft and his team walked right on into the water at the pocket beach, zipped into

drysuits, and, with masks and snorkels, had a look around.

Instead of the bald rock wall that once formed a sheer, hard barrier where the land meets Puget Sound, today the inviting, soft slope of the pocket beach welcomes park visitors to the water while the stepped habitat bench, made of suitable, smaller rock fill, welcomes colonization by underwater plants and animals.

Could something that sounds so simple— a bunch of rocks intended to create an intertidal habitat—really work? At Toft's invitation, I decided to have a look at things underwater for myself. On a foggy July morning, I shuffled backward into the water at the pocket beach, encased from head to toe in a hooded dry suit with gloves, mask, snorkel, and fins, alongside Toft and his crew. I wanted to see just what it was like beneath the blue mirror of the surface. Could there really be anything here in this most urban of waters, I wondered, looking up at the Space Needle and the high rises of downtown?

With a kick and a splash, I rolled over, submerged my mask in the cold water, and slipped into an unseen world (fig. 6.7). Silvery herring patrolled the waves, each fish slim and glittering. The school was moving as one, surging through the water. Perch were everywhere, shining in the shallows. I went deeper and discovered kelp, emerald green and moving in the current.

Toft pointed to a squad of juvenile Chinook salmon—out migrants, probably, from the Green-Duwamish River. Seattle's only river, it is one of the most important Chinook rivers in the state, every year producing the first, second, or third largest number of Chinook in Puget Sound. Here they were, the telltale vertical bars on their bodies marking them as young of the

year, fattening up and resting just offshore of the beach, before beginning their long journey to the sea.

We kicked our way south, toward the habitat bench, and here amid the piled rock were crabs by the hundreds. Tiny, busy, just going on about their day-to-day. It was so extraordinary to see their ordinary lives, right here, right amid ours. Here was not just a place on a map, but a community with its own agency, history, and future, a constellation of lives, growing, swimming, eating, seeking, being. Our living companions. A civilization far older and far larger than our own, connected to all the seas of the world, in all its eons of time long before us. More vast, more powerful and nurturing. Making billions of lives, ceaselessly renewing. All of this was here before us; we made none of it; we destroyed much of it. And now, it was back: the life of Puget Sound.

This park brought not only art but life to this place. Within earshot of tourists strolling the shore, businesspeople talking on their cell phones, and cyclists zipping by on the bike path, Puget Sound is very much alive. I popped my head up

FIG. 6.7
Underwater view of juvenile salmon at habitat bench on the beach at the Olympic Sculpture Park, 2008.

FIG. 6.8
The valley pre-cinct in autumn with a spruce tree's shadow on Richard Serra's *Wake* (2002–3) and a ginkgo tree at right.

from the water and saw kids and families strolling through Myrtle Edwards Park, just feet away. I wanted to bring them right into the water. To come see and be glad. At all that is here and so very alive. In a world where so much sometimes seems to be getting worse, here was a big, thriving piece of better.

## A Forest, Lost and Found

Moving upward from the water, the park's layered landscapes beckon. Not just one palette of green, but a whole diversity of experiences unfolds (fig. 6.8). For the setting of the park is richly informed by the natural world that was here during the time of the First Peoples. Some 80,000 native plants and trees invoke a feel for some of the abundance of the Puget Sound shoreline, mead-ows, and forest of a century ago. A mountains-to-sound design renders the natural history of Puget Sound country in miniature.

The rich gardens of native plants created at the site have multiple purposes. One is utility: pollution at the site is managed with a three-foot thick layer of engineered soil that cleanses runoff, to replicate the site conditions before urban development. Dense plantings of trees, soils, and the understory further contain and cleanse runoff before it reaches the sea. This natural drainage solution was the fourth and final

restoration intervention at the site, in addition to the environmental cleanup and the construction of the pocket beach and habitat bench.

To walk the park in its entirety also is to be unobtrusively instructed in the native flora of the Pacific Northwest, and even the native names for the plants of this place. From the high country to the low, the forest to the understory, all of the mainstay plants and even obscure ones of this eco-region are here to enjoy, to study up close, to smell and watch go through the seasons. The plantings honor the first forests and shorelines of this place, with plant markers written in Lushoot-seed, the native language of the First Peoples of Puget Sound, the Coast Salish.[4] Their lifeways are commemorated in the plants.

Cedars were used by the Coast Salish peoples for everything from shredded bark for diapers to timbers for the longhouses that stood on these shores. The biggest cedars then, as now, are cherished by carvers for making canoes. Cedar was for cleansing the floor of the longhouse before ceremonies, sweeping the fresh green branches over any bad feelings to leave only welcome. Cedar for carved feast bowls, for house posts, for masks and boxes, for the benches from which to watch the winter dances and songs as fires burned in the center of the home where families gathered for the long winters. The time of oratory, ceremony, and feasts.

Yew was for roasting sticks, skewering clams and chunks of salmon to cook to succulent perfection. There was thimbleberry and salmon-berry. And the consoling song of Douglas fir, tall enough to carve the high winds. Snowberry sparkled white and glistening. Nootka rose scented the summer air, and ferns graced every glade. All of these are heavily featured in the landscaping plan.

FIG. 6.9
The meadow
precinct with
Alexander
Calder's *The Eagle*
(1971), n.d.

FIG. 6.10
Aspens line the
soft woodchip
path through the
grove precinct,
2007.

The plantings progress through four precincts: valley, grove, meadow, and shore, organized from the top of the site, along the edge of the city, to the water (see pp. 136–37). Each provides its own experience for viewing the sculptures and enjoying the park.

At the top of the site, along the city street that defines the park's eastern edge, are the tallest trees, providing a full screen from the city when walking the so-called valley precinct of the park. Here, native spruce, cedar, and hemlock create a cool and shaded realm. Under the big trees, trillium, sword ferns, Oregon grape, vine maple, and more create a green tangle, succored in native forest duff brought in to the site.

Along the edge of the forest, planted right in the graveled walk, are dawn redwoods and lacy-leafed ginkgo trees. From the region's earliest age, these trees remind us of the ancient world that gave rise to the forests we know today. The redwoods and gingkoes enliven the valley below the forest. Paths wind up from there, to snowberry and salmonberry and rose thickets.

The plants embrace sculptures nestled amid their abundance, growing right up to and around them, setting off the textures of metal and stone. Pollinating bees and butterflies and birds thrive amid the art. So integrated are the sculptures with their setting, it becomes hard to imagine one without the other. Alexander Calder's *The Eagle* (1971, fig. 6.9) soars from the meadow precinct into open views to the sky. Richard Serra's *Wake* (2002–3) looms massive like the ginkgoes, cedars, and Douglas fir that abide with it in the valley.

Above the valley rises the second precinct, the grove, where a wedge of quaking aspen is still growing toward maturity. Here is where the four seasons of the park are pronounced, in the

FIG. 6.11
White aspen
trunks rise
from the grove
precinct, with
a glimpse of
Teresita Fernán-
dez's *Seattle
Cloud Cover*
(2004–6) in the
background,
2007.

FIG. 6.12
Visitors enjoy
the Seattle
Art Museum's
summer in the
park program-
ming, 2011.

its trunks are a solace amid the city, an escape. Here, too, amid the grove is a soft woodchip path (fig. 6.10). Its give underfoot is an unspoken reminder to slow down, to feel the nurturing presence of trees on both sides, and overhead too. The sense of enclosure is delicious, with views of all that is beyond screened by the white trunks (fig. 6.11).

Emerging from the grove, the Z-shaped path offers a traverse to the third precinct, the meadows. The east meadow and north meadow are perhaps the biggest surprise: open areas, left to thrive as such. Not throwaways nor blank spaces, in addition to framing the art, they invite the eye to

shining gold leaves of autumn, the stark white trunks of winter, the tender green of spring, and lustrous, fluttering summer canopy. The whispered conversation of this grove and embrace of

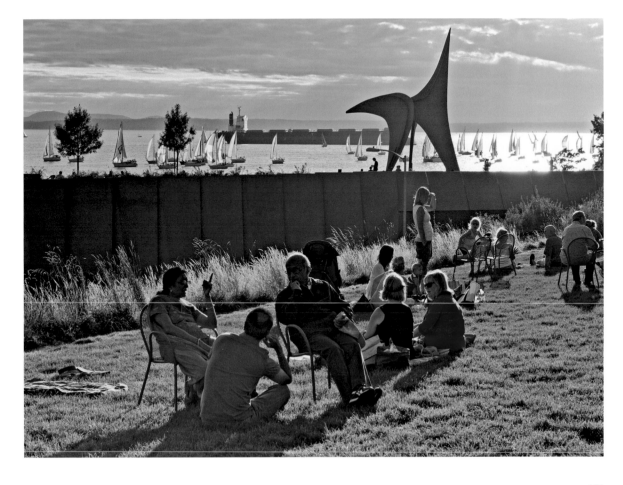

see the views beyond, from meadows wonderfully open and wide, to the sky.

*Here* is the view that is so often blocked by buildings, the sweep of sea and sky and mountain typically only glimpsed. Laid out gloriously, 180 degrees of it, unobstructed now and forever, for the enjoyment of anyone who wants to flop down on the grass or pull up a chair along the path (fig. 6.12). It is a glorious habitat for people. Gravel promenades are clean and broad, the grass green, soft, and edged. Comfortable, matched red metal chairs by the dozens are set out in a neat row each morning, awaiting enjoyment by visitors who may move and arrange them as they please, to be in the sun or shade, alone, or clustered with a group of friends. Some people eschew the chairs altogether, choosing to lie on their backs in the meadows and just watch the clouds. Here, patches of grass are allowed to grow long,

swaying in the wind, setting seed, and keeping company with Queen Anne's lace, asters, and the dip and swing of swallows and insects. They, too, are drawn to these open, sunny swards.

Finally, along beach and shoreline, comes the fourth precinct, the shore (fig. 6.13). Here live the tough customers that can take salt air and wind: the shore pine, the tufted hair grass, and salal, with its lovely white bell flowers in spring, aging to plump, purple berries. The dark leathery leaves of garry oaks.

The beach, the topography, the four precincts of plantings, the birds and bugs combine to create a multisensory experience. And punctuating it all is the rhythm of the trains, the signature soundscape of the Olympic Sculpture Park. The busy tracks that slice through the park bring a frequent sense of the world beyond, of traveling and arrival, commerce and questing. The sound of the train's

FIG. 6.13
Shoreline plantings near the pocket beach, 2008.

FIG. 6.14
A BNSF train
passing through
the Olympic
Sculpture Park,
viewed from the
waterfront plaza,
2011.

horn, the bell at the railroad crossing nearby, the rumble of the train on its tracks, all are part of the experience of being at the park. In some places, including the beach, the train is just so *right there*, its grumble and rumble and massive, heavy progress a startling surprise amid reverie. But a grounding, too, in the here and now that is this park in the middle of a big city.

Being able to safely watch the trains from broad pedestrian crossings, elevated above or along the tracks, is one of the delights of the park (fig. 6.14). All kinds of trains, audible from a distance. Oil trains long enough to stretch around the bend out of view. Trains bearing our garbage to the landfill in Oregon. Containers full or empty, mysterious in unmarked multitudes. Commuter trains. They all come through here, amid the art, amid the swimming salmon, the glamorous high-rises, reminding us of the interconnections, and intersections in our lives, acknowledged and not.

It is a park set on the verge, of saltwater and land, of roads and trains, of nature and city. An oil train clanks through; the mock orange is in full

flower, soft, fluffy, and sweet scented. Sun and sky and weather wash over the site, over us. No visit is the same twice, just as we are never the same, nor the water, nor these plantings, nor our experience.

### An Ambassador from the Watershed
An invitation to wonder awaits visitors to the park approaching from the west. Ferns press against the glass of a conservatory placed right amid some of the city's busiest thoroughfares. Purpose-designed green panes cast everything inside with the glow of a forest. For that is a bit of what's within, in *Neukom Vivarium* (2004–6, fig. 6.15), artist Mark Dion's reminder of the watershed that is home to this park.

The sloped, green-glass building is cryptic from the sidewalk view, like something from the planet Venus, or a chrysalis for an exotic insect; a visitation from some sort of beyond. Which is exactly what it is. Open the door, and there is a shock of scent: soil, duff, moisture, and forest. The names of great naturalists parade on tiles atop the wall. A field guide appears in tiles on the

FIG. 6.15
Interior view
of Mark Dion's
*Neukom Vivarium*
(2004–6), on
opening day
of the Olympic
Sculpture Park,
2007.

wall too: bacteria, fungi, lichen, plants, insects. The tools of botany fill a cabinet. Forceps, a plant press, clippers, magnifying glasses, microscopes.

At the center of it all is a log, in regal repose within this climate-controlled glass house, where temperature and humidity approximate, as well as can be rendered in the heart of downtown, the deep forest from which it came. The log is about four feet five inches around at the base, weighs 55,000 pounds, and is sixty feet long. The approximately 150-year-old western hemlock fell during a winter snowstorm in February 1996 that brought twenty inches of snow and three days of wind and rain. It fell not far from a logging road in the upper Green River watershed. It took a 550-ton crane to lift and load the log onto a truck, to bring the hemlock to the park in 2006. The nurse log has been carrying on with its long-term business of decomposing ever since, atop a viewing platform with a window cut into the living soil that teems beneath it.

Forest ecologist Mark Harmon in the College of Forestry at Oregon State University is nicknamed "Dr. Death" for his prowess in understanding the new life for dead trees. He explains that when it dies, any tree's new life is just beginning. Here in *Neukom Vivarium*, amid death, the nurse log is crowded with life: ferns, mosses, lichens, liverworts. Seeds and spores, ferns and shrubs. And billions of lives that can't be seen: bacteria and the reaching tendrils of hyphae by the mile. There even are young trees sprouting in the damp of its decomposing bark.

In a forest, a nurse log is so-named because it provides food and shelter for a multitude of organisms that colonize it and progressively degrade the log back into the soil from which it came. That process is underway now in *Neukom Vivarium*. Cool and wet to the touch, the log is softening with rot; it gives with the press of a finger.

The log is watered with rain collected off the roof into cisterns, each holding hundreds of gallons. "The idea is to replicate some of the conditions of where the log came from," says Bobby McCullough, SAM facilities and landscape manager. He strives to keep the temperature within the building the same as outside. "We welcome death," says McCullough, who works to keep up

FIG. 6.16
Harbor seal
pup rests on
the Olympic
Sculpture Park's
pocket beach,
2015.

to brown out, McCullough lets it die. "I like to leave it, to show the natural processes."

He's had to cut down some trees sprouted on the log, they grew so well. Alder, spruce, ferns, evergreen huckleberry all are flourishing in this bit of forest under glass. Mushrooms and lichen festoon the log, moss too. The root wad of the downed tree is sprouted with ferns. Even a bigleaf maple is getting a start, growing right out of the log. "It's neat to see the school groups come in here, the kids who haven't been hiking or camping," McCullough said. For here is a bit of forest for them, right downtown.

with the life nurtured by the log: new trees all the time, shrubs pressing up into the glass ceiling in the aqueous light. "There is so much going on, the conditions we have created are a little too perfect. We don't have days of pounding rain, the animals, the snowpack crushing this down." As a result, sword fern and evergreen huckleberry flourish. Burgeon, even. When a plant does start

The log, the equipment used to maintain it, and the glass house comprise Dion's art installation. It is a reminder of how much human infrastructure and fuss are needed to maintain and approximate even one small slice of nature.

FIG. 6.17
Crow perched in
Roxy Paine's *Split*
(2003), 2008.

The log is just one of the wild lives that make the sculpture park home, amid the art. In his years taking care of the park, McCullough has seen everything from sea lions, coots, and buffleheads at the beach to eagles perched in the cotton-woods. Hummingbirds fiercely defend their patch in the dawn redwoods—and once even built a nest in *Neukom Vivarium*. Field mice nest in the meadow, some perhaps descended from the stowaway mouse that arrived at the park with Dion's nurse log before making its escape.

As the sculpture park's vegetation matures, more of life unfolds here as nature takes over (figs. 6.16–17). McCullough didn't have long to wonder if a large, rodent-like animal lumbering across the meadow was a nutria; it was quickly swept off by an eagle. McCullough says he has loved watching the park grow into its maturity, as the plantings settle in and stretch out and the

seasons bring their changes. Each day has its cycle. The greenhouse ticks as sun heats the glass. Outside, diamonds glimmer on Elliott Bay, and sailboats slide through the shimmer. Ferry-boats slink across Puget Sound and the Olympics loom above the blue.

A seagull looks down over it all from above, cruising the thermals, right on the verge of a stall. Visitors crunch along the gravel paths. A train chuffs through; the sun is a golden bath in the long, late light from the west. A man lies on his back in the meadow, propped up on his backpack to watch for the sunset while petting his dog. There is a quiet sound of conversation in many languages, a hummingbird's "tick, tick, click," and the bright "me, me, pretty, pretty me" call of a song sparrow.

The experience of being here invokes an effect of energizing ease. Maybe it's knowing this

FIG. 6.18
Sunset over Elliott Bay seen from the Olympic Sculpture Park, 2013.

beauty is here forever, a park, always here to enjoy, season by season, year by year. The nurse log sets the park's pace. So time unwinds, the tide slides up and down the beach, the weather and light pour over the great Z and its terraced delights.

The snowberries are heavy with fruit, and leaves of the aspen give voice to the wind. The white fluff is on the cotton aster, and pollinating bees and wasps bumble around the salal, cultivating its fat berries. Spring's roses have given way to big rose hips, the fireweed's last blossoms crown the tops of waving wands. The winged seeds are on the maples, their season coming to fruition. A hummingbird floats from tree to tree, alighting atop a gingko glowing chartreuse in the evening light. Another day is ending at the park, and another summer (fig. 6.18). But there will be countless more as the park grows and changes with the seasons.

A whole city rises all around it, close, yet just far enough away to let this be a place apart, in it, and of it. A splendid realm, all its own. A glorious bit of nature, brought back to life.

## Notes

1. Peter Hummel, in telephone conversation with the author, August 30, 2019.

2. Hummel, telephone conversation.

3. For a summary of Jason Toft's monitoring data from the Olympic Sculpture Park, see his website: http://sites.google.com/a/uw.edu/olympic-sculpture-park/. His research is also published in Jason D. Toft, Andrea S. Ogston, Sarah M. Heerhartz, Jeffrey R. Cordell, and Emilie E. Flemer, "Ecological Response and Physical Stability of Habitat Enhancements along an Urban Armored Shoreline," *Ecological Engineering* 57 (August 2003): 97–108.

4. In 2006, in anticipation of opening the Olympic Sculpture Park, the Seattle Art Museum collaborated with Lushootseed language and ethnobotany experts Vi taqʷšəblu Hilbert, Zeke əsʔwəli Zahir, and Tracy Rector on the research project *dᶻixʷ dxsʔugʷusaɫ tiʔəʔ swatixʷtəd* (The Earth Is Our First Teacher). As an example of ongoing intergenerational transfer of knowledge, SAM's collaborators drew on the knowledge of their elders, ancestors, and teachers, honoring the ongoing stewardship of local lands and waterways by the First Peoples of Puget Sound and its environs. The researchers documented Indigenous names—in Southern Lushootseed, Northern Lushootseed, and other regional dialects—and uses for many of the native plants incorporated in the park's landscaping. Inspired by Lushootseed traditional oratory, which casts plants and trees as the first "teachers," SAM then created educational signage for the sculpture park detailing its plants' Lushootseed names, their aboriginal uses for food, medicine, and technology, and their native habitats. See map on pp. 136–37 for examples.

A Community
Perspective

*History of Seattle
and Vision for the
Future*

Leonard Garfield and
Maggie Walker

*This we know: the earth does not belong to man; man belongs to the earth. This we know: all things are connected.*     *—Chief Seattle, January 12, 1854*

## On the Shores of the Salish Sea

In the years before the Olympic Sculpture Park emerged, before the industrial degradation that scarred the site for over a century, before the first nonindigenous settlers claimed it for homesteads in the 1850s, before the first European explorers charted its shoreline in the 1790s, and back through countless generations memorialized in oral traditions, the site of today's park stood at the thriving heart of Coast Salish culture, a place of complex waterways, a gentle marine climate, dense stands of cedar and fir, and an abundant ecosystem that formed a nurturing home to Seattle's First People—the Duwamish, the "people of the inside."

The Duwamish people, connected to other Coast Salish groups through bonds of kinship and commerce, lived on Elliott Bay for centuries and sustained a flourishing culture based on the abundance of salmon, shellfish, and other marine life, the richness of the forests and the Pacific flyway, and robust seasonal trade throughout the coastal and interior Northwest. Duwamish connections at the Olympic Sculpture Park are deep and broad, stretching back millennia and across hundreds of miles.

But by the 1700s, local Indigenous culture was assaulted by tumultuous and wrenching upheaval, beginning with the advance of European-borne diseases. By the mid-nineteenth century, the rapid westward expansion of the United States brought new people and new patterns of land use and imposed entirely new systems of economics, politics, and culture on the Indigenous peoples of what had become the Pacific Northwest.

Permanent European-American settlers arrived on what they renamed Elliott Bay in 1851; within a few years, the Duwamish would be displaced and their lands "claimed" by a government whose seat lay three thousand miles away. At the site of the Olympic Sculpture Park, longstanding human and cultural connections to the Elliott Bay waterfront would be sundered for the next 160 years.

## An American Town

If the site of the Olympic Sculpture Park embodied timeless continuity for the Duwamish, to Seattle's pioneer American settlers in the 1850s and 1860s, the Elliott Bay waterfront represented a very specific future. The deep natural harbor, at the edge of the continent, made it the perfect site for a young community poised to enter the Industrial Age and dreaming of international trade (fig. 7.1).

Indeed, within a few months of settlement, a novel, steam-powered sawmill took pride of place on the central waterfront; within a year, that first industrial enterprise was shipping milled lumber

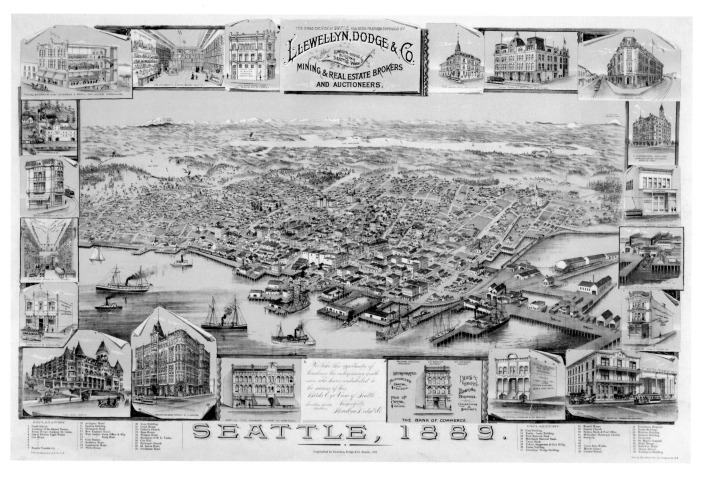

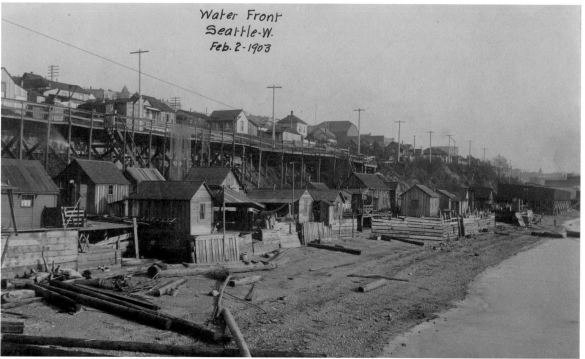

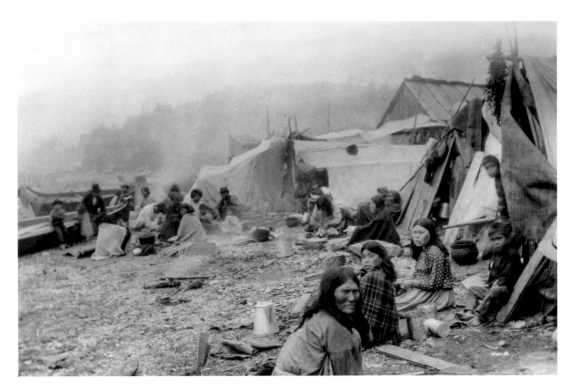

FIG. 7.3
Duwamish camp near the outskirts of Seattle on Elliott Bay, n.d. Photo by Asahel Curtis. Museum of History & Industry, Seattle (MOHAI), Lantern Slide Collection, 2002.3.71.

across the Pacific; and over the next few decades, a vast web of factories, wharves, and tracks served by a chaotic jumble of vehicles and vessels crowded the shore.

Suddenly, the Seattle waterfront—including the site of today's park—was the noisy, noxious engine that propelled the nascent city's industrial economy (fig. 7.2). The Indigenous people whose land had been expropriated were relegated to the outskirts of the new town (fig. 7.3), barred by law from living in the place that, incorporated as a city, bore the anglicized name of their revered leader Si'ahl (sometimes rendered as Sealth, from which "Seattle" derives).

### The Industrial Waterfront

Seattle's industrial engine remained in full throttle on the Elliott Bay waterfront for the next fifteen decades as sawmills made way for rail lines, rail lines for shipyards, shipyards for other roaring manufacturers. With that growth came an industrial workforce numbering in the tens of thousands, drawn to Elliott Bay from around the world.

Supporting this industrial hub was a collateral infrastructure of warehouses and wharves (fig. 7.4), storage tanks, and power plants that fueled the city's expansion even as it cut the city off from the natural connections that so enriched Duwamish culture. All of it disfigured the site of the Olympic Sculpture Park—bisected by rail lines, traversed by highways, and despoiled by toxic industrial waste for a hundred years (fig. 7.5).

By the early twentieth century, Seattle was the economic capital of the Pacific Northwest, and the central waterfront was the manufacturing heart of the region, so thoroughly industrialized that city planners in the 1920s began to envision a future in which the lanes of commerce would rise above and beyond the downtown shoreline, with an elevated waterfront highway expeditiously moving commercial traffic, as well as the tens of thousands of private automobiles that now clogged Seattle streets.

Finally opened to traffic in 1953, that aerial highway—the Alaskan Way Viaduct—was a concrete edifice of little character but massive

scale, and it literally overshadowed the waterfront, severing the shoreline further from the rest of the city (fig. 7.6). From the roadway's decks, the bay became, at best, a distant vista from a moving car. The separation of the waterfront, including the future park site, from the city that shared its shore was now complete.

## Seeking Public Space

With the central waterfront reserved as the province of industry by the late nineteenth century, Seattle's civic leaders began to imagine the kinds of public spaces that might foster a more hospitable dimension to the booming city. Plans for open spaces and civic centers, some successful, others aborted, began at the dawn of the twentieth century.

Perhaps most astonishing was the decades-long effort in the early 1900s to lower and level

Seattle's hilly topography, a move that transformed land near the Olympic Sculpture Park to a flattened and initially vacant cityscape (see fig. 1.7). Intended to expand commercially viable land for new businesses and apartments, the so-called "regrading" left scores of blocks partially undeveloped for years, a haunting reminder of the dispiriting power of engineering when divorced from a larger civic design.

FIG. 7.4
Piers on the Seattle waterfront, 1930. Museum of History & Industry, Seattle (MOHAI), 2002.3.288.

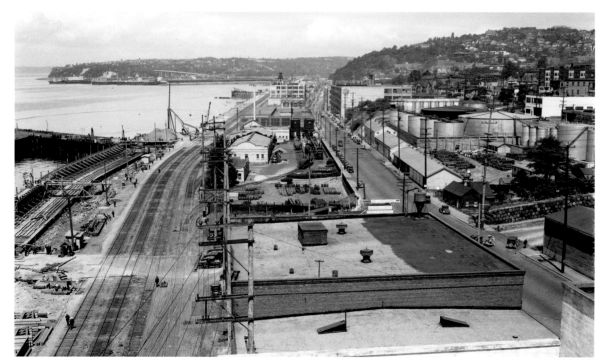

FIG. 7.5
Railroad Avenue, from top of the American Can Co. looking north to Unocal property (today's corner of Alaskan Way and Broad Street), 1934. Seattle Municipal Archives, Image 8956.

FIG. 7.6
Aerial view of the
Seattle waterfront
with the Alaskan
Way Viaduct
separating the city
from the shoreline,
October 16, 1961.
Photo by John F.
Vallentyne.
Museum of
History & Industry,
Seattle (MOHAI),
2009.23.77.

FIG. 7.7
Court of Honor
and Geyser Basin
at the Alaska-
Yukon-Pacific
Exposition,
Seattle, 1909.
Photo by
Frank H. Nowell.
Museum of
History & Industry,
Seattle (MOHAI),
1990.73.115.

FIG. 7.8
The Bogue Plan for
Civic Center, 1911,
by Virgil Bogue.
Seattle Munic-
ipal Archives,
Drawing 54.

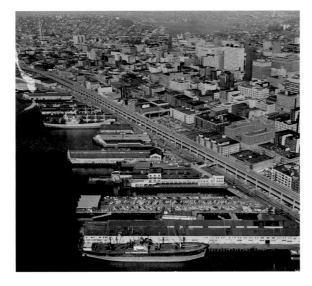

More aesthetically pleasing, although equally ambitious as the city gained economic power and sought international stature, was the Alaska-Yukon-Pacific Exposition of 1909, a world's fair that successfully imagined a White City on the remote University of Washington campus, a confection of neoclassical (and temporary) architecture, grand plazas and esplanades, and views to Lake Washington and Lake Union (fig. 7.7). While dramatic, the plan was largely ephemeral and far from the city's center.

Subsequent plans to create green open space in Seattle's growing central city fared less well. The so-called Bogue Plan of the 1910s (fig. 7.8),

inspired by the City Beautiful movement, envisioned a monumental Lake Union train depot, a Denny Regrade civic center, and a large park on Lake Washington. The voters, sensing that the plan favored the rich (and the rich, sensing that it would cost them too much) defeated the plan before it could gain traction.

While grand gestures like these seemed short lived or stillborn, the introduction of green space in Seattle flowered most successfully not in the city's center but in the streetcar suburbs and residential districts that became favored escapes from the urban core, which was crowded and chaotic. The city's municipal park system, whose master plan was designed by the distinguished Olmsted Brothers firm in 1903, envisioned interconnected green spaces, boulevards, and vistas that would link the neighborhoods of the growing city for the next century with a greenbelt of parks and parkways.

Approved by voters and funded by taxpayers, the park plan was an unfolding success, carefully designed to enhance residential districts where park amenities would serve as both real estate

incentives and civic investments (see fig. 1.3). But the Olmsteds' master plan avoided conflicts with lucrative industrial uses, and consequently plans for the central waterfront were largely unrealized.

Later initiatives for public space in central Seattle in the twentieth century were less ambitious and were closely tied to commercial developments; none attempted to repurpose the central waterfront to create large-scale civic amenities. The city's ongoing regrading projects continued through the 1930s, guided strictly by real estate goals, while a downtown development scheme in the 1920s, called the Metropolitan Tract, encompassed some of the architectural features of the Bogue Plan but with a singular focus on private business, and without compensating green spaces, plazas, or waterfront access.

## Civic Visions for the Jet Age

Already an industrial powerhouse, Seattle catapulted into a major metropolis amid World War II. As the city's industrial economy converted to wartime manufacturing, the Boeing Company raced to the first ranks of American business, designing and building some of the most technologically advanced products in the world. Building B-17s and B-29s not only helped win the war; it laid the groundwork for a high-tech city, a home base for engineers and designers, a place imbued with the attitude that smart people could find workable solutions for even the most intractable challenge.

After the war, Boeing ramped up commercial aircraft production and launched a new age of global travel that firmly established Seattle's connection with the wider world. And the ambitious spirit of Seattle's corporate leadership inspired grand schemes in the civic realm as well, as the community tackled a massive environmental cleanup of Lake Washington, the construction

of floating bridges, the evolution of a leading research center at the University of Washington and, most symbolically, a World's Fair that heralded the made-in-Seattle Jet Age.

The Century 21 Exposition, the Seattle World's Fair of 1962, was a dramatic reflection of postwar Seattle's ambitions to be a city of the future. The fair designers converted underutilized commercial land north of the central business district into a futuristic exposition site and incipient civic center, complete with green spaces and cultural venues. When the fair closed after seven months and nearly ten million visitors, the fairgrounds transitioned into a large urban park, retaining a collection of entertainment and artistic venues alongside a few iconic reminders—notably the Space Needle (see fig. 1.20)—of the city's dreams of the future.

Buoyed by the fair's success, the region's voters approved the so-called Forward Thrust plan of the 1960s to build on the momentum that the fair created, although on a less grandiose scale. The plan funded a coordinated set of parklands, including several modest waterfront parks, as well as an aquarium on Elliott Bay. But neither the fair nor Forward Thrust resulted in an integrated plan for central public spaces that would fundamentally reconnect the growing city to its historic waterfront.

In lieu of that bold vision, and as the region's economy took a rare tumble in the early 1970s, public attention turned away from the grand gestures of earlier decades and toward more incremental plans to preserve and enhance the city's reputation for livability. Most notably, voters adopted plans to rehabilitate Pike Place Market (fig. 7.9), the iconic farmers market widely viewed as Seattle's most treasured public space. Over several decades, the restored and expanded

market revived an important downtown gathering place, enlivened by food vendors, farm stands, and a festive spirit that contributed critical activity to the city core. But while the renewed market colorfully perched above the waterfront, it was largely cut off from the shore by the massive, noisy viaduct and the surface roadway below it.

By the end of the twentieth century, a consortium of public and private figures—notably including Paul Allen, the Microsoft Corporation cofounder who, by the 1990s, had increasingly turned his attention to large-scale philanthropic ventures—proposed a final grand plan for open space in the central city. Allen's vision to recast a large swath of central Seattle was the first public manifestation of the power of the region's new technology wealth to reshape the civic landscape in bold ways.

The Seattle Commons project envisioned a vast public lawn framed by offices, apartments and condominiums, and a variety of urban amenities, stretching from the heart of the city to the Lake Union shoreline (fig. 7.10). But like the Bogue Plan at the start of the century, which shared a similar spirit, the Commons twice failed to win voter support, in 1995 and 1996. Given the prominence of the Commons' proponents, the investment in its plan, and the attendant public campaign, this ultimate failure came as a surprise.

In the wake of that defeat, the area of the proposed Commons quickly became a high-tech campus, replete with corporate offices and towering apartments, with nearby Lake Union Park providing critical open space and water access, but without the central greensward or connective fabric of the original plan.

In retrospect, while Seattle's boldest engineering plans—levelling hills and elevating highways, boring tunnels and floating bridges—have often lasted decades or longer, the city's boldest civic visions—the Alaska-Yukon-Pacific Exposition and Century 21, the Bogue Plan and, indeed, the Seattle Commons—have been more transitory, often morphing over years into something that veers from the striking ambitions of the original plan.

But the fate of the Commons did something else that would only emerge in the following decade. It left a legacy that would inform more successful efforts to create open space, serving as a nucleus for work that would evolve to become the Olympic Sculpture Park and onward to the redevelopment of the entire central Seattle waterfront at the start of the twenty-first century.

**The New Century**
The Commons initiative spawned a determined and experienced leadership cadre committed to generating a more favorable ecosystem for the elevation of parks and open space in the city's growing metropolitan area. From their ranks, the Seattle Parks Foundation was born, built on the knowledge that Seattle's park system needed a nonprofit partner that could generate both monetary and political support for parks. The current parks superintendent, Ken Bounds, had worked with the Woodland Park Zoo Society to successfully transfer management of the zoo

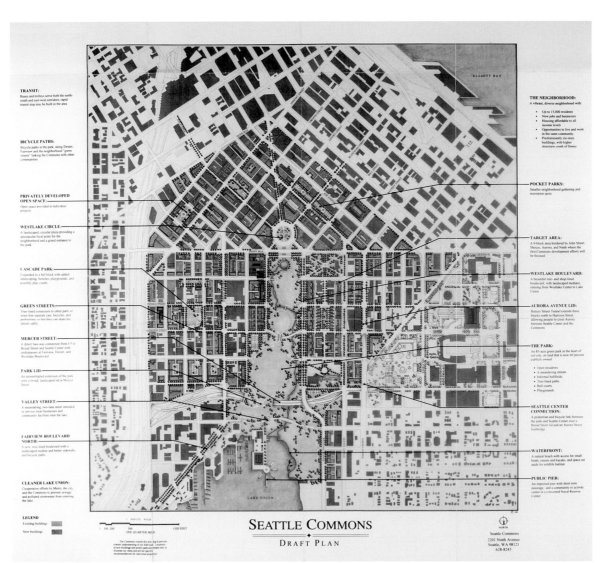

FIG. 7.10
Seattle Commons
Draft Plan, 1995.
Seattle Munic-
ipal Archives,
Map 339.

from the Parks Department to the nonprofit Woodland Park Zoo Society under a twenty-year agreement. Having also worked on the Commons project, he realized the importance of a partner with an established base of support to leverage in order to expand the parks system's ability to serve the community.

Seattle was becoming a residential downtown with the development of the South Lake Union district. The failure of the Commons project did not stop the inevitable redevelopment of that sorely neglected and underutilized area. Paul Allen had lent the project $20 million to acquire the properties that would have been the park's

foundation. If the voters had approved the Commons, Allen would have forgiven the loans and contributed the land for public use.

With that project's second failure at the polls on May 21, 1996, the properties became Allen's in lieu of payment, and he created Vulcan Real Estate, a development arm, to craft and manage a vision for the neighborhood as a mixed-use technology and biotech hub. This mixed commercial/residential neighborhood accelerated the conversion of Seattle's downtown into a more lived-in and livable district than it had been in decades. As that effort was unfolding, the City of Seattle realized a small piece of the Commons vision, creating Lake Union

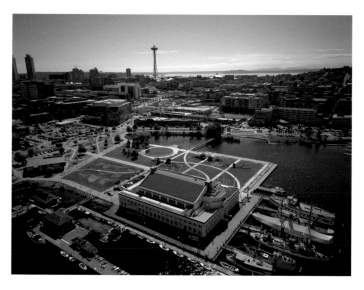

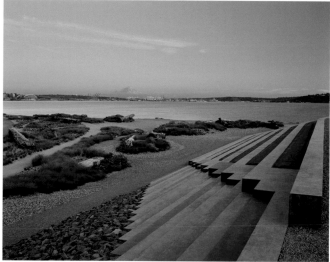

FIG. 7.11
Museum of
History and
Industry, Lake
Union Park, 2018.

FIG. 7.12
View from the
Expedia Group
Beach looking
south over Elliott
Bay, 2019.

Park and the Museum of History and Industry (MOHAI) through two more collaborations with nonprofit partners to redevelop land along Lake Union and the old US Naval Reserve Armory into public assets (fig. 7.11).

Lake Union Park was the first major Seattle Parks Foundation project; they successfully raised substantial private funding for the park's construction. MOHAI followed hard on the heels of the park's completion with a rehabilitation of the armory building into a history museum using a combination of public and private gifts. The new MOHAI campus and Lake Union Park provided critical relief from the density of downtown's explosive growth, gaining a central location to serve as important public amenities.

In 2008, Mayor Greg Nickels drafted many of the leaders of the Commons, Seattle Parks Foundation, zoo, and Olympic Sculpture Park to work on a new waterfront plan as the city contemplated the impact of removing its earthquake-damaged elevated freeway. They brought experience and wisdom to the process, as well as an understanding of the benefit a nonprofit collaborator could bring to creating a robust civic asset.

The Waterfront Seattle project began as the Olympic Sculpture Park was being completed and immediately recognized for its successful strategy for redeveloping and managing a blended public

and private space, with a nonprofit partnering with the City of Seattle for a better outcome. In 2019–20, the completion of the waterfront trail section just south of the Magnolia Bridge replicated this model, with the Expedia Group, a private corporation, improving the waterfront north of Myrtle Edwards and Centennial Parks (figs. 7.12). The corporation redesigned and rebuilt this area on its own land as a public amenity and manages it in partnership with the city. Barry Diller, chairman and senior executive of IAC/InterActiveCorp Expedia Group and a veteran and champion of park creation in New York City, reportedly first encountered the trail site on a walk north starting from the Olympic Sculpture Park and, experiencing the extraordinary physical space that is Seattle's waterfront heritage, immediately visualized and understood the opportunity to develop that site for the public good.

The designer of Waterfront Seattle, James Corner of James Corner Field Operations, similarly responded to the experience of walking the full length of the existing waterfront space in 2010. At the time, the sculpture park stood out as a remarkable departure and an exemplary conversion of a degraded industrial sector into a place of beauty and opportunity, drawing a city to those joyful chance encounters that build common ground. Corner had designed and just finished the

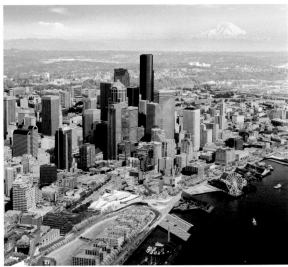

first section of the High Line in New York, another conversion of fallow industrial space repurposed for beauty while honoring its character and past.

Like a set of dominoes, these developments created a chain reaction: the Seattle Commons, Seattle Parks Foundation, Lake Union Park, Olympic Sculpture Park, and now Waterfront Seattle gathered increasing traction. With the city's rapid development and its ambition to be a player on the global stage, it had both the resources and the vision to create a great city. By all measures, arts, culture, and parks are a large part of achieving that status.

## Reimagining the Waterfront

The final stage in the century-long effort to reimagine the city's waterfront began, as is so often the case in Seattle, with the forces of the natural world—in this instance, a major earthquake in 2001 that shook Seattle both physically and in public awareness of it geologic vulnerability. In response to the damage that the Nisqually earthquake wrought upon the infrastructure adjacent to the central waterfront, specifically the elevated Alaskan Way Viaduct freeway and the dilapidated hundred-year-old seawall, the city and state began the long process of grappling with the renewal of Seattle's transportation corridor (figs. 7.13–14).

The tremblor serendipitously forced Seattle to reimagine its signature natural, economic, and civic asset—its waterfront—just as the design selection process for the Olympic Sculpture Park got underway. Already several years in development when the earthquake struck, the sculpture park soon became the first postindustrial creation that celebrated the city, the setting, and Seattle's civic possibilities. It was a bellwether for the emergence of the new Seattle, modeling collaboration, design excellence, and tenacity, and foreshadowing the potential of a new waterfront writ large.

At its heart, the Olympic Sculpture Park offered a novel and challenging approach to rethinking the downtown core. Seattle was becoming a global city through commerce and technology but had yet to embrace that role in a physical sense. One of the great assets the city owned was its magnificent harbor—among the most beautiful in the world and a busy working port. For well over a century, the waterfront had been a maritime and commercial hub, managed for effectiveness as a port but not as a cultural or aesthetic benefit to Seattle's citizens. Yet by 2001, the central waterfront was in a state of some decay, and those who lived in the region turned outside the city center for recreation amid the natural beauty of the surrounding mountains and sea.

FIG. 7.13
Aerial view of Seattle Central Waterfront, looking northeast, 2017.

FIG. 7.14
Rendering of the planned Waterfront Park by James Corner Field Operations, 2012.

With the dawning of the twenty-first century and the explosion of the technology and service economy, the city again served as a magnet for the best and the brightest who would come to make their fortunes, though not in the old way of shipping and logging. While the big nature and cultural sophistication of Seattle were tremendously appealing to those who wished to live in a lively and beautiful place, the city had yet to establish an interesting and unique downtown, and it lacked distinguishing features beyond the Space Needle. Revitalizing the city core and reclaiming the beauty of its setting became priorities with the arrival of a new generation of workers who wanted a different kind of city.

The Olympic Sculpture Park was a crucial first move in the creation of a downtown green waterfront—a test of the city's nascent vision for reimagining its abandoned industrial zone. The conversion of the former Union Oil Company of California site was a miraculous proof of concept: a muddy, ugly oil-storage facility on the shores of the harbor converted to a lovely green space with magnificent views of city, mountains, and water—and equally iconic works of art. It was a revelation and a harbinger.

The current design for the rest of the central waterfront, to the south of the sculpture park, is at once an homage to and a continuation of the park's concept of reinvention. It carries forward both the aesthetic and environmental strands of the Olympic Sculpture Park's DNA, recovering the beauty of the place while making the site's impact actively restorative (fig. 7.15). The park's marriage

of public accessibility and artistic opportunity is also encoded in the new waterfront, with a master design by James Corner Field Operations that envisions multiple ways for the community to engage and perform in park spaces, aiming to bring people together to experience each other without fear. Ultimately, the Olympic Sculpture Park created a new paradigm for the civic space of the twenty-first century, and the Waterfront Seattle plan is an extension of that thinking.

**Toward an Integrated Plan**

The success of the Olympic Sculpture Park and its effective design created a sense of possibility that proved essential for the redevelopment of the central waterfront. Once the city decided to build a tunnel to replace the damaged viaduct, the need for a thoughtful approach to the reuse of the liberated right of way became self-evident.

The committee of citizen advisors appointed by Mayor Nickels succeeded admirably on many fronts—not least by following the sculpture park's lead in recommending a design competition, which yielded Corner's innovative plan. One of four finalists, James Corner Field Operations envisioned a revitalization that honored the identity and history of the city and reconnected the downtown core with the shoreline of Elliott Bay, just as the Olympic Sculpture Park's design had. Corner's plan calls for both the rebuilding of the seawall and the new Elliott Way road project as part of an integrated design, an approach that aims to bind the waterfront park elements, public piers, Seattle Aquarium, and Pike Place Market together in one flowing experience from the civic stadiums in the south to the Belltown neighborhood in the north (fig. 7.16).

The space vacated by the removal of the two-deck elevated highway (which was relocated to a new tunnel) provides an opening for over

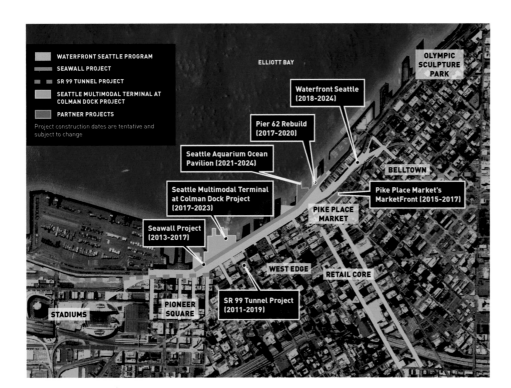

FIG. 7.16
Waterfront Seattle
program by James
Corner Field
Operations.

twenty acres of public space along this 26-block stretch of the central waterfront. Carved into this space is a grand waterside promenade cantilevered over a new seawall—the greenest in the world—and a salmon highway of protected habitat for the migrating juvenile salmon from the Duwamish River moving out into Puget Sound and the Pacific Ocean (fig. 7.17).

This broad walkway is punctuated by gardens, boardwalks, and several multiacre public spaces that parallel the new tree-lined Alaskan Way and dedicated cycle track, which runs through the gardens. The two public piers are flexible spaces that will host markets, festivals, yoga, soccer, ice skating, and concerts, as well as passive enjoyment of the spectacular views of water, mountains, and city. The plazas in front of both the Seattle Aquarium and the Ferry Terminal flow into the promenade as gathering spaces for sports fans, outdoor classes, food trucks, and so on. The heart of the project is a land-bridge garden and play area, Overlook Walk, that flows down from the Pike Place Market to the water—over the street and wrapping the iconic new Aquarium

Ocean Pavilion—providing those extraordinary Seattle views once enjoyed from the elevated highway.

The proposed seawall and adjacent land-scaped roadway, pedestrian promenade, and dedicated bike path would green and link the various neighborhoods of the waterfront district. Moreover, these infrastructure extensions are both important to and emblematic of Corner's project design, rather than isolated and disconnected elements. The fully realized Olympic Sculpture Park likewise incorporates a public beach, bike path, and reimagined seawall, as well as solving the problem of bridging a major arterial road and train track, providing a model for the collaborative and comprehensive creation of a civic asset through a public/private partnership.

## Sustaining the Vision

Seattle has always had a future-oriented culture, willingly reinventing itself in each epoch, and it entered the twenty-first century as a global center for innovation amid insistent demands for an urban public realm to support that identity. The Seattle

FIG. 7.17
Waterfront
Seattle typical
cross section for
by James Corner
Field Operations.

Art Museum showed Waterfront Seattle the way with its Olympic Sculpture Park project, from the role of great design in iconic place making to the patience required in developing a comprehensive project within this unique urban context of complex environmental and infrastructure issues.

In response to concerns about how managing a large waterfront park might burden the rest of the city's park system, Waterfront Seattle's citizen committee helped to pass a Metropolitan Parks District initiative that secured new dedicated dollars for future operations of the waterfront park. However, in developing its strategic plan for the implementation of the Waterfront Seattle design, the project committee recognized the need for a powerful nonprofit partner for the city. Like the Seattle Parks Foundation—and, elsewhere, the Friends of the High Line, New York's Central Park Conservancy, and Chicago's Millennium Park

Foundation—the Friends of Waterfront Seattle would come together to raise the private philanthropic capital for the park's construction as well as to provide ongoing private support for stewardship of this new civic asset—from programming and public engagement to public safety. This nonprofit partner could also mobilize important political support for the project now and in the future.

The Friends of Waterfront Seattle was born out of the project's strategic plan and, in 2012, blessed by the Seattle City Council and then-Mayor Mike McGinn, who tasked the organization with fundraising goals and with understanding the public needs for spaces that are free, safe, and programmed. While the Expedia Group renews the shoreline to the sculpture park's north on Port of Seattle property, and to its south a city/state collaboration recasts the central waterfront, the Olympic Sculpture Park stands as the cornerstone of Waterfront Seattle, orienting its mission to strengthen the city's vital infrastructure while recapturing the natural beauty and long history of this place on the Salish Sea (fig. 7.18).

FIG. 7.18
Waterfront Seattle
western overlook
walk rendering
by James Corner
Field Operations,
2018.

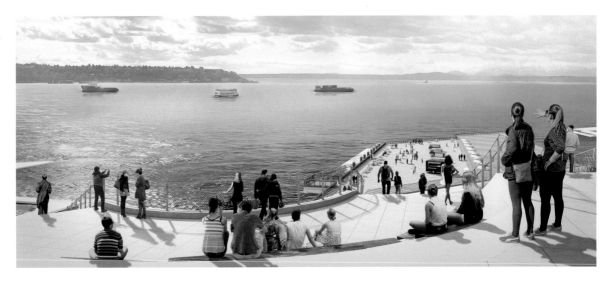

# Olympic Sculpture Park

*Project Timeline*

**1995**
Jon and
Mary Shirley
initiate idea of a sculpture
park in Seattle. Seattle Art
Museum (SAM) Trustee Virginia "Jinny"
Wright and SAM Director Mimi Gardner
Gates enthusiastically buy in.

**1995–1996**
Integration of sculpture into proposed
Seattle Commons discussed. Seattle
Commons fails when Seattle voters
reject tax levies to fund project.

**1996–1997**
SAM partners with Trust for Public Land
(TPL) to identify and acquire sculpture
park site, a waterfront brownfield
owned by Union Oil of California
(Unocal).

Shirleys pledge to endow sculpture
park operations if SAM raises funds to
purchase and develop site.

TPL/SAM option property for $100;
confidential negotiations with Unocal
continue until late 1999.

**1998**
TPL/SAM, City of Seattle, and Unocal,
in consultation with Washington State
Department of Ecology, negotiate
distribution of environmental
responsibilities.

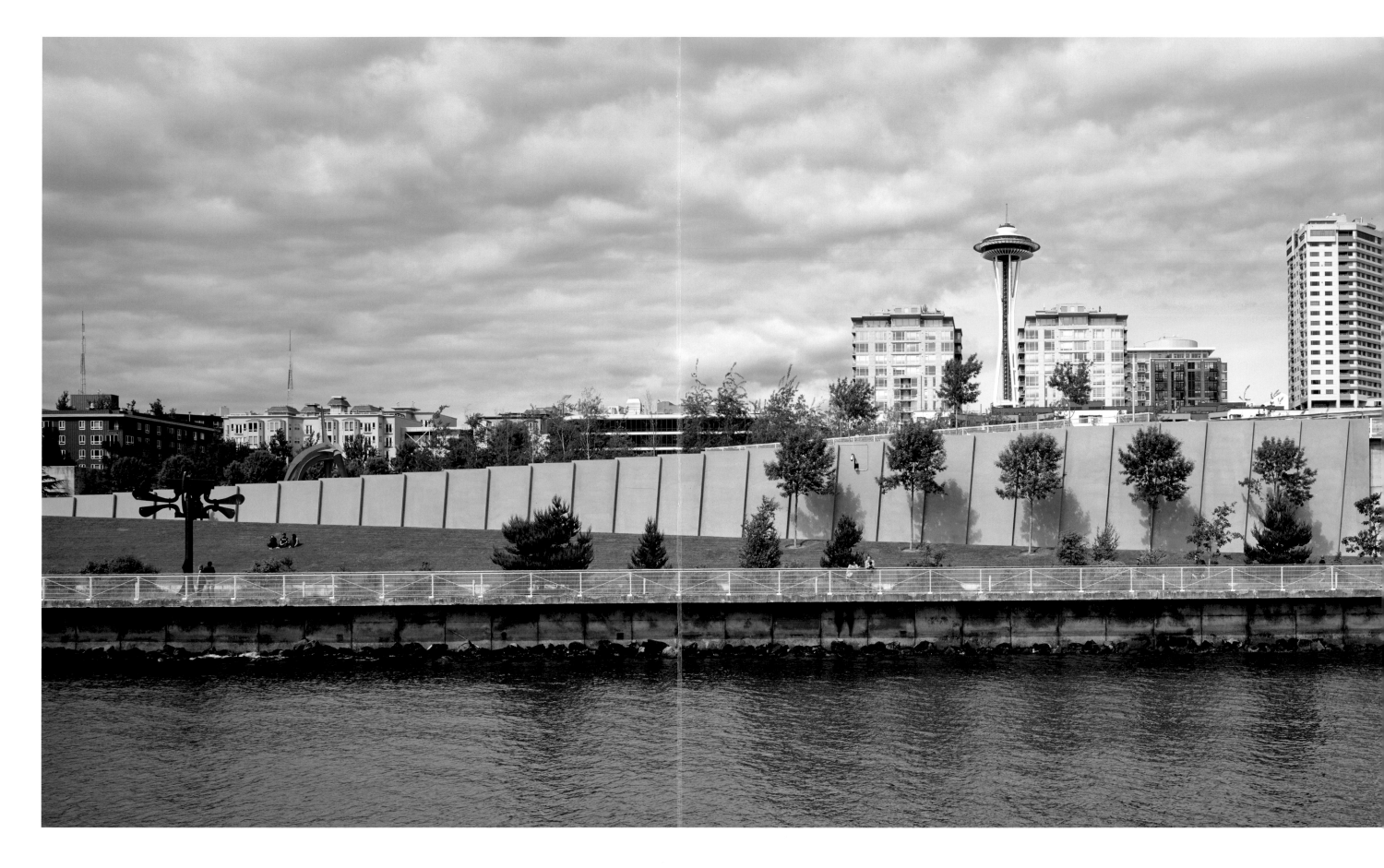

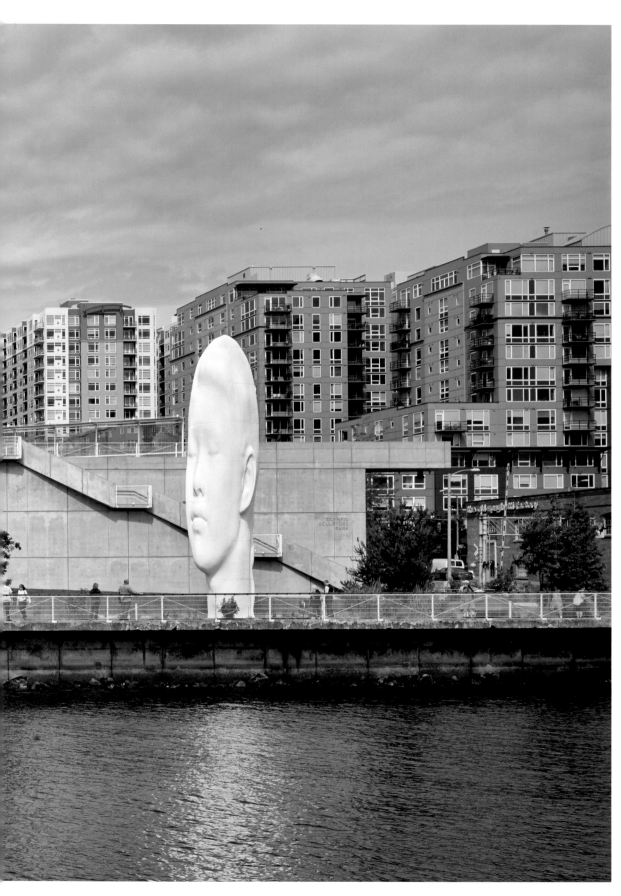

The Olympic Sculpture Park from Elliott Bay, with Jaume Plensa's *Echo* (2011), 2014.

**2005**
*Groundswell* exhibition, Museum of Modern Art, New York, features OSP.

SAM hosts park groundbreaking ceremony, community celebrates.

All permits received; general contractor Sellen Construction begins work.

Removal of waterfront streetcar maintenance barn opens entire park land for construction.

**January 2006**
Washington State Department of Natural Resources grants SAM permission for habitat enhancement of tidelands.

**Spring 2006**
Shaped by 200,000+ cubic yards of fill, OSP's major landforms east of BNSF tracks near completion.

Installation of artwork begins.

Bicycle/pedestrian pathways in Myrtle Edwards Park, adjacent to OSP, rebuilt for connection to new paths along OSP waterfront.

**Summer 2006**
Grading, landscaping, and infrastructure near completion; installation of freestanding sculpture begins.

July 31–August 28: King County concrete workers strike, delaying park's opening several months.

**Fall 2006**
Calder's *The Eagle* installed.

**Early 2007**
January 21: OSP public opening (upper 2 parcels only) draws over 23,000 people. First temporary exhibitions open in the pavilion.

Construction proceeds on waterfront parcel.

**June 2007**
Waterfront parcel opens, extending public access to entire Olympic Sculpture Park. By end of 2007, park receives major design awards.

# Olympic Sculpture Park Awards

**2020**
Thomas Jefferson Foundation Medal in Architecture awarded to Marion Weiss and Michael A. Manfredi

**2016**
RECORD's Top 125 Buildings, *Architectural Record*

**2014**
Mies Crown Hall Americas Prize (MCHAP) finalist, the College of Architecture, Illinois Institute of Technology

**2010**
ULI Amanda Burden Urban Open Space Award finalist

**2008**
World Architecture Festival: Nature Category

Environmental Design Research Association (EDRA) Great Places Award

American Architecture Award, the Chicago Athenaeum

Design Awards 2008: Best Cultural Space, *Travel + Leisure*

Top Restored Beach Award, American Shore and Beach Preservation Association

2008 Engineering Excellence Awards: Grand Award, American Council of Engineering Companies

Top 10 Architectural Marvels 2008, *Time*

**2007**
Veronica Rudge Green Prize in Urban Design, Harvard University Graduate School of Design

The American Institute of Architects (AIA) Honor Award for Architecture, AIA National

The American Society of Landscape Architects (ASLA) Honor Award

The American Institute of Architects (AIA) Excellence in Design Award, AIA New York State

The American Institute of Architects (AIA) Honor Award, AIA New York Chapter

The American Institute of Architects (AIA) Honor Award, AIA Seattle Chapter

International Urban Landscape Award finalist (Weiss/Manfredi), *Topos – International Review of Landscape Architecture and Urban Design*, *A&W* (*Architektur&Wohnen*), and Eurohypo Aktiengesellschaft, Frankfurt, Germany

**2005**
Exhibition selection, *Groundswell: Constructing the Contemporary Landscape*, Museum of Modern Art, New York (February 25–May 16), curated by Peter Reed

**2003**
Progressive Architecture Award: Architecture Magazine

# Recommended Reading and Resources

## Sculpture Parks

Ault, Julie, Brian Wallis, Maryanne Weems, and Philip Yenawine. *Art Matters: How the Culture Wars Changed America*. London: New York University Press, 1999.

Beardsley, John. *Art in Public Places: A Survey of Community-Sponsored Projects Supported by the National Endowment for the Arts*. Washington, DC: Partners for Livable Place, 1981.

Busquets, Joan, ed. *Olympic Sculpture Park for the Seattle Art Museum: Weiss/Manfredi*. Cambridge, MA: Harvard University Graduate School of Design, 2008.

Farber, Paul M., and Ken Lum, eds. *Monument Lab: Creative Speculations for Philadelphia*. Philadelphia: Temple University Press, 2019.

Finkelpearl, Tom. *Dialogues in Public Art*. Cambridge, MA: MIT Press, 2000.

Florence, Penny. *Thinking the Sculpture Garden: Art, Plant, Landscape*. New York: Routledge, 2020.

Harper, Glenn, and Twylene Moyer. *Landscapes for Art: Contemporary Sculpture Parks*. Perspectives on Contemporary Sculpture. Hamilton, NJ: ISC Press, and Seattle: University of Washington Press, 2008.

Hedreen, Ann, Rustin Thompson, Todd Jefferson Moore, Johnny Utah, Marion Weiss, Michael A. Manfredi, and Mark Dion. *Art without Walls: The Making of the Olympic Sculpture Park*. Seattle: White Noise Productions, 2007. DVD.

Jacobs, Mary Jane, and Michael Brenson, *Conversations at the Castle: Changing Audiences and Contemporary Art*. Cambridge, MA: MIT Press, 1998.

Langen, Silvia. *Outdoor Art: Extraordinary Sculpture Parks and Art in Nature*. Munich: Prestel, 2015.

Simms, Matthew. *Robert Irwin: A Conditional Art*. New Haven, CT: Yale University Press, 2016.

Simms, Matthew, Ed Schad, and Sally Yard. *Robert Irwin: Site Determined*. Long Beach, CA: University Art Museum, California State University, and New York: Del Monico, 2018.

Walker Art Center. *Sculpture: Inside Outside*. Minneapolis: Walker Art Center, 1988.

## Architecture, Landscape Architecture, and Infrastructure

Allen, Stan, and Marc McQuade, eds., in cooperation with Princeton University School of Architecture. *Landform Building: Architecture's New Terrain*. Baden, Germany: Lars Müller, 2011.

Bilkovic, D. M., M. M. Mitchell, M. K. La Peyre, and Jason D. Toft, eds. *Living Shorelines: The Science and Management of Nature-Based Coastal Protection*. Boca Raton, FL: CRC Press, 2017.

Duany, Andrés. *Landscape Urbanism and Its Discontents: Dissumulating the Sustainable City*. Gabriola Island, BC: New Society Publishers, 2013.

Gastil, Raymond W. *Beyond the Edge: New York's New Waterfront*. New York: Princeton Architectural Press, 2002.

Mostafavi, Mohsen, and Gareth Doherty. *Ecological Urbanism*. Rev. 4th edition. Zürich: Lars Müller Publishers, 2016.

Orff, Kate. *Toward an Urban Ecology: SCAPE / Landscape Architecture*. New York: Monacelli Press, 2016.

Reed, Peter. *Groundswell: Constructing the Contemporary Landscape*. New York: Museum of Modern Art, 2005.

Waldheim, Charles. *Landscape as Urbanism: A General Theory*. Princeton, NJ: Princeton University Press, 2016.

Waldheim, Charles, ed. *The Landscape Urbanism Reader*. New York: Princeton Architectural Press, 2006.

Weiss, Marion, and Michael A. Manfredi. *Public Natures: Evolutionary Infrastructures*. New York: Princeton Architectural Press, 2015.

Weiss, Marion, and Michael A. Manfredi. *Site Specific: The Work of Weiss/Manfredi Architects*. New York: Princeton Architectural Press, 2000.

Weiss, Marion, and Michael A. Manfredi. *Weiss/Manfredi: Surface/Subsurface*. New York: Princeton Architectural Press, 2008.

# Index

# Contributors

**Barry Bergdoll** is Meyer Schapiro Professor of Art History at Columbia University and the former chief curator in the Department of Architecture and Design at the Museum of Modern Art, New York. He is the author, most recently, of *Marcel Breuer: Building Global Institutions* (Lars Müller, 2017). His earlier publications include *Mastering McKim's Plan: Columbia's First Century on Morningside Heights* (Columbia University Press, 1997) and *Léon Vaudoyer: Historicism in the Age of Industry* (MIT Press, 1994), among many others.

**Lisa Graziose Corrin** is director of the Mary and Leigh Block Museum of Art at Northwestern University. Her previous positions include director of the Williams College Museum of Art and deputy director of art / curator of modern and contemporary art at the Seattle Art Museum, where she was the artistic lead for the Olympic Sculpture Park. Most recently, she co-curated the Block's *A Feast of Astonishments: Charlotte Moorman and the Avant-Garde, 1960s–1980s* (2016).

**Renée Devine** is a Seattle-based project manager and consultant. She joined the Seattle Art Museum in 2004 as the art program director for the Olympic Sculpture Park, then served as senior project manager and, later, director of Dale Chihuly Studio. She previously worked for Zabriskie Gallery, New York, coordinating the publication of *Zabriskie Fifty Years* (Ruder Finn, 2004).

**Leonard Garfield** is executive director of Seattle's Museum of History and Industry. He previously served as director of the King County Office of Cultural Resources (now 4Culture) and Washington State Architectural Historian. He is coauthor, with the staff of the Washington State Office of Archaeology and Historic Preservation, of *Built in Washington: 12,00 Years of Pacific Northwest Archaeological Sites and Historic Buildings* (Washington State University Press, 1990).

**Mimi Gardner Gates** was director of the Seattle Art Museum from 1994 to 2009. Previously, she was curator of Asian Art (1975–86) and director (1987–94) of the Yale University Art Gallery. In the field of Chinese art, she has taught, curated numerous exhibitions, and authored essays in catalogues including *Bones of Jade, Soul of Ice: The Flowering Plum in Chinese Art* (Yale University Art Gallery, 1985), *Porcelain Stories* (Seattle Art Museum, 2000), and *Cave Temples of Dunhuang: Buddhist Art on China's Silk Road* (Getty Trust, 2016). Gates currently chairs the Dunhuang Foundation and the Blakemore Foundation and serves on the boards of Heritage University, the Seattle Symphony, the Northwest African American Museum, Asian Art Museum of San Francisco, and Copper Canyon Press, and is a trustee of the Gates Cambridge Scholars Trust.

Lynda V. Mapes is a journalist, currently at the *Seattle Times*, where she specializes in coverage of the environment, natural history, and Native American issues. She is the author of *Witness Tree: Seasons of Change with a Century-Old Oak* (Bloomsbury, 2017), *Breaking Ground: The Lower Elwha Klallam Tribe and Unearthing of the Tse-Whit-Zen Village* (University of Washington Press, 2015), and *Elwha: A River Reborn: The Resurrection of a River* (Mountaineers, 2013), among other publications.

Peter Reed, former senior deputy director for curatorial affairs at the Museum of Modern Art, New York, organized numerous exhibitions, including *Groundswell: Constructing the Contemporary Landscape* (2005). His many previous publications include *Oasis in the City: The Abby Aldrich Rockefeller Sculpture Garden at the Museum of Modern Art* (MoMA, 2018) and *The Show to End All Shows: Frank Lloyd Wright and the Museum of Modern Art, 1940* (MoMA, 2004).

Maggie Walker is a board member of the University of Washington Foundation, where she chairs the Advisory Board of the College of the Environment. She is also co-chair of the Prosperity Partnership's Cultural Task Force, co-chair of the Central Waterfront Committee, chair of the Board of Global Partnerships, and chair of Friends of Waterfront Seattle.

Marion Weiss and Michael A. Manfredi are cofounders of Weiss/Manfredi Architecture/Landscape/Urbanism, a multidisciplinary design practice based in New York City known for the dynamic integration of architecture, art, infrastructure, and landscape. The firm's award-winning projects include the Olympic Sculpture Park, the Women's Memorial at Arlington National Cemetery, Brooklyn Botanic Garden's Visitor Center, and Hunter's Point South Waterfront Park in Queens.

# Olympic Sculpture Park
# Project Credits

## Weiss/Manfredi Architecture/ Landscape/Urbanism Team

Design Partners: Marion Weiss and Michael A. Manfredi
Project Manager: Christopher Ballentine
Project Architects: Todd Hoehn and Yehre Suh
Project Team: Patrick Armacost, Michael Blasberg, Emily Clanahan, Beatrice Eleazar, Hamilton Hadden, Mike Harshman, Mustapha Jundi, John Peek, and Akari Takebayashi
Additional Team Members: Lauren Crahan, Kian Goh, Justin Kwok, and Lee Lim

## Consultant Team

Structural and Civil Engineering Consultant: Magnusson Klemencic Associates
Landscape Architecture Consultant: Charles Anderson Landscape Architecture
Mechanical and Electrical Engineering Consultant: ABACUS Engineered Systems
Lighting Design Consultant: Brandston Partnership, Inc.
Geotechnical Engineering Consultant: Hart Crowser
Environmental Consultant: Aspect Consulting
Aquatic Engineering Consultant: Anchor QEA
Graphics Consultant: Pentagram
Security, Audiovisual, and Information Technology Consultant: ARUP
Catering and Food Service Consultant: Bon Appetit
Kitchen Consultant: JLR Design
Retail Consultant: Doyle + Associates
Architectural Site Representation: Owen Richards Architects
Project Management: Barrientos LLC
General Contractor: Sellen Construction

## Donor Credits

Founding Donors: Jon and Mary Shirley

The following named precincts and park features honor the support of our generous donors:

Gates Amphitheater
The Trust for Public Land Terrace
PACCAR Pavilion
Allen Family Foundation Plaza
Alvord Art Lab
Neukom Vivarium
Ackerley Family East Meadow
Kreielsheimer North Meadow
Ketcham Families Grove
Eaton Skinner Trail
Benaroya Path
Foster Foundation Path
Moseley Path
Mimi Gardner Gates Bridge
The Boeing Company Bicycle Path

# Sculpture Credits

The following list includes works exhibited at the Olympic Sculpture Park and reproduced in this publication. Except as specified, all works are in the collection of the Seattle Art Museum.

Louise Bourgeois, American (born France), 1911–2010
*Eye Benches I*, 1996–97
Black Zimbabwe granite
Each 48¾ × 53 × 45¼ in.
Gift of the artist, in honor of the 75th Anniversary of the Seattle Art Museum, 2005.113.1-2
© Louise Bourgeois

Louise Bourgeois, American (born France), 1911–2010
*Eye Benches II*, 1996–97
Black Zimbabwe granite
Each 48 × 76¹⁵⁄₁₆ × 46 in.
Gift of the artist, in honor of the 75th Anniversary of the Seattle Art Museum, 2005.114.1-2
© Louise Bourgeois

Louise Bourgeois, American (born France), 1911–2010
*Eye Benches III*, 1996–97
Black Zimbabwe granite
Each 51 × 96 × 54¹⁵⁄₁₆ in.
Gift of the artist, in honor of the 75th Anniversary of the Seattle Art Museum, 2005.115.1-2
© Louise Bourgeois

Louise Bourgeois, American (born France), 1911–2010
*Father and Son*, 2005
Stainless steel, aluminum, water, and bronze bell
Overall fountain basin: 36 ft. × 26 ft.; father figure height: 77 in.; son figure height: 57 in.
Gift of the Estate of Stu Smailes, 2006.141
© Louise Bourgeois

Alexander Calder, American, 1898–1976
*The Eagle*, 1971
Painted steel
38 ft. 9 in. × 32 ft. 6 in. × 32 ft. 6 in.; estimated weight 6 tons
Gift of Jon and Mary Shirley, in honor of the 75th Anniversary of the Seattle Art Museum, 2000.69
© 2021 Calder Foundation, New York / Artist Rights Society (ARS), New York

Anthony Caro, British, 1924–2013
*Riviera*, 1971–74
Steel, rusted and varnished
10 ft. 7 in. × 27 ft. × 10 ft.
Gift of the Virginia and Bagley Wright Foundation, in honor of the 75th Anniversary of the Seattle Art Museum, 2014.25.9
On view 2007–10
© Anthony Caro

Mark Dion, American, born 1961
*Neukom Vivarium*, design approved 2004; fabrication completed 2006
Mixed-media installation
Greenhouse structure length: 80 ft.
Gift of Sally and William Neukom, American Express Company, Seattle Garden Club, Mark Torrance Foundation, and Committee of 33, in honor of the 75th Anniversary of the Seattle Art Museum, 2007.1
© Mark Dion

Teresita Fernández, American, born 1968
*Seattle Cloud Cover*, design approved 2004; fabrication
    completed 2006
Laminated glass with photographic design interlayer
Approx. 9 ft. 6 in. × 200 ft. × 6 ft. 3 in.
Olympic Sculpture Park Art Acquisition Fund, in honor of the
    75th Anniversary of the Seattle Art Museum, 2006.140
© Teresita Fernández

Ellsworth Kelly, American, 1923–2015
*Curve XXIV*, 1981
⅜-inch weathering steel
6 ft. 4 in. × 19 ft. × ⅜ in.
Gift of the Virginia and Bagley Wright Collection, in honor of
    the 75th Anniversary of the Seattle Art Museum, 2016.17.2
© Ellsworth Kelly

Roy McMakin, American, born 1956
*Love & Loss*, 2005–6
Mixed-media installation with benches, tables, live tree,
    pathways, and illuminated rotating element
Overall: 24 × 40 ft.
Olympic Sculpture Park Art Acquisition Fund and gift of Paul G.
    Allen Family Foundation, in honor of the 75th Anniversary
    of the Seattle Art Museum, 2007.2
© Roy McMakin

Roy McMakin, American, born 1956
*Untitled*, 2004–7
Concrete, bronze, and steel with porcelain enamel
Bench: 5 × 5 × 3 ft.; with other elements, dimensions variable
Gift of the artist and Michael Jacobs, in honor of the 75th
    Anniversary of the Seattle Art Museum, 2006.32
© Roy McMakin

Louise Nevelson (born Louise Berliawsky), American
    (born Russia), 1899–1988
*Sky Landscape I*, 1976–83
Welded aluminum, painted black
10 ft. × 10 ft. × 6 ft. 2 in.
Gift of Jon A. Shirley, 2021.4
© Louise Nevelson

Claes Oldenburg, American (born Sweden), born 1929, and
    Coosje van Bruggen, American (born the Netherlands),
    1942–2009
*Typewriter Eraser, Scale X*, 1998–99
Painted stainless steel and fiberglass
19 ft. 11¼ in. × 12 ft. 8½ in. × 11 ft. 4 in.
Lent by the Allen Family Collection
On view 2007–17
© Claes Oldenburg and Coosje van Bruggen

Roxy Paine, American, born 1966
*Split*, 2003
Polished stainless steel
Height: 50 ft.
Gift of the Virginia and Bagley Wright Collection, in honor of
    the 75th Anniversary of the Seattle Art Museum, 2016.17.3
© Roxy Paine

Beverly Pepper, American, 1924–2020
*Perre's Ventaglio III*, 1967
Stainless steel and enamel
7 ft. 10 in. × 6 ft. 8 in. × 8 ft.
Gift of Jon and Mary Shirley, in honor of the 75th Anniversary of
    the Seattle Art Museum, 2005.200

Beverly Pepper, American, 1924–2020
*Persephone Unbound*, 1999
Cast bronze
10 ft. 2 in. × 31½ in. × 21 in.
Gift of Jon and Mary Shirley, 2009.14

Jaume Plensa, Spanish, born 1955
*Echo*, 2011
Polyester resin, marble dust, steel framework
Height: 45 ft. 11 in.; footprint at base: 10 ft. 8 in. × 7 ft. 1 in.;
    gross weight: 13,118 lb.
Gift of Barney A. Ebsworth, 2013.22

Pedro Reyes, Mexican, born 1972
*Capula XVI (obolo a)* and *Capula XVII (obolo b)*, 2006
Stainless steel and woven vinyl
Each approximately 8 ft. 2 in. × 8 ft. 2 in. × 6 ft. 6 in.
Olympic Sculpture Park Art Acquisition Fund and the Modern
    Art Acquisition Fund, in honor of the 75th Anniversary of
    the Seattle Art Museum; Commissioned from the artist
    by the Seattle Art Museum, 2007.3-4
On view 2007-8
© Pedro Reyes

Pedro Reyes, Mexican, born 1972
*Evolving City Wall Mural*, 2006
Mixed-media installation
Approximately 14 ft. 11 in. × 54 ft. 7½ in.
Olympic Sculpture Park Art Acquisition Fund and the Modern
    Art Acquisition Fund, in honor of the 75th Anniversary of
    the Seattle Art Museum; Commissioned from the artist
    by the Seattle Art Museum, 2007.5
On view 2007-8
© Pedro Reyes

George Rickey, American, 1907–2002
*Two Plane Vertical Horizontal Variation III*, 1973
Stainless steel
8 ft. 1 in. × 5 ft. 8 in. × 5 ft. 8 in.
Gift of Martin Z. Margulies, 2007.263

Ginny Ruffner, American, born 1952
*Mary's Invitation—A Place to Regard Beauty*, 2014
Coated aluminum
Approximately 4 × 10 × 3 ft.
Gift in memory of Mary Shirley, from her friends, 2014.22
© Ginny Ruffner

Richard Serra, American, born 1938
*Wake*, 2002–3
10 plates, 5 sets of locked toroid forms, weatherproof steel
Each set, overall: 14 ft. 1¼ in. × 48 ft. 4 in. × 6 ft. 4⅜ in.; overall
    installation: 14 ft. 1¼ in. × 125 ft. × 46 ft.; plate thickness
    2 in.; weight: 30 tons (each plate)
Purchased with funds from Jeffrey and Susan Brotman,
    Virginia and Bagley Wright, Ann Wyckoff, and the Modern
    Art Acquisition Fund, in honor of the 75th Anniversary of
    the Seattle Art Museum, 2004.94
© Richard Serra

Tony Smith, American, 1912–1980
*Stinger*, 1967–68/1999
Steel, painted black
6 ft. 6 in. × 33 ft. 4¼ in. × 33 ft. 4¼ in.
Gift of Jane Smith, 2004.117
© Estate of Tony Smith / Artists Rights Society (ARS),
    New York

Tony Smith, American, 1912–1980
*Wandering Rocks*, 1967–74
Steel, painted black
*Smohawk*: 23 × 48⅜ × 28 in.; *Shaft*: 45½ × 63⅜ × 28 in.;
    *Crocus*: 45 × 43⅜ × 28 in.; *Slide*: 23 × 64⅜ × 28 in.;
    *Dud*: 23 × 32⅜ × 83½ in.
Gift of the Virginia and Bagley Wright Collection, in honor of
    the 75th Anniversary of the Seattle Art Museum, 2016.17.4
© Estate of Tony Smith / Artists Rights Society (ARS),
    New York

Mark di Suvero, American, born 1933
*Bunyon's Chess*, 1965
Stainless steel and wood
Height: 22 ft.
Gift of the Virginia and Bagley Wright Collection, in honor of
    the 75th Anniversary of the Seattle Art Museum; Commis-
    sioned from artist by Virginia and Bagley Wright, Seattle,
    1965, 2016.17.1
© Mark di Suvero

Mark di Suvero, American, born 1933
*Schubert Sonata*, 1992
Painted and unpainted steel
Height: 22 ft.
Gift of Jon and Mary Shirley, the Virginia Wright Fund, and
    Bagley Wright, 95.81
© Mark di Suvero

# Photography Credits

Artwork © Louise Bourgeois: figs. 4.14–15

Artwork © 2021 Calder Foundation, New York / Artist Rights Society (ARS), New York: fig. 2.13

Image courtesy of the City of Seattle: fig. 7.13

Image courtesy of the City of Seattle and James Corner Field Operations: figs. 7.14–18

Image courtesy of Jan Day: fig. 2.3

Artwork © Mark Dion: figs. 5.2–3

Artwork © Teresita Fernández: fig. 5.5

Image courtesy of Mimi Gardner Gates: fig. 2.9

Image courtesy of Peter Hummel, Anchor QEA: figs. 6.5–6, 6.13

Image courtesy of Louisiana Museum of Modern Art / Artwork © 2021 Calder Foundation, New York / Artist Rights Society (ARS), New York: fig. 1.9

Image © Museum of History & Industry (MOHAI), Seattle, all rights reserved: figs. 1.3, 6.2–3, 7.1–4, 7.6–7, 7.9

Digital Image © The Museum of Modern Art / Licensed by SCALA / Art Resource, NY: fig. 1.8

Artwork © Claes Oldenburg and Coosje van Bruggen / Image courtesy of Walker Art Center: fig. 1.11

Artwork © Glenn Rudolph: page 14, no. 2; figs. 4.17–19

Image courtesy of the Seattle Art Museum: figs. 4.14–15, 4.17–19, 5.2–3, 5.5

Image courtesy of the Seattle Municipal Archives: figs. 7.5, 7.8, 7.10

Image © 1999–2005 Seattle Post-Intelligencer: fig. 2.17

Image courtesy of Jason Toft: fig. 6.7

Image courtesy of Weiss/Manfredi: figs. 1.15, 3.5, 3.7–8

Image courtesy of Weiss/Manfredi Architects: figs. 3.5–6, 6.14

Image © Weiss/Manfredi: page 6

Photo by Isobel Alexander, Courtesy of Sno-King Marine Mammal Response SKMMR: fig. 6.16

Photo by Antiqua Print Gallery / Alamy Stock Photo: fig. 1.4

Photo by Iwan Baan: pages 138–39, 158–59; fig. 1.19

Photo by Iwan Baan, Courtesy of Weiss/Manfredi: pages 116–17; figs. 3.9, 3.11, 3.15

Photo by Greg Beckel: fig. 1.11

Photo by Lillian Bennett: fig. 5.9

Photo by Benjamin Benschneider: pages 2–3, 9, 14–15 nos. 20–21, 92–93, 176–77; figs. 1.13, 1.17, 1.20, 2.11, 2.13, 4.5, 4.12–13, 4.16, 5.8, 5.11, 5.13, 6.18

Photo by Benjamin Benschneider, Courtesy of Weiss/Manfredi: pages 38–39, 70–71; figs. 2.19, 3.1–4, 3.13, 4.7,

Photo by Alan Berner / The Seattle Times: figs. 2.2, 2.6

Photo © Marion Brenner Photography: fig. 7.12

Photo by Andrew Buchanan / SLP: figs. 1.16, 2.10, 4.8, 6.10–11

Photo by Susan A. Cole: pages 14–15 no. 14

Photo by Asahel Curtis. © 1910 by Asahel Curtis, Courtesy of Weiss/Manfredi: fig. 1.7

Photo by Danita Delimont / Dissolve: fig. 6.9

Photo by Derby Photography: fig. 2.7

Photo by Alice Dias Didszoleit / Alamy Stock Photo: fig. 1.14

Photo © David Pillow / Dreamstime.com: fig. 4.3

Photo by Nina Dubinsky: fig. 4.2

Photo by Steve Estvanik / Shutterstock. com: fig. 1.6

Photo by Jeff Goldberg / © Jeff Goldberg / Esto, Courtesy of Weiss/Manfredi: fig. 1.15

Photo courtesy of Granger: fig. 1.2

Photo by Kim Hansen: fig. 1.9

Photo by Lydia Heard: figs. 2.12, 6.17

Photo by Mitro Hood: fig. 1.10

Photo by Norah Hummel: fig. 6.13

Photo by Don Ipock: fig. 1.12

Photo by Paul Macapia: pages 14–15 nos. 1, 3–5, 8–9, 15–16, 19, 22, 24–25; figs. 2.5, 4.6, 4.10, 5.1, 5.10, 5.12, 6.15

Photo by Bruce Moore: figs. 2.17, 3.10, 6.1, 6.8

Photo by Bruce Moore, Courtesy of Weiss/Manfredi: pages 16–17; fig. 3.10

Photo by Brian Morris: fig. 7.11

Photo by B. O'Kane / Alamy Stock Photo: fig. 1.1

Photo by Angela Olivera: fig. 6.4

Photo by Chuck Pefley / Alamy Stock Photo: fig. 2.18

Photo by Owen Richards: fig. 6.15

Photo by Andy Rogers / Seattle Post-Intelligencer: fig. 2.15

Photo by Seattle Post-Intelligencer: fig. 2.16

Photo by Julie Speidel: fig. 2.1

Photo by Lara Swimmer, Courtesy of Weiss Manfredi: page 6

Photographer unknown, all rights reserved: fig. 4.11

Photo © Albert Večerka / Esto, Courtesy of Weiss/Manfredi: figs. 3.7–8

Photo by Robert Wade: figs. 1.18, 4.1, 4.20, 6.12

Photo by Paul Warchol: cover; figs. 2.14, 5.7

Photo by Paul Warchol, Courtesy of Weiss/Manfredi: figs. 3.12, 3.14

Photo by Nathaniel Willson: pages 10, 14–15 nos. 6–7, 10–13, 17–18, 23; figs. 2.4, 2.8, 4.4, 4.9, 5.4, 5.6

Photo by Natali Wiseman: fig. 1.13

## Map Photo Credits, pp. 136–37

Valley: Tim Hancock / Shutterstock; Mizy / Shutterstock; Erik Agar / Shutterstock; Sizekapook / Shutterstock

Meadow: Andrea C. Miller / Shutterstock; Robert Mutch / Shutterstock; Doug Waylett / Flickr

Grove: Sharon Talson / Alamy Stock Photo; Photos314159 / Shutterstock; Nikki Yancey / Shutterstock; Northwest Wild Images / Alamy Stock Photo

Shore: Robert Mutch / Shutterstock; Bob Gibbons / Alamy Stock Photo; Tara Schmidt / Shutterstock

Generous support for this publication was provided by Susan Brotman, the Bill & Melinda Gates Foundation, Lyn and Jerry Grinstein, Janet Ketcham, Linda Nordstrom, Faye Sarkowsky, Virginia Wright, Ann Wyckoff, and Martha Wyckoff and Jerry Tone.

Produced by Lucia | Marquand, Seattle
luciamarquand.com

Copyedited by Kristin Swan
Proofread by Barbara Bowen
Designed by Ryan Polich
Typeset by Tina Henderson
Indexed by Dave Luljak
Color management by iocolor, Seattle
Printed and bound in China by Artron Art Printing

Library of Congress Control Number: 2021910399
ISBN: 978-0-932216-80-9

Published by
Seattle Art Museum
1300 First Avenue
Seattle, WA 98101
seattleartmuseum.org

Published in association with
University of Washington Press, Seattle and London
uwapress.uw.edu

Vellum endsheets: Detail of Teresita Fernández's *Seattle Cloud Cover* (2004), digital rendering for the artist's *Seattle Cloud Cover* (2004–6). Courtesy of the artist

Cover: Alexander Calder's *The Eagle* (1971) at sunset, 2006. Photo by Paul Warchol

Frontispiece: View across Elliott Bay toward the Olympic Mountains from the Olympic Sculpture Park, with Alexander Calder's *The Eagle* (1971), 2021. Photo by Benjamin Benschneider

Page 6: Olympic Sculpture Park pavilion exterior at night from Western Avenue, 2007. Photo by Lara Swimmer

Page 10: George Rickey's *Two Plane Vertical Horizontal Variation III* (1973), installed 2010, with the Olympic Sculpture Park pavilion in the background. Photo by Nathaniel Willson

Page 14, no. 2: Glenn Rudolph, *Travelers*, gelatin silver photograph, 35 × 41 in. PONCHO and the Mark Tobey Estate Fund, in honor of the 75th Anniversary of the Seattle Art Museum, 2006.53

Pages 16–17: Precast concrete panels with reflections of Teresita Fernández's *Seattle Cloud Cover* (2004–6) and the aspen grove, 2006. Photo by Bruce Moore

Pages 38–39: Olympic Sculpture Park opening day, January 20, 2007. Photo by Benjamin Benschneider

Pages 70–71: Olympic Sculpture Park pavilion at dusk, 2007. Photo by Benjamin Benschneider

Pages 92–93: Louise Bourgeois's *Father and Son* (2005) and *Eye Benches II* (1996–97). Photo by Benjamin Benschneider

Pages 116–17: View across Elliott Bay with Roy McMakin's *Love & Loss* (2005–6). Photo by Iwan Baan

Pages 138–39: Pocket beach at the Olympic Sculpture Park, 2011. Photo by Iwan Baan

Pages 158–59: View of Elliott Bay from the Olympic Sculpture Park with Mark di Suvero's *Schubert Sonata* (1992). Photo by Iwan Baan

Page 176: The Olympic Sculpture Park from Elliott Bay, 2014. Photo by Benjamin Benschneider